ART AND RELIGION AS COMMUNICATION

ART AND
RELIGION AS
COMMUNICATION

Edited by James Waddell and F. W. Dillistone

JOHN KNOX PRESS
Atlanta, Georgia

Scripture quotations are from the *Revised Standard Version of the Bible*, copyrighted 1946 and 1952.

Acknowledgment is made for permission to quote from *One Flew Over the Cuckoo's Nest* by Ken Kesey. Copyright © 1962 by Ken Kesey. All rights reserved. Reprinted by permission of The Viking Press, Inc.

Portions of "The Way into Matter" by John Dixon appeared in the Spring 1969 issue of *Theology Today* in an article entitled "Faith and Twentieth Century Forms" and are reprinted by permission of *Theology Today*.

Library of Congress Cataloging in Publication Data

Waddell, James, 1938–
 Art and religion as communication.

 Bibliography: p.
 1. Art and religion. I. Dillistone, Frederick
William, 1903– joint author. II. Title.
N72.R4W32 700 73–5353
ISBN 0–8042–1930–3

For Ann

CONTENTS

INTRODUCTION

In contemporary Christian efforts to understand religion and art as communication, two widely accepted propositions seem to be emerging. The first is that each of the two's ordering and communication of experience is unique. The second is that there is, nevertheless, an interrelation and interpenetration between religion and art which do not infringe on the distinctiveness of either but which issue from their differences. Until recently, attention was extensively directed toward exploring the peculiar characteristics of religion and art and establishing their mutual irreducibility. Now, however, there is an increasing concern with building bridges between them without jeopardizing either's integrity.

One of the most productive approaches is found in an examination of the proposal that religion (specifically Christian theology) and art share a common status as processes of the constructive imagination, but each develops its own responsible account of reality. In short, both Christian theology and art as functions of the constructive imagination are seen to order experience in their own ways and in their own languages. Each has something to communicate in its special language about "the self," "form," "content," and "space." One does not need to assign final authority to either language; both can be used to shape and communicate an understanding of experience.

The purpose of this book is to demonstrate some kinds of bridge-building this approach suggests and to stimulate readers to explore other types of spanning activities. Contributors were encouraged, therefore, to pursue patterns which would be provocative

and suggestive of further developments and applications in theology and/or art. The following pilot statements give an overview of the result.

The essay by John W. Dixon, Jr. sets the tone of the volume and anticipates themes of several of the other essays. In speaking symphonically and systematically of the artist as the cartographer of the inner life, he attempts to clear the ground "for art to work as an independent mode of the religious life, not as a handmaid to a propositional system." His landscaping is conducted by no longer viewing theology as the ruling account of reality but as one of many ordering experiences. It is like art, physics, sociology. etc., which all function as principles of the constructive imagination but have their own individual languages. Theology, he argues, is not an accurate account of reality; it is "an energetic structure by which a particular mode of human experience is embodied within the possibilities of a particular language." In what way, then, does art function religiously? Dixon answers this question by examining the art of Richard Lippold. Lippold's art requires us to reorder our sense of space, time, material, and cause—categories which Dixon believes are basic modes for defining the self. Here lies art's relation to religion. In their structuring activity Lippold and some other contemporary artists are "helping us toward one of the greatest achievements of the modern intelligence: self-consciousness about who we are, self-consciousness about the means for our grappling wtih experience." One consequence of this self-consciousness may be to lead to a new and generative relationship between men and the order of the earth. Whether it does or not "may depend on the ability of Christians to transcend their propositional past, take up the body of their belief into a more complete bodily faith, and make real the vision of the new man Christ came to reveal." With these thoughts Dixon then provides a broad analysis of the resources presently available for pressing the search further on different levels.

In speaking of Jesus as "a prophet of indirect communication," in the next essay E. J. Tinsley refers to the form of Jesus' life and speech. Jesus' method of communicating was cryptic, indirect, and allusive. Tinsley says, "His [Jesus'] parabolic and

ironic method was central to his purposes because, to use Blake's phrase, 'it roused the faculties to act.' This 'indirect' method did not impose on others but submitted itself to their free judgment." Tinsley believes that the form of Jesus' life provides one reason why it is appropriate to use analogies from art to communicate the gospel. Given the Christian religion's basis on a unique incarnation, he is surprised that the incarnation, both as God's act of becoming man and as the form of Jesus' life, has not prompted more use of the analogy of a work of art. After mentioning several reasons for the reluctance to use the analogy from art either as the *act* of incarnation or the *form* of the life of the historical Jesus, Tinsley pursues the analogy along both lines. He first discusses, in terms of Berdyaev's thoughts on "creation," the analogy between the art form and the incarnation as God's act of becoming man in Jesus of Nazareth. Then he turns to the analogy of art and the whole course of Jesus' mission. This analogy is important, he believes, because of the paradigmatic significance as form and content that the life and activities of Jesus Christ have for the believer. In spite of the difficulties exposed by form and other types of Biblical criticism, Tinsley thinks it is possible to get an idea of the "mind of Christ" through an analysis of the titles of Jesus. Eschewing traditional analysis, Tinsley examines the pattern of imagery of Jesus' speech. He characterizes Jesus' manner of speech as "ironic," his "style" as "sign/skandalon." Hence the necessity for Jesus to be called "a prophet of indirect communication." Tinsley is convinced that the form of the incarnation creates essential canons of evangelism criticism in the same way that a work of art establishes canons of art criticism. He says, "It is the purpose of both types of criticism to point to the original and not to become a substitute for it." The importance of form leads Tinsley to conclude that Bonhoeffer's theological enterprise of "concretisation" is more promising than Bultmann's demythologizing.

Following Tinsley's essay on Jesus' use of indirect communication comes James D. Whitehill's exploration of indirect communication in Kierkegaard and Beckett. Whitehill begins with a partial exposition of Kierkegaard's theory of indirect communication for the purpose of achieving a heuristic perspective on what

occurs in Beckett's drama when it is encountered in more than a critical, objective way. He wants to move away from approaching dramas as "things," "events," "cultural events," "the author's traumatic self-reflection," etc., to recover them as addresses to men, between men, that raise men in freedom while plunging them to their depths. In his description of the theory of indirect communciation, Whitehill centers his attention on the following aspects: the intention, the content, the method, and the relation of communicator and receiver of an indirect communication. All of these reveal, especially in Beckett's drama, that indirect communication reveals ourselves. For example, in regard to content, Whitehill writes that ". . . while in direct communication a content is delivered to the receiver, indirect communication delivers the receiver into himself as an essentially existing human being." The words that travel between communicator and receiver in indirect communication are so shaped that their appropriation as direct communication is frustrated and hindered at every turn; they act in concert to activate reflection, not upon the communicator or on the objective truth of the content, "but reflection upon oneself in one's own primitivity and freedom."

In my essay I utilize Whitehill's four categories to compare Jesus' style of communication to the indirect communication of Randle Patrick McMurphy, the protagonist of Ken Kesey's novel *One Flew Over the Cuckoo's Nest*. While trying to avoid some common dangers of discussing Christ-figures in literature, the concern is to learn something of Jesus' communication through the story of a unique literary character's attempt to get each man to confront himself. The critical method used is to re-create selectively and in detail the story of McMurphy's communication and then to use the story to reflect on Jesus' communication.

F. W. Dillistone's essay broadens the discussion of Christian communication. He is aware that both the art critic and the theologian face the danger of trying to squeeze the totality of experience into categories too limited and stereotyped to contain it. His main concern is to suggest a possible relationship between the categories "form and content" and "medium and message" which make it possible to distinguish between two situations.

Through an analysis of Keat's "Ode on a Grecian Urn" and Blake's "Jerusalem," he concludes that whereas it is legitimate and illuminating to use the categories "form and content" when we are relating ourselves to cultural situations comparable to ancient Greece, the categories "medium and message" are more appropriate in an apocalyptic age. Where everything is in flux, "Instead of form and content we can apply the terminology of purpose and technique, of end and means, of media being used as tools to shape the earthly representation of the message already partially apprehended." Dillistone thinks that Marshall McLuhan's focusing of attention upon Gutenberg as a symbol of one of the most important changes in the history of man is valid. Gutenberg marks the stage when the dual category "form and content" began to decline in significance in the West while the dual category "medium and message" regained its significance and assumed greater importance at an accelerating rate. Dillistone does not believe, however, that the language of form and content should be abandoned. He suggests that an analysis of the exact nature of the context in which a particular problem is being considered will issue to both the art critic and the theologian the appropriate set of categories. His *modus operandi* is demonstrated through an examination of what can be said about the "forms" of Christian ethics, liturgy, and doctrine.

In assessing the achievement of Marshall McLuhan in communication theory, W. Richard Comstock is interested in the role of certain models which encourage members of a particular culture to organize their experiences according to socially approved categories. McLuhan argues "that the cultural models or forms in ascendancy at a given time are developed out of the interaction between people and the predominant technological devices concurrently in operation." Two models, claims McLuhan, played a major role in the formation of post-medieval sensibility. The first post-medieval cultural form stressed perspective and lineal sequence. When this model is used, emphasis is on clarity of outline and discreteness with which each part of the pattern is perceived. One example here is Newtonian absolute space. The second model emphasizes a simultaneous mosaic in which continuous sequences

defer before the conception of the simultaneous interacting field. For example, in physics there is the image of space which is curved and determined by fields of energy rather than Euclidean lines and vectors. A cultural form or technological medium which provides a given culture with its most influential patterns of behavior and organization is called iconic. McLuhan is convinced that the modern artist is at his best when he points to the possibility and necessity of devising new ways of organizing, "perceiving," experience that will overcome the restrictive nature of past iconic models. The "message" of a contemporary art that has abandoned the ideas of perspective and literal representation of the sensible world to explore new combinations of form has, he believes, contributed to the death of a literary ethos which is dependent on a lineal model. Comstock's sympathetic but critical evaluation of McLuhan's argument not only illuminates McLuhan's position, but also provides some interesting questions for theologians: Are many of the difficulties faced by contemporary theologians generated by the inextricable association of theological pursuits with the literary ethos? Are the demythologizing theologians operating in terms of an older literary sensibility that is fast being eroded?

Whereas McLuhan and Comstock are interested in the interaction between people and a predominant technology to develop models for organization of experience and its communication, W. H. Poteat is concerned with the bondage that Western sensibility in general and the Western epistemological tradition in particular have fallen into by relying upon visual perception as a source of models for all paradigmatic discourse about perception and knowledge. He is especially worried about the alliance of models of visual perception and ways of conceiving space. This alliance, he believes, has lead to the "commonsense view" in the West "that space is primordially that within which objects are enabled to be the particular objects which they are and the medium within which these objects are distinctly separate." Poteat does not want to say that this commonsense view of spatiality, which had its inception in artistic and mathematical speculation, is false. Under certain terms it is safe to use the view in talking about *things*. He does want to show, however, that total reliance upon

it will generate a lethal model for discourse about *person*. The problem is that the commonsense view does not in itself provide the grounds for any unique, incarnate substantiality which can provide some point of orientation. Consequently there is no basis for a personal "place," and the concept of "person" is rendered problematic. Then all sorts of absurdities are generated about the self. To combat these absurdities Poteat maintains, over against the commonsense view, that space "is primordially that by means of which I orient myself, or, more exactly, *by means of which I am oriented from within my body.*" This concept of space, he argues, makes it possible to speak coherently about "place" and "person," and he proceeds to develop the concept.

Following Poteat's conceptual and linguistic analysis of "space," Peter F. Smith studies "those processes within the mind which shape interpretation of that milieu of architecture and space, artifact and nature, which comprises urban development." At the center of his essay is the criticism that the contemporary style in architecture fails to answer some of the psychological needs which seem to be inherent in human beings. In short, there is a failure of communication between the styles and our psyche. His purpose is to suggest some ways in which "built space" or town environment can answer the psychological bipolar drives for equilibrium and exploration. The intention is not to consider specific buildings but to investigate the psychological impact made by the milieu of objects and spaces which comprise a given environmental sequence. He sums up under the general term "perception" the areas of mental activity which, he believes, regulate the interaction between an individual and his environment. He too is concerned here with the problem of the relationship of visual perception and space. He is convinced that the dual psychogenic drives have a decisive influence on shaping our perception and hence our concept of space. The first part of this shaping of perception is called *motivation*. Joining motivation to regulate visual perception are *learning* and *memory*. The three structure the mind to impose symbolic significance upon buildings. Reasons for the symbolism range from the personal to the collective or even possibly to the universal. The conclusion of the essay is that the success of environment to

provide mental stimulation lies in dialogue. The mind searches environment for an enactment of the drama of life with all of its fears and aspirations. The environment which answers both with security and tension will stimulate the mind. Smith illustrates his theory with a description of Wolfegg, a village in Bavaria.

These pilot statements should make it obvious that the essays could have been arranged in other patterns. The present one seems valuable, however, because it strives for both "equilibrium" and "exploration." This is to suggest that the reader can interrupt the volume's "lineal sequence" to follow any "mosaic design" that is perceived. It should also be apparent that when the reader arrives at the description of Wolfegg, his journey into the inquiry has just begun. A selected bibliography is provided to help chart the way.

ACKNOWLEDGMENTS

The support and assistance in the course of editing has been extensive, and I am indebted to several people. My foremost obligation is to F. W. Dillistone, my teacher and friend, who responded to the idea of the volume by providing contacts with British contributors and an essay of his own. Horton Davies, Gene Outka, John Reeder, and Richard Gelwick made useful suggestions for the direction and organization of the manuscript. In addition to his essay contribution, James Whitehill was always available for advice. I am also grateful to Rhonda Murray, who helped systematize the bibliography, to Nancy Kirby and Evelyn White, who were graciously ready with a typewriter when needed. The library staffs of Fairmont State College and Stephens College were always prepared to help me in any possible way, and I thank them for their thoughtfulness.

At John Knox Press, Richard Ray escorted the volume through difficult stages and Mary Weaver saved the book from many inelegances. The flaws which linger are solely my responsibility.

James Waddell
Columbia, Missouri

THE WAY INTO MATTER

John W. Dixon, Jr.

AN OVERTURE

The artist is not the conscience but the cartographer of our inner life. In the dialogue of our common life he gives form to the inchoate yearnings of our sensibility and gives back to us the sensible tools for our experience of the world. He does not so much give us faith as the tools of faith, for faith is an act of the sensibility, not of belief. It is a commitment of the acting, feeling, intelligent, and passionate body, not of ideas that pass with the passing of each age.

FIRST MOVEMENT: THEME AND VARIATIONS

Discussions of the possibility or the nature of "Christian art" usually presuppose that we know what "Christianity" is and what "art" is. Their relations, or the lack of their relations, have then to be determined on the basis of the logic that originally gave rise to the definitions. But this is a rigged game and nothing much has come from it. There is no reason to think anything should; logic is a very useful tool, but artists and Christians don't really think much about it, at least while they are being artists and Christians. Suspended as we are between two ages of the imagination, it is hard for us to realize what other people are or have been. What was an art work like to a Byzantine Christian or to a devout Sienese of the thirteenth century? "Play me a tune on an unbroken spinet," said Thomas Wolfe; tell me what the workmen said to

each other as they ate their lunch, sitting on the unfinished blocks of the Parthenon.

The living past is forever gone, but the art work is not. Its structure reveals *now* something of what it was to the people *then*. It was an object that inhabited the world of persons, a thing. It may have had a peculiar and distinctive sacredness, but it **was** sacredness present in the space and time of persons. What those things stood for is not our concern at the moment; it certainly was not what things stand for to us. What we can see is the relation established between the art work and persons. Whatever the quality, the texture of that relation, the person and the art work lived in the same place.

"The function of the painter is to render with lines and colors, on a given panel or wall the visible surface of any body, so that at a certain distance and from a certain position it appears in relief and just like the body itself." Elsewhere the same writer, Leon Battista Alberti, defines the painting essentially as a window opening onto a created world. Thus the work of art is no longer an object inhabiting the world of the spectator; it is, instead, a means to an experience not itself.

A major complaint of the "average man" against "modern art" is that it gives him no illusion of anything other than itself; it does not *represent*; it *is*. The average man requires of objects, particularly works of art, that they be subservient to him, that they be ordered within his own world of intelligibility. He has no emotional resources for contending with objects that are organizations of energy indifferent to him.

The dominance of illusion lasted six hundred years. It was instituted by Giotto around 1300. It was ended by Cézanne around 1900. Giotto painted devotional objects for the walls of chapels, but these objects were openings onto a world of unique moral complexity, disposing human passion in unique moral authority. It is, perhaps, the most complete, the most detailed, the most humane demonstration of traditional Christianity yet achieved.

Cézanne painted easel pictures for museums or private collectors (their eventual destinations—he could not sell them during his lifetime). They were mostly landscapes, windows onto the seen world. But always dominating the illusion is the coherence of the surface of the painting. Whenever he was unable to transmute the structure of nature into the structure of the painting, he simply abandoned the painting in the field. There is no moral complexity, only structural tension resolved into coherence. The moral authority is only that of the creative hand responsive to the requirement of nature and the painting. Thus each man stands with a foot in each world: Giotto created objects that moved into illusion; Cézanne created illusions transmuted into objects.

The "Western mind" matured between these events. Giotto defined the space of the Western imagination that Cézanne (and his contemporaries, the physicists) destroyed. The "Christian mind" also matured (inseparably) during this period. Since nobody in the church has moved, with Cézanne, into the new spatial image, the church still tries to maintain itself within symbolic structures that are no longer even approximately weathertight.

The historical description of events like these in their full complexity is extraordinarily difficult. Any accurate moral judgment is impossible. The sensitive young, the rebellious, those who have supported these structures with their substance, all join in rejecting the institutions built on this ancient spatial image. This is not a necessary conclusion; the sense of human moral complexity in Giotto was filled out in the following centuries to the most comprehensive picture of man in his world that has ever been achieved. Yet this great and eloquent knowledge was bought with a price: when men removed the world to the other side of the picture surface, they detached themselves from it. They were left alone with the knowledge so hardly won. They no longer lived with the sacred objects and the events manifested iconically in the object. A Byzantine crucifixion makes the crucifixion present in the space of the worshiper, in the church or in a corner of his house. A Sienese crucifixion or a Rembrandt crucifixion generates the emotion proper to a particular understanding of the crucifixion.

Man's intelligence nourishes itself on the products of its own activity; intelligence could no longer feed on the icon and required the penetration into emotion and understanding. The achievement of understanding was conditioned on the achievement of distance: the picture on the other side of the surface; the illusion. But emotions go dead with incessant stimulus. The ideas were exhausted and no longer impressive to an understanding trained by those same ideas to a sensitivity the generating ideas could no longer sustain. Men were left only with the mental structures determined by this process: reality was "on the other side" of the picture, whether the picture was a painted one or a verbal statement of doctrine.

Thus ethics began to dominate serious mental life. The theme of the overture returns; the artist could be incorporated into serious mental life only as conscience. This worked well with fiction and drama, and a finely worked, subtle, and perceptive Christian criticism of literature developed. It worked for the visual arts only as the *subject* could be amalgamated to the modes of drama. When subject became exhausted as an occasion for art, the relevance of art for religion could be maintained only if it were diagnostic of the ills of the age. When this, too, failed to work, the "mind of the church" was left without an intelligible doctrine of the role of art.

But the artist is not the conscience, he is the cartographer of the inner life. He charts, sometimes as reporter, sometimes as explorer, the rhythm and tensions of all those modes of the vital intelligence once known as emotion, will, purpose, feeling. Since we are not persons who *have* these things but *are* the operative sum of all of them, the artist is working at the generative core of human experience, recording the subtle shifts in tone and weight, in tension and relation, that form the varying selves by which we experience the world around us, or generating the new forms by which we, as living selves, are transformed in our relation of the world.

Theology tried for many centuries to subsist on its descriptions of the illusion, the picture on the other side of the painted or verbal surface. In doing so it discovered much that has nourished the spirit of man and more than we can fully use for many decades to come. But this is now an exhausted enterprise, not least exhausted in its attempt to account for art theologically. Theology is now anthropology and psychology; to define "God" it must first uncover what definitions are made *with*: the creative energy of man.

These are matters to examine more systematically, not only as variations on a theme.

SECOND MOVEMENT: THE DEVELOPMENT

To contribute to a resolution of the stated problem, I ought to be required to define both theology and art. I am incompetent to undertake systematic definitions, and to do so would contradict my basic case. I shall, therefore, offer only practical definitions.

Theology is a system of verbal propositions attempting to account for God or divinity, or sacredness. Art is the sum total of all those objects we are talking about.

Theology talks about God; art is composed of objects made by men. It is therefore not surprising that many have felt that theology has a certain primacy in human affairs, a certain transmitted authority like the sultan's grand vizier. Let us check that authority by looking at the nature of theology's operation, for contained in the theological act are several assumptions not demonstrated and yet quite clearly determinative for this argument.

If theology is the systematic presentation in verbal proposition of the convictions, experiences, and beliefs of a particular group of believers, then that presentation has to be based ultimately on some body of evidence, some authority. The nature of this evidence varies widely among religions and includes historical events, personal experience, ritual acts, revelation (meaning the document that purports to be revelatory), and so on. The case is probably a little different, depending on the nature of the claimed authority, but let me concentrate on what I judge to be the essential Christian

claim to the authority of its theology. Briefly, this would be something like the following: Christian theology is based on the revelation of God in moral law and historical acts, both transmitted by an authoritative Scriptural document maintained and interpreted by an institution.

This is a comprehensive statement, each part of which is relevant to the work of the theologian but too much for us here. The essence, for all Christian theologies, is the words and the acts of Jesus. Enormous, endless controversy has grown up from those acts, but they remain the final norm.

Now the question becomes: How do we determine the accessibility of those acts? There has been some controversy over this question. There has been a distinguished modern attempt to detach the history and meaningful core of the teaching from the presumed mythology that surrounds them. There have been constant attempts to detach the original history from later additions. These are necessary critical acts, but not to my purpose here. What all the theologians share is the sense that the acts (or their chosen group of acts) are available to them, that they are accessible and usable as such. Futhermore, they assume that the meaning of those acts is transparent to their prose, that it is possible to state, in the propositions of their system, the essence of the events. This conviction is so strong that the formulations are taken to be authoritative to the point of indispensability.

The only trouble with this scheme is that, at every point in it, we have to do with a work of art, not with an event. This has not, to my knowledge, been taken seriously enough, even by "form critics," so strong is the conviction that essential reality is available to our propositional systems.

It is fashionable among some scholars to deny that the Gospels are literary works at all, in any usual sense of that term. Yet this seems to me obviously false. Leaving aside the question of conventional forms (the Gospel form is *sui generis,* not exactly matched by any other similar work), the Gospels clearly meet any defensible definition of a work of art known to me. They are highly abstract, clearly structured according to an intelligible principle, clearly articulating means to a chosen end, consistent,

general without weakening the sense of the idiosyncratic. It is quite beside the point whether they are good works of art. The point is that they *are* works of art, with all the possibilities and limitations of works of art.

A whole scheme of aesthetics and of criticism should be inserted here, but space does not permit that. I will say only what I judge to be essential: a work of art is a structure by which we experience reality, but the experience of reality is never separable from the structure of the work. There is not an experience in an appropriate structure; the structure is the means of the experience. Therefore the experience presses against the structures, constantly modifying them and occasionally transforming them. Similarly, the structures press against the experience, and changes in the structure change the reality as it is experienced. The Gospels are *sui generis* as art works, as experiencing structures, because the reality they make manifest was unlike any reality experienced before and required the generation of new forms. But there is no experiencing that new reality outside the Gospels. The Gospels are pointless without the reality of Jesus, yet Jesus is inaccessible except through the forms, the art works, created by Matthew, Mark, Luke, and John.

There is a corollary to this conclusion that points to a long, even book-length, argument, but the implications are unavoidable. The structures of the Gospel writers were not generated only by their experience of Jesus but by their experience of their inheritance, and their culture. Thus Jesus is accessible to us only through a work of art constructed, in part, out of energies and tensions that have nothing to do with the essential idea of Jesus. I refer in part to those "mythical" elements the demythologizers want to get rid of, such as demons, the three-story universe, and so on. But I refer also to even more fundamental matters: the tone, rhythm, scale, the harmony and order of human relations, of the ordering of man in nature, images of the nature of men and women, all those matters that are basic to human experience.

It should be immediately evident that this is equally true of ourselves; we bring to the apprehension of the Gospels an imagination shaped by many forces that are only in part the

experience of the Gospels or even compatible with the Gospels, much less the reality that, in part, generated the Gospels. This sounds as if there is a double screen between us and the reality beyond the Gospels. But I see no reason to think the human mind works that way. Schemes like this exist for the sake of understanding and ought not to be superimposed on experience. The creativity of our imaginative activity (not fantasy, but the formation of images in our neural equipment) is so great that there is a fusion of experience right through the process. I am affirming, however, the complexity of the contribution to the process of knowing.

The argument begins now to circle back to the point I took off from; theology can no longer be seen as an authoritative account of reality to which other disciplines are responsible, against which the others are imperially checked. Rather, theology is one of the ordering experiences, the experiencing structures by which men contend with the unmanageable complexity of their experience. It is, in other words, more like a work of art; or rather, theology and art (and physics and sociology and so on) share a common status as principles of the constructive imagination, each developing a working structure of responsible experience in a particular language. Theology is not a description of or an accurate account of reality. It is a structure of energies and their intersection, a coherence of weights and tensions, a harmony of images, an ordered balance of rhythmic forces; in short, an energetic structure by which a particular mode of human experience is embodied within the possibilities of a particular language.

What conclusion can be reached from all this? Is this, in fact, a digression from my defined task of somehow establishing a relation between Christianity and art? I think it is not. It is the distinctive custom of those religions with developed theologies to take theology as normative. Thus, to talk of the relation of Christianity to art has usually meant to talk of the relation between Christian theology and art, which is a very different thing. To acknowledge this primacy of theology gives art only an auxiliary role in the process of thinking about religion. To claim comparable authority for art has always seemed to me to distort both theology

and art. I have, therefore, been compelled to seek a redefinition of the work of the mind to see theology as a function of the constructive imagination and not the queen of the sciences. Thus the ground is cleared for art to work as an independent mode of the religious life, not as a handmaid to a propositional system.

It is not altogether facetiously that I am reminded of the classic statement of James Baldwin, summing up not only the main energies of the civil rights movement but much else as well: "I don't want to marry your sister. I just want to get you off my back."

Thus, if I have succeeded in clearing the ground for art, it still remains necessary to define with some reasonable clarity the way art functions religiously or in what mode art is relevant to religion. It is at this point that it is required of us that we look at the contemporary artist.

I say this not from chauvinism, but under pressure of intellectual necessity; the case I am trying to develop here is inseparable from the enterprise of modern art. I am not sure I can say that modern art has been that generally responsible for this great shift in modern thought, for many other intellectual disciplines match it in the extent of their transformation. But here we are responsible to art and not to the others, and it is the power of art over the imagination that I want to bring out.

Let me recall the earlier analysis. The apostles knew Jesus only in the imaginative structures they had learned from their culture. The experience of Jesus pressed against the structures to generate a new form. So it has been with every age. Whatever their documentation—the Scriptural text, the tradition, the liturgy—Christians have brought to it imaginative equipment formed in a very complex historical mold which included a large number of things that have little or nothing to do with Christ. Again, the experience of Christ within the interaction of their forms with the form of the Gospel pressed destructively and creatively against newly generated forms.

Our situation is a distinctive one. I am not at all sure how we got this way, but we have arrived at a point where Christ is not understood as in any way a living reality but is identified with

the imaginative modes of an earlier time. It is a curiously composite picture: the original documents remain the same, but we have difficulty seeing their characteristic structure through the fog of competing world views contained in our various exegetical structures. Our propositional structures are a mixture of metaphysical assumptions from the fourth to the twentieth century. Our liturgies are in good part medieval, but put together with bits and pieces from all over the place. The form Christ takes in architecture is rarely a subject of much conviction, but is borrowed almost entirely from some other mode of architectural speech.

How we arrived at that point is very difficult to say, but the artist is probably as responsible as anyone. For centuries Christian art was considered iconic, a bearer of the sacred, an operative mode of the sacramental. Thus the art work was an object functioning within the Christian life. Around 1300, with Giotto, there began the fateful search for illusion. Previously the art work existed in the world of the spectator. Now the spectator—the worshiper—was compelled to accept the world of the art work within which the sacred event took place.

Given the power, the worshiper participated in the illusion offered him, and Christian experience was felt as deeply and as comprehensively as it has ever been. But the world of the illusionistic event, however it resembled the world of experience, was separate from it. The world of experience—the "secular" world—became a reality. (Historians have a right to be a little annoyed with the theologians of the secular who apparently think they have discovered as a twentieth-century achievement something the Renaissance was all about.) This was "the discovery of the world and of man," and the achievement was the discovery, and therefore the establishment, of the human personality in a fullness never before known. But in all human achievement there is a price. This liberation was bought with the separation of the realm of the sacred from the normality of human experience. The illusion of the sacred event became a narrative empty of sacred content, and the ancient images became exhausted.

The psychological issue here is very complex, and I am not at all sure anyone can truly untangle it. Some theologians have

responded to this situation by concluding that *God* is dead, but this is not at all a necessary or demonstrable conclusion. It is better to say that language is dead or—since it is true to say that language cannot die—it may be more accurate to say that we have lost all sense of the relation between language and vital truth. For we can know God only in the forms and structures of our languages, and if the forms of language we use no longer have reference to mighty things, then we believe, if at all, only in the little things our language can handle.

Yet there is still hope, for language cannot die so long as man lives. But things do happen to us and to the modes of our use of language, and if we understand what that is, we may have a better sense of who or what has died. But the understanding complicates the picture further. Where are our languages still alive?

Fortunately, in a great many places. Let me mention only one that is particularly revealing of our general cultrual (and therefore theological) problem, and then turn to our present subject.

It is no great achievement to speak of science as a major dimension of our culture, but the failure to see science as a vital cultural language is a seriously inhibiting force in our creativity and in our science; it is a major force in destroying our sense of language and therefore our sense of God. Some scientists and most of the general public (including the general intellectual public) still regard science as a description of the nature of things, and so they cannot grasp it as one of the great symbolic modes of man's communication with the cosmos. Thus it does not *work* in the cultural and theological consciousness. Seen as a description of reality, it encourages sensitive minds to think that science has refuted the claims of religion and drives the more restricted minds to the defense of impossible symbolic structures.

This account of the warfare of science and religion is not intended to explain it away, for, in truth, science does demolish the claims of religion: by transforming our symbolic activity, science has destroyed the usefulness of the old symbolic structures in which the incarnation happened. Equally, scientists have not accomplished what may not be their job, the presentation of science

as a symbolic structure that can nourish the spirit of man. Thus religion no longer has a living home.

Descriptively, the arts occupy much of the same position. The arts as a basic cultural language are extraordinarily alive in our time, but the arts are very nearly inaccessible to the general life of culture. The average man has not recovered from thinking of art as representation or ornament, or rather, ornamental representation. The central language of modern art has entered his consciousness indirectly by way of the popular arts—advertising, commercial art, television. But since it is indirect and quite detached from those orders of society to which he overtly feels committed—church, politics, school, social structures, etc.—the great images of modern art are never available to his nourishment and so add to rather than heal the discontinuity, the cultural schizophrenia, to which he is subject. Yet they remain, necessarily and inevitably, at the foundation of his thought and feeling and, again, tend to drain away the imaginative strength from those institutions built (as the church is built) on images that no longer correspond to the way that ever elusive creature "modern man" experiences the world.

Therefore the cry for relevance. But, unhappily, relevance belongs among those things that will be added unto us only if they are not sought directly. This sad fact is not among the mysteries. It is made inevitable by the inherent distortions of the problem. To make "theology" relevant to "art" is to presuppose that theology is something separably identifiable, a thing to be isolated out of the generality of human experience.

The failure is a necessary consequence of the fallacy of hypostatized systems, the assumption that the sum total of the products of a process make up a separate thing with an identifiable personality of its own. Under such an assumption it does make sense to think of theology influencing art or, in the more modest mode of contemporary thought, of art influencing theology.

Unfortunately for that position, what we have learned from those modern modes of thought is that created objects are the products of processes. These processes are intricately involved with the products of other processes, but essentially our relation

is not to a hypostatized body of objects but to the process of a living experience of reality. There is, in the intricate economy of human processes, a mode of interaction of hypostatizations, but that lies quite outside the range of present controls. What we primarily live with is the knowledge that those stable systems that have sustained us for so long, those systems of theology or of style that we thought boxed up eternal truth for us, are events in consciousness and never relieve us of the unending encounter with the reality of experience.

So it is not my function here to extract the theological implications of modern art or to offer a rationale for the use of avant-garde forms in the public life and worship of the church. Both of these seem futile enterprises, although the second is more fun and ultimately more profitable than the first. Rather, what we need is of a different order—that fusion of Christian experience and living sensibility that has always been the source of Christian art.

As we face this task, this need, it becomes inescapably necessary to admit that *as Christians* our sensibility is impoverished. Our sensibility may be well nourished elsewhere by our participation in the works of modern culture, but it is not nourished in the life of the church. The conclusion of this line of reasoning would appear to be to bring those nourishing forms and experiences into the church. This is probably a worthy thing to do. I, with many people, find church services extraordinarily dull, and the vitality of contemporary art could liven things up considerably. But I am not at all sure that dullness is a necessary symptom of falsity. Liveliness is not, on the contrary, an inevitable criterion of truth. To use modern art is a good thing, but T. S. Eliot's comment is still valid: the ultimate treason is to do the right thing for the wrong reason. But what, it might properly be asked, is the wrong reason, and what is the right reason?

The wrong reason is beginning the Christian life with the creations of man and expecting to move from there to God, like Jack climbing the beanstalk. Current dogma has it that God is in the "secular" forms, but since this affirmation exists without the possibility of either demonstration or proof, it is no more than a

postulate convenient to the occasion. The consequence is inevitable. If I can have these experiences without theological baggage or Christian responsibility, why assume those burdens? Thus we are led inevitably to the dissolution of a distinctive Christian affirmation or experience, for creativity is defined elsewhere. Such Christian life as we may attempt to maintain is parasitic on cultural forms.

I should have said enough already to indicate that I don't think we can any longer sustain ourselves on ancient forms, which appears to leave us between the devil and the deep blue sea. Fortunately, for me at least, I am not that pessimistic, but the way out will be found only if we know why neither procedure really works. It is at this point that I should turn directly to an examination of modern art. I choose for my examination the work of Mr. Richard Lippold.

Please note carefully that in examining this work I am not sitting in judgment of it. It happens that it gives me a great deal of pleasure to look at it, which I suppose is what we mean when we say a work is good, but at the moment that is beside the point. Neither will I assume the right to tell Mr. Lippold what he should have done or even what he did do. What I want to do is rather to describe what happens to us because of Mr. Lippold's work.

I should like to underline that way of putting it. Of course what has happened to us has been because of a great many people and not Mr. Lippold only, but his is a distinguished part of it. I am not saying I want to describe what Mr. Lippold's work looks like, although that is part of it. I am not even saying I want to describe how we see it, although that is instrumental to my purpose. Rather, by means of that I want to get as nearly as I can to what happens to us because of Mr. Lippold's work.

The first thing is the transformation of our relation to space. This comes about in a variety of ways. Unlike Jackson Pollock's paintings which have abandoned axiality altogether, these works are still axial, but multi-axial: the axes stream off in all directions. Sometimes one axis—particularly the vertical—will be stronger, but amiably so. It does not dominate or control the work.

Next it is necessary to see that it is organized according to its own structural tensions and not according to my view of it. It is serenely indifferent to me. Thus, instead of standing securely in my own place contemplating the subservient work, I participate in the radiant space of the work.

Corollary to this is the transformation of my sense of material. What is the material of Mr. Lippold's work? If I look at it out of the corner of my eye it appears almost solid, but if I look at it directly it dissolves into light. Or is it space?

The clarity of inside and outside is a requirement for my orderly sense of time. The terms hardly have meaning anymore. Who can talk intelligibly of inside and outside with Mr. Lippold's work? Is the space on the other side still "my" space? Or is it the space of Alice's mirror?

Do I meet Mr. Lippold as a person when I look at the work? Yes, of course, for he made it. But what kind of personality made it? I don't know, for the dramatic imprint of the person is not there. The connection with the artist has been cut. The work is singularly there. It is serenely elegant and endlessly fascinating, for it seems so carefully to exist in a new space and time detached from me—and from Mr. Lippold.

The philosophically minded may have recognized the ordering of the notions I have used here. I have affirmed that Mr. Lippold's work requires us to reorder our sense of space, of time, of material and cause. These happen to be ancient and honorable philosophical categories, but more to our purpose is the fact that the phenomenological psychologist assert—and I think rightly—that these categories are the basic modes of our ordering in the earth. They are, in short, the definition of the self.

There are further observations to be made. What I have outlined as the effect of the work of Mr. Lippold and his colleagues for a long time past is very nearly an exact contradiction of the statements about these categories that have prevailed for about five thousand years.

Now something like the full range of the problem begins to appear, for the language that modern art contradicts has been the language of the Christian imagination since its beginning. Chris-

tianity was, I might say inevitably, born not only into a particular culture but into the particulars of that culture. We now know enough about personality to know that we cannot think of a self inhabiting a culture and independent of it. The self is in part its culture, although not coterminous with it; what the Christians did exploded the Roman Empire, but the Christians themselves *were* late classical people and therefore could not see Christianity except by means of and in terms of the peculiar imaginative vision that characterized the eastern Mediterranean.

There was a vast range in this imaginative vision, shaped as it was by Jew, Greek, and Roman, and more than touched by the submerged but powerful imaginative forces of Africa and Asia. But there were common assumptions that provided the skelton of the varied imaginative arts, and these assumptions coalesced to provide the structure of the Western imagination within which we have lived. The sense of a dominant verticality with God or divinity or sacredness at the top of hierarchy went back to the Egyptian pyramids, inherited through the Near Eastern sky gods and the Greek acropolis. Linear time was Biblical. Fused with Greek causality this linearity rapidly became the dominant mode of thought in the Western world. Matter was desacralized by the Jews, made intelligible by the Greeks, made subservient by the Romans. This is, of course, vastly oversimplified, but at the same time I am convinced it describes rather basically the mind, the imagination, of man that shaped and was shaped by Christianity.

A very different question here is whether there is such a thing as Christianity apart from these forms in which it was manifested. The answer to this question cannot be demonstrated or documented and, certainly at present, can only be the subject of commitment or perhaps even hope. One of the tasks of our day is to answer that question, to see if there is anything identifiably Christian that can generate or regenerate imaginative forms in our own day, or whether Christianity—God—died with the death of our imaginative language.

For it is indeed true that the language has died or has become so transformed that it is a very different thing. We don't have to hold Mr. Lippold responsible, for the process began long

before either he or I was born. At the latest it began with Kierkegaard and Marx. But, since we are not concerned with sources, let's stay with Mr. Lippold for a moment and look at some of the further consequences of this work.

Mr. Lippold may not be the best example of this aspect of modern art, but if his style is described in sufficiently general terms, as I tried to do a moment ago, another striking conclusion is forced upon us. This is not the first time such an ordering of things has appeared, for nearly the same terms can apply—again, generally—to primitive cave painting. The basic differences are great and of the first importance, but the likenesses are of even greater psychological significance. It may even be more illuminating psychologically with Mr. Lippold, who brings a cool and sophisticated rationality to his work, than it would be with some of his colleagues who are more concerned with fecundity and primitivism in general.

What it suggests is that at a new level of self-consciousness we are reliving what is basic to the history of man. There are those among us who want to go back to the archaic—I think of Robert Graves, Norman O. Brown, Richard Rubenstein—but at this point the cool intelligence of some of our artists is as important as the fecund passion of others, for it makes possible not simply the mind-suppressing return to the primitive past, but a taking up of what was basic to the primitive intelligence into the vital life of our own day.

Now I hope the shape of my argument becomes clearer. I do not want to offer a theological interpretation of modern art. Nor do I want to extract theological implications from modern art. Both of these efforts would, it seems to me, be quite false to the best work of the modern mind. Rather, I want to define as accurately as possible what they have done both *for* us and *to* us. What they have done is to diagram for us the redefinition of the self, show us with remorseless clarity who we are. This kind of vocabulary used to be applied to those artists or those arts that reveal our moral life, the grandeur and the misery of man. When the modern artist abandoned representation, this part of his responsibility was partly surrendered. Rather, he is concerned with

the primary disposition of the soul, the skeletal structure of cosmic order by which men live, which, in fact, they fundamentally *are*. There is nothing mysterious or mystical about all this. I am speaking precisely—and I think it possible to speak precisely—of our structuring of space, of time, of cause, of material, of order, of force, of tension and rhythm, by which we relate ourselves meaningfully to the world. In doing so, modern artists are performing one of the immemorial functions of the artist. In doing so with the distinctive quality of intelligence that they bring to the task, they are helping us toward one of the greatest achievements of the modern intelligence: self-consciousness about who we are, self-consciousness about the means for our grappling with experience.

The consequences of this new self-consciousness go far beyond our imagining. It seems to me that one very great consequence is the discovery of true ecumenicity. When we discover that our primitive ancestors are still meaningfully alive in us, when we discover that Christ was not to be shut up in our little boxes, shutting out other peoples' structures as embodying only the enemy, then we can begin to live in other men's structures as well as to grasp with some sense of wholeness what they were trying to do. Tolerance of social customs, sympathy for cultural forms, does not really give access to the essentials of another people. To grasp, even to live within, the spatial order of another people's images is to communicate with them at the basic human level.

If I am right, much of the movement of the modern mind, the modern sensibility, has been a yearning toward this community of man. Some of this is bizarre, some very dangerous, some noble and humane. Very often, particularly in the theological community with a growing awareness of the imperialism of its former claims and the collapse of the inherited languages, there has been a turning away from the Christ and abandonment of the name. Sometimes this is simple apostasy. Sometimes it is a truly Christian yearning to transcend the barriers that finite languages have set up between men. Always this abandonment will dissolve the faith.

And yet there is little reason to think that the abandonment

is required of us. We may have learned the partiality and limitation of our languages, but we have also learned the common humanity of man. The temptation of the intellectual in our day is to make the artist what he never should be—the high priest of a religion of form. The appeal for relevance, the appeal for the use of the new art in the church, is dangerously close to the repetition of the ancient error—trying to shut Christ up in a box. It is a box, even if it is the newest and most fashionable box. Yet Christ does not come to men like that. He can speak only in the language of the incarnation; the enterprise of the demythologizers is, in many ways, pathetic, for it is not really possible for us to conceive of Jesus apart from the structure of space and time which he sanctified by his presence. To demythologize the gospel is to drain it of its lifeblood, even when we know that we nourish ourselves and experience the world by means of a wholly different mythic structure.

Thus we do not give the contemporary artist authority over Christ, but neither do we give a Jesus shaped by a first-century imagination authority over our culture. We must know, rather, that Christ is he who comes in the immediacy of things, and the conviction that Christ is in this or that aspect of the contemporary world is no more reliable than the equal certainty of the ancient Jew. Christ cannot be boxed in a first-century box or a twentieth-century box. Rather he is incarnated in the lives of men.

Our duty, then, is not to worship idols, old or new, or to demand of the artist that he be priest or prophet to fill the voids of our own making. Rather, we must become most fully the new men that our new ordering requires of us. Being new men in this way goes far beyond just a gracious appreciation of art. Rather, it involves a reordering of our psychic life, a restructuring of our social and economic order, a new kind of relation between men and women—in short, a revolution. It is not for us to deny the Christ because he does not come in the modes he once used or to dictate the modes he must use among us. Rather, we seek obedience in the new ordering of things, openness to the new vision, and, at his will, the rest will be added to us.

RECAPITULATION AND CODA

What is Christianity? A system of belief, an explanation of the ordering of things, a mode of living, a devotional posture? Man's techniques always defeat him; theology defends these and other definitions of Christianity, but it does so *theologically*. Thus whatever the expressed content of the theology, Christianity is being defined as theology. The medium is the message.

If the mind of past historical men is inaccessible to us despite their many artifacts, how much more remote is prehistoric man! Yet we guess, and we think we find a man who is immersed in an animate world, a world "redundant with life." The object lives with its own personality; sometimes an object detaches itself from the mass as a distinctive form of control but not (how can we know?) as a mode of access to an experience other than itself. It is not very important what the shape of this object is. Within our own experienced history it is evident that, to the unsophisticated man, the ancient object (or image) bearing only the crudest resemblance to natural forms is very often the bearer of greatest sacredness. To resemble too greatly is to distract attention from being what it is. An idol should not *mean* but *be*.

The skilled artists of the devotional life often find crude, garish popular images more efficacious than fine works of art which, they say, distract attention from God to themselves.

This, of course, assumes that God is somewhere else.

The advocates of the "Great Books" are fond of referring to "the great conversation" across the centuries. This is not true: there is no conversation when both can speak but only one can respond. Men of the past knew no more than what we know of what is yet to come. It is probable that their thinking was no simpler than the thinking of most of us, but it was simple in a different way. We think simply because we cannot grasp, much less control, the infinitely complex languages that bombard us. They thought simply because they had very few and very simple lan-

guages to use. We alternate between arrogant self-confidence at all that is open to us and helpless despair that there is more than we can hope to control. Is it too much to imagine that they alternated between serene confidence in the simple ordering of the world and desperate terror at the inexplicable sensations that flooded their experience?

When did man first become human? With the making of the first tool, the uttering of the first word, or the first shaping of the sacred object from magic into meaning? There may have been, in fact, no such distinction as our classificatory intelligence likes to make, but within such classification different modalities seem to emerge from these different starting points: the useful act, the word, the meaningful shape.

With the shape there came a different ordering of experiences of a kind forever inaccessible to us. Man could subject nature—by tool or by idol—as well as be immersed in it. We do not know whether this was the power of magic or of aesthetic harmony with the ordering of things, or even if such distinctions have any meaning. In any case, pre-Hebrew religions, non-Western religions, establish a continuity of control, of harmony, or of participation with the natural order.

Hebrew prophecy and Greek rationality detached man from nature; only so could man become independently man. Now the art work either was forbidden or it became statement. The long, slow detachment from objects began. The object crept back behind the picture plane until man was solitary. "The silence of those infinite spaces terrifies me." When the modern artist again found the grace of objects, almost no one was able to see with him.

Despite any doctrinal assertion about God as "the God of history," man is inescapably a man of nature. Outside nature he does not exist, for he is of the very substance of the earth. He communicates with the earth through eating, through work, through weather, through sexual intercourse, through sports. He comes to

know nature and to impose an order on it through the mythology of science. His harmony or disharmony with nature is defined by art. The forming of material into meaning, whether in the "fine" arts or the popular arts, defines, reflects, determines man's relation to the order of the earth.

Is it possible truly to love men without loving the earth? The story is told of St. Bernard riding all day through the Swiss lakes with his cowl drawn over his face as he read his prayers. Bernard loved God and Christ and the Virgin. Is it possible, after Abelard, to say he loved men?

It would seem possible to say that one of the definitions of an artist is love of the material. Style, the manner of his forming, defines the mode of that love. The spectator who can see the work experiences the love. Art is only occasionally concerned with man's tragedy. It is always, if it is true art, concerned with man's love.

The object on the other side of the picture plane was an object drawn from experience and assumed its own independence. To place it on the other side of the plane the artist had to look at it as objects had not been looked at before. Objects had been loved before, but never seen so independently with such ecstatic wonder. To make them independent, the act of looking had to be looked at as it had never been before; technique, too, became the occasion for ecstatic wonder. But technique can be learned as well as won in wonder, and the object became imprisoned beyond the picture plane, helpless to intersect with the inner life of men.

Few modern artists have recovered the power of the object (Andrew Wyeth, a few of the pop artists). But they have recovered the work of art as object in all its power, its entrancing charm, occasionally in its grace. This could lead back to the primitive identification with the order of things, or it could lead to a new and generative relation between man and the order of the earth. Which it is may depend on the ability of Christians to transcend their propositional past, take up the body of their belief into a

more complete bodily faith, and make real the vision of the new man Christ came to reveal.

I turn now from this outline of the case I wish to make to the resources presently available for pressing the search further. This means bibliographical resources: who has written what that is of most use? The definition of the problem will, of course, prejudice the choice, for clearly I will feel that those writings that contribute most directly to the conclusion I have reached are the most valuable and that others are headed in the wrong direction. On the other hand, it is possible that the scheme here outlined may suggest why "the others" have gone in the wrong direction.

As a matter of fact, there really is not very much that deals directly with the subject. In an earlier article I was compelled to say that there really was not much critical literature to compare with the commodious production of the literary critics who have addressed themselves to this problem. This is the case still. It is as true now as it was then that the most useful critical work is done by the historians who are concerned, in responsible work, to elucidate what the artist himself was trying to do.

Almost no one in any concerted and continuous fashion has applied himself to the elucidation for the life and thought of the Christian of, say, the painting of Jackson Pollock, as Nathan Scott, to pick only one of several possible examples, has written on such writers as Samuel Beckett, whose work is in no direct way "Christian," but which presents and interprets the human condition in ways that require the disciplined attention of the responsible Christian intellectual.

This is a pity, for all intellectual life is a dialogue, and the artist's contribution to that diaglogue deserves to be heard in the general working out of the details of the Christian life. It is not being heard now, for too often the attempts to translate it have been based on false assumptions about art and about talking about art. They very often take the form of illustrating a category or conclusion predetermined by the logic of theological reason. Thus cubism "reflects the brokenness of modern times" (it doesn't; it is

a highly disciplined, constructive style) or happenings are "cele-brational" (generally speaking they aren't; they are either highly disciplined explorations into the interactions of the senses or manifestations of instinctual life or strained and neurotic pretenses after a lost unity). This is a homiletical interest, sophisticated and refined, but nonetheless methodologically not very different from the "sermon illustration" so beloved of popular preachers. It may be harmless to an extent, and it at least makes the artist present as he often has not been, but it does neither him nor homiletics much service to proclaim thereby the primacy of modes of *belief* rather than modes of *involvement*. By this treatment the believer is still left tangled in propositional abstraction, not creatively involved with the material of the earth.

Another temptation, more common among the avant-garde of the church, is to find in the artist the unique mode of access to otherwise inaccessible spiritual truths. Lionel Trilling commented once that it depressed him to see how seriously intellectuals took the modern American dramatist's views on life. This love affair with dramatists was quite a thing for a while, but lately politics has rather overwhelmed drama in the loyalties of many of the church's intelectuals, and artists are seen as the means of achieving new spiritual insight.

This is a very tangled psychological situation; New York critics prove their perceptiveness by the discovery of a successful artist and the superiority of this perceptiveness by defending him at the expense of all rivals. Unfortunately, the breathless adoration of these critics sometimes comes over into the work of the more journalistic Christian commentators. Sometimes works are thereby inflated out of all proportion to their true worth, and sometimes the work of very competent artists is burdened with a weight of significance that it was never intended to carry. The greatest harm, however, is in the implied teaching that the artist is the priest or prophet of a new Gnosticism, which is not his proper role.

There are a few attemps to exploit the arts for professional theological advantage because they are fashionable, and rather more honest, workman-like (and fairly dull) attempts to introduce the general public of the church to the history and general prin-

ciples of "Christian" art, defined as art with a subject chosen from Christianity's mythology or having some ecclesiastical function.

Thus very little of real use has been done in the theological community, with the exception of the phenomenologist Gerardus van der Leeuw and the theologian Joseph Sittler. Neither resolves the questions that only the professional critic can handle, but each has done great service, not only in presenting art to the religious and theological communities, but in providing an alluminated context for the work of the artist, the critic, and the historian.

Van der Leeuw's book is misleadingly called *Sacred and Profane Beauty* in English (while he does make the distinction, he is writing about sacred beauty). The German title—the subtitle in the English edition—is *The Holy in Art*. As befits a phenomenologist, he is less concerned with defining religious art than in accounting for the way art has functioned religiously and in looking for those characteristics in works of art that make them fuction that way. As does not befit a phenomenologist, much of the book is highly speculative. (I do not know how it could be proved, but van der Leeuw is convinced that dance is the first art.)

The only inadequacy I find in the book is the tendency to generalize on the basis of his selected experiences so that much very great art (e.g., Rubens) is excluded as religious art because it does not conform to the standard. The exclusions carry their own refutation; phenomenologists, like many anthropologists, tend to define man in terms of those of his manifestation that are held in common from primitive to later folk man and those more sophisticated men who manifest a continuity with primitive or folk expression. Since this denies a very considerable part of human creativity, it makes the whole procedure suspect. This is probably a mistake, for within his self-defined limits van der Leeuw has made a considerable contribution to our understanding of the way art works culturally and psychologically.

Since he has very firmly fixed religious art as a psychological necessity, an important question which is extremely relevant to contemporary theological debate constantly occurs to me as I read him. Is this need a culturally conditioned one, or is it of the nature of man? The argument certainly suggests the latter, and

if this is true it is a relevant attack on the current orthodoxy about religionless man and the world of the secular.

Be that as it may, the book serves to restore human relevance of the work of art, the human function of the work. Yet in defining the modes of that functioning, it does not tell us how it functions that way or enable us to discriminate the intelligibility of various works of art. He has, therefore, done a basic act of analysis on man's religious work but not, in the final sense, on art.

Sittler has done a related job on art and theology. He comes, perhaps, a little closer to the actual work of art, since he has a genuine sense of the distinctive personality of art and, in some of his writings at least, manifests an artistic creativity in his own language. (This is less true of some of his more recent writings which have gotten both turgid and mannered—perhaps reflecting the fact that he has carried his case as far as it can go.) He has, further, a remarkable sense of the sermon as a work of art.

The good he does in the theological community in making art legitimate in their terms is matched by the good he does for those of the artistic community who know his work. For them he has (to use the title of an early paper) articulated "A Theology for Earth" that elucidates to the verbal intelligence what the artists knows by professional instinct: that the matter of the work of art is potentially the carrier of the sacred and therefore an instrument of grace. This is the charter of admission of the artists to the active work of the theological community and the formal devotional and teaching life of the church. It is also the charter of responsibility of the theologian and the churchman to sit at the feet of the artist who, by speaking in a medium that is his alone, says things that no one else is able to say.

This achievement is also the clue to real dangers in the theologian's handling of art; the issuing of a charter of admission to the work of the theological community is too often considered a charter of admission to the human enterprise. The *theological* explanation of the work of art is presumed to account for its reality rather than simply making it accessible to those who speak the language of theology. Sittler is less inclined to this than most, but he slipped badly once. In an otherwise illuminating article

entitled "The Matrix of Form in Church Architecture," he elaborately demonstrated that there is no such thing as Christian art because the word *Christian* cannot, under the Aristotelian causes, be accurately applied to art. Since I had never supposed that the Aristotelian causes were adequate to account for Christian art, I didn't find the argument very useful.

This is a momentary aberration in an otherwise very useful body of work, yet it is a symptomatic one. The artist, the historian, or the critic is not really likely to see the usefulness of a tool from another man's tool chest, however useful it may appear to be (and in fact is, in an appropriate context). Yet in this argument, the implicit and undemonstrated assumption is that so technical a device as the Aristotelian causes is quite decisive. In general, discussions of this kind have been sadly handicapped by the assumption that verbal logic is adequate to the task at hand. The assertion of my argument is that we do not so much need to apply propositional logic to evidence it doesn't fit, but to learn how to speak more directly the natural speech of the artist. It is in the nature of things that to discuss this speech at the level of its findings we are compelled to use words and are duly responsible for the logical ordering of those words, but salvation here lies in the recognition that the discussion is a pointer, an approximation, at best a crude translation, and in no sense an equivalent of an enterprise conducted in its own irreplaceable language.

Therefore, despite the immense usefulness of each man in making these two great disciplines accessible to each other, their work is not going to resolve the problem. The problem is not to translate one discipline into the relevant terms of the other or to account for one discipline in the structure of the other. The problem is to speak and hear a language directly, and that is the problem we are not equipped to resolve.

It is increasingly clear to many of us that the traditional instruments are not adequate to the job, even when considerably refurbished. Too many of the traditional instruments assume the primacy of the propositional even while working with new evidence. Thus the theory of symbolism, absolutely essential to this endeavor, has been too much in the hands of the philosophers and

gets turned too quickly into a device for providing grist for the philosophic mill. Even so, the work of a philosopher such as Susanne Langer is of immense importance.

How much Mrs. Langer includes in her word "feeling" is never entirely clear to me. It is clearly more than is commonly associated with the word, but, rightly or wrongly, it is equally clear to me that it is not adequate to the structural and cognitive role of art, perhaps because she insistently makes philosophy the decisive act of man's intelligence and must, therefore, circumscribe art to keep it tame. Some of these questions may be clearer in Mrs. Langer's work in process.

I would judge that the reason philosophers cannot really resolve the problem of symbolism for us is precisely because they subsume it under philosophy even when they, by philosophic techniques, affirm its independence as a mental activity. The real problem is not symbolism as a *mode* of the activity of the mind but as *shaping* the activity of the mind, including those functions that attempt to account for it.

In this respect, those concerned with the theory of communication are perhaps of more real use than the philosophers. There is a much larger literature than I command; those most useful in my own work have been Walter Ong and Marshall McLuhan. These men are not guiltless of the faults of theologians and philosophers; somehow their own writings seem emancipated from the strictures directed against other forms of verbal communication. This is only being human, however, and used guardedly, their work is of great usefulness, for they see the reciprocation between the physiology of mind and the means of communication that places art in the center of human consciousness and not as one of its ornaments. Only so can there be any significant understanding of the interaction of religion and art.

From another direction the anthropologists are deepening our sense of symbolic functions by their powerful analyses of the way in which culture shapes the structures of man. Again, there is a larger literature than I can command. Most useful to me have been certain essays of Clifford Geertz and—at a much lower

intellectual level—the two books by Edward Hall, *The Silent Language* and *The Hidden Dimension.*

Since the word "shapes" should not be seen, mildly, as influences on thought but rather as forming the very neural apparatus we work with, clearly the analysis has to be pushed back into the study of the structures and tensions of the body. At this point I ought to insert the names of relevant biologists, but now I must demur altogether since my incompetence approaches the absolute. I have looked for help in the writings of Adolf Portmann and Ludwig von Bertalanffy, but the most help I have received has been from a remarkable book by L. L. Whyte, *The Internal Factors in Evolution.*

My own experience in the physiological questions has been largely with a mixed bag of neurophysiologists, psychologists, and phenomenologists whom I will be content to list in the bibliography. It is probably suggestive that the physiological question becomes most accessible to a scholar humanistically trained through the psychologists and philosophers. It is not altogether irrelevant; the theological critic of art does not have to wait till the physiological problems are finally resolved, which is going to have to be a long, long time. In full responsibility he has only to assure himself that there is reasonable evidence for saying that cultural forms (including art, theological systems, physical theories, etc.) are constituent elements of physiological structures and tensions. Then, given a reasonable model to work with, he can get on with his own task. I am content that this can be done out of the material at hand and thus ground the dignity of art in the central acts of man's experience. For my purposes, the so-called existential psychologists have been of the first importance, for their analytic work has not dealt so much with the symbolic material of Jung and Freud as with the basic modes of interaction between man as living flesh and the world of space, of time, of cause and material, of tension and rhythms, in which his life works itself out. In this analysis art and religion are inseparably locked into the creative and generative core of man's life and the philosophical concept-juggling begins to seem almost ludicrously irrelevant.

Thus, bibliographically, we have worked our way to the innermost center of the human psyche. These structures, so identified, work their way out again by way of increasingly specific forms. At this point guidance will increasingly come from L. L. Whyte's work on "general morphology," which so far has appeared only in brief essays. When this central activity of the mind begins to take shape within the world of forms and appearances, the largest analytical assistance comes from work like that of Gaston Bachelard, who relies heavily on literary evidence but whose greatest contribution comes in the study of the psychology of forms in the common experience—fire, stairs, chests, the earth, air, water, etc. The anthropologist Edward Hall, much criticized by some of his colleagues as old-fashioned, has nonetheless greatly helped me in my work with his illuminating accounts of the power in experience of the controlling spatial order. Similarly, a much criticized semiprofessional like Benjamin Lee Whorf introduced me to basic issues in the interaction of language and the ordering of existence. Further guidance in the work of language as a primary symbolic mode is found, again, in Walter Ong and in the writings of the extraordinary poet and critic Elizabeth Sewell.

At perhaps a more basic level is the work of the great are historian Sigfried Giedion. In three massive volumes Giedion has traced with high scholarship and visual intelligence the rooting of the religious order in the image of space. It is equally obvious that the work of the modern art is the major document grasping its own revolution, so this essay needs to nourish itself on its own purposeful material. Of modern critics the only one immediately germane is Herbert Read, whose *Icon and Idea* works with a principle implicit in Giedion.

Lancelot Whyte's earlier book, *The Next Development in Man,* traces these language structures into the processes of history, as Merleau-Ponty does in the structures of philosophy while adding solid material to the grasp of the phenomenology of experience. The emergence of these images into the realm of "mind" is exquisitely delineated by Owen Barfield and the professional psychologists such as Rollo May, Henri Ehrenberger, Ludwig Binswanger, and others.

In the field of explicitly religious thought, it is less the theologians who are helpful, for they have trapped themselves into confusing their own structures of images with the reality experienced by those structures. More to the point are those who take Scripture seriously as an ordering of images (e.g., Austin Farrer's *Rebirth of Images*) and those who seek in myths not so much eclectic compendia but charts of man's psychic life. Also, there are those who work toward "the shape of the liturgy."

The very length of this list, which mentions only some of the books that have served me as guides, emphasizes the range of work now going on and waiting to be appropriated into the active work of the intelligence. Everywhere I turn I find the principle at work. See, for example, William Brandt's *Shape of Medieval History* and Thomas Kuhn's *Structure of Scientific Revolutions*, Marshall McLuhan on communications theory, and—at great length—so on.

This material cannot be dealt with as simply as shifts in the kinds of things we talk about or even a different mode of talk. Rather, there is a massive shift in the very structure and operation of our communication. This is not something that can be incorporated into the structures of traditional theology. Rather, the whole theological task is restructured, so that the analysis belongs to other languages.

This is why theology cannot account for art within its characteristic structures, even those inherited from Aristotle. Rather, art can more nearly account for theology, for theology has been one of the high arts, its structured energies expertly disciplining a complexity of experience that has been essential to Western man. This is not an enterprise to repudiate but to build on.

The task, in fact, might be described as requiring that the faithful practitioners of the other languages bring theirs to as high and careful a discipline as the theological language so that man will no longer seek to nourish himself on the dry and exhausted partialities of experience. Herbert Read (in the first sentence of *Icon and Idea*) quotes Conrad Fiedler: "artistic activity begins when man finds himself face to face with the visible world as with something immensely enigmatical. . . . In the creation of a

work of art, man engages in a struggle with nature not for his physical but for his mental existence." On the same page Read himself says ". . . art has been, and still is, the essential instrument in the development of human consciousness."

This is the charter of all that is said here and an underlining of the desperate need to restructure our understanding of the imaginative processes. Thus a bibliographical essay directed to a theological problem cannot avoid working through those disciplines that examine, even in their partiality, the structures of the mind. Building on the verbal heritage of the Greek philosophers and the Hebrew prophets, Christian theologians have been able to achieve great things. But words no longer nourish men in the same way, and reiteration of older philosophic techniques will no longer suffice as new and creative theological work.

Theologians have boxed themselves in in ways other than the ones already mentioned. They are concerned to be "radical" and judged they have achieved that goal when the conclusions of their logical operations vary a bit from those of the past few centuries. But the operations themselves and most of the data to which they are applied are entirely traditional so that the most "radical" theologian looks very tame compared with the real needs of the present religious situation. Nothing less than a new theological language can now suffice to a very new situation, and in the molding of that language the artist has a great role to play. His work needs to be made accessible.

THE INCARNATION, ART, AND THE COMMUNICATION OF THE GOSPEL

E. J. Tinsley

THE INCARNATION AND THE ANALOGY OF ART

At first sight it might well seem that the Christian religion, centered as it is in an historical, particular, and unique incarnation, would inevitably have assigned a prominent place to the arts and to analogies from art in its apologetics. The implications of the word *incarnation* ("enfleshment," "embodiment," "taking form") would lead an observer to assume that art would have a key place in Christian expositions of its meaning. The incarnation, both as the act of God becoming man and as the form of the life of Jesus, could be expected to prompt use of the analogy of the work of art since the latter is by its very nature an embodiment, a "significant form," to use Clive Bell's famous term.

Only occasionally, however, has this been the case. When employed at all, the analogy from art has more commonly been related to the doctrine of creation rather than the incarnation. Augustine speaks of the Logos as "the art of almighty God" and compares God's creation of the world to the making of a poem.[1] Indeed, among the Latin fathers *Deus artifex* or *figulus* (artistic creator) are frequently used as terms for describing God's activity in creation. Basil and Ambrose also speak of creation as a work of art. Very rarely indeed, however, is the analogy from art used in relation to the incarnation, and still less to the life of Jesus. To think of the latter in terms of artistic creativity is exceptional, and most Christians until very recently would have found these words of van Gogh somewhat bizarre: "Christ lived his life as an artist,

a much greater artist than the one who is concerned with mere matter like clay or colour. He worked upon living flesh."[2]

There are a number of interesting reasons for this reluctance to use the analogy from art either of the act of incarnation or of the form of the life of the historical Jesus.

In the first place, the atmosphere of early Christian theology was inimical to such a development. The first major speculation about the person of Christ, particularly in his relation to the Godhead, was Arianism. The Arians believed that the Son of God, incarnate in Christ, was not identical in his being with God but was a created existence, a creature of God, the greatest of God's creatures, of course, and the paradigm for believers, but still a creature. The analogy from art, if used, would have had special appeal to the Arians who might well have preferred it to orthodox talk about *homoousios*! In this formative period of Christian theological speculation, the use of art as an analogy would therefore have suggested Arianising tendencies, and so long was the struggle with Arianism that the doctrinal climate in the church remained inhospitable to the development of a doctrine of the incarnation in terms of a unique and perfect artistic creativity. This naturally hindered the growth of a Christian theology of art and human creativity.

A further important factor minimising the exploitation of the analogy from art was the long struggle to accept in a realistic way the historical, biological, and indeed psychological actuality of the humanity of Jesus. It has taken Christians a very long time to accept the implications of their belief that Jesus Christ has come *"in the flesh"* (1 John 4:2), namely, that there was in the incarnation a radical and unprecedented self-giving. The early church worked with the idea that the human biology and psyche assumed in the incarnation was pre-fallen or un-fallen and therefore not subject to the necessities or indeed the mortality of "fallen" human nature. In such circumstances the use of the analogy from art was bound to appear highly improper. While some of the Fathers might talk about Christ allowing "a measure of the manhood to prevail over himself," it was a very small measure that they had in mind, and it did not include self-

awareness or suffering. Christ remained divinely self-conscious in a reflexive way, and he only suffered humanly. Any idea that the incarnation was such an unqualified commitment to humanity as to involve the use of human means of cognition and faith, or to be a case of God too fearing death would have been foreign to the patristic mind.

The issues at stake here are well illustrated by the theological debate that lay behind the iconoclastic controversies of the eighth and ninth centuries. The iconoclasts were opposed to all attempts to portray Christ (and ipso facto to the use of art as an analogy) on the grounds that since God is infinite, incomprehensible, and ineffable, it is nothing less than blasphemy to paint Christ. The assumption here is that it is only the divine nature of Christ that matters, and this is incapable of representation. The theological opponents of the iconoclasts argued that this position really amounted to a denial of the significance and relevance of the incarnation. Precisely because God had become man in Christ, in a genuine circumscribed and particular human nature, the imaging of Christ in art was not only permissible but imperative, continuously incumbent upon Christians as the only appropriate way of doing homage to the incarnation and accepting its full reality.

It is a residual Docetism of this kind which has prevented the examination of some features of the life and activity of Jesus from the point of view of their relationship to a relevant art form. I am thinking particularly of the study of the poetry of Jesus in relation to the methods of poetry criticism. The implications of a work like C. F. Burney's *The Poetry of Our Lord*,[3] that Jesus worked with words as a poet and that therefore the study of poetic apprehension is of central importance for an understanding of his mind and purpose, have not been prominent in New Testament studies. These have not been marked, apart from an exception like the work of Austin Farrer,[4] by an emphasis on the study of poetic sensibility and the human imagination. Historical background, philological, and lexical studies have taken precedence over the logic of poetic imagery or the habits of the allegorical cast of mind. Christian tradition has more commonly thought of the poetic

qualities of Christ's words along the lines of a seventeenth-century Spanish work on poetry, which describes Christ as a poet because by divine inspiration he was "master of all sciences and arts."[5] This is little more than religious rhetoric and suggests that inspiration was taken to mean knowledge of an encylopedic and infallible kind.

Other hesitations about the use of the analogy from art are perhaps the consequence of those wounds gained in the church's conflict with Gnosticism which have never properly healed. Gnosticism has left many a scar in the fabric of Christian belief, perhaps none deeper than in this area of creation and human creativity. The Gnostics were, of course, never able to stomach a doctrine of creation of the kind which asserted that matter, stuff, the lumpiness of earth, could be directly attributable to the creative hand of God. They were so repulsed by the messy materiality of physical existence that they assumed that this must be the work of a secondary, not-so-good God, and their doctrine of redemption did not include any idea of the restoration or the "recapitulation" of physical existence. The latter was something to be sloughed off as hopelessly unredeemable. Now while, of course, officially Christian theology had to denounce Gnosticism, one has the feeling that there have been (and still are) many Christians who perhaps would have been not too unhappy if the Gnostics had, in this matter at least, won the day. One could quote many Christians in whom there has been a struggle between a Manichaean dualism and a Christian willingness to accept the flesh and materiality as redeemable. Augustine is obviously one, but there are many, many others. Thomas Traherne and Julian of Norwich are rare figures in the history of Christian literature. Very few Christian writers have dared to express and to do it in the name of Christ. O course, strictly speaking, the Christian must have an ambivalent attiude to created existence. He must believe both that creation is good and that it is shot through with evil and suffering, a fallen universe and therefore not to be accepted and used in an unqualified way. But this is one of the many delicate feats of balance which the Christian finds it hard to maintain. Looking back over Christian tradition as a whole, one could be forgiven for coming away with

the impression that the majority voice had expressed in a pessimistic way the evil character of created existence and its dubious capacity for salvation, the incorrigibly and universally evil character of human desire (especially sexual desire), and the inevitably diabolical character of human creativity as a whole.

This is a sad thing because one would have expected that the resources of the Christian doctrine of man, especially in his being made in the image of God, were such that a richly articulated concept of man as God's "pro-creator" would have developed within Christianity, and that this might have affected the Christian attitude to the artist. Actually, the record is such that one has to admit that Christians have been curiously niggardly in their approach to man's status as "pro-creator." In fact, it would seem that the whole concept of pro-creation has been as limited as that of English popular usage where procreation means, in a slightly arch way, the begetting of children. This is illustrated by the 1928 debate on the English *Book of Common Prayer*. Quite clearly the 1928 revisers found the language of the 1662 Prayer Book for the marriage service too direct. They rejected that very rich and deeply Christian phrase to describe one of the objects of marriage: "for the procreation of children" in favor of the not simply unimaginative but starkly sub-Christian: "for the increase of mankind." A fully articulated doctrine of man as "pro-creator" could have clarified the attitude of the Christian church to the arts, have enabled it to face without hysteria talk about "man's coming of age," have integrated by now into the fabric of Christian doctrine the spheres of power and matter, and have enabled the church to enter into a living relationship with the arts on a basis of entire freedom and equality and unqualified reciprocity.

In Christian tradition the artist has remained the incorrigible prodigal son who has wandered so far off that it is now impossible to fetch him home. The artist has become an anti-creator. The "pro" of "pro-creator" has been taken to mean "instead of" rather than "on behalf of." One thinks of the phrase of Stanislas Fumet about art being "in culpable rivalry with God."[6] What is at stake in discussion over the status of the artist is nothing less than human freedom. Perhaps we have paid too high a price for the

Thomistic view that it belongs to God alone to create and that man cannot in any way share in God's creativity. It is very difficult to see how we could work with any concept of human freedom which does not imply some real kind of delegated creativeness. John Hick, in *Evil and the God of Love* has a good section on "freedom as limited creativity." "The concept of freedom as creativity," argues Hick, "would make it possible to speak of God as endowing his creatures with a genuine though limited autonomy. We could think of him as forming men through the long evolutionary process, and leaving them free to respond or fail to respond to himself in uncompelled faith."[7] Again, one might have expected a religion which is centered on the "Word become flesh" of the incarnation to be very much more sensitive to the parabolic significance of the poet as a worker in words. The way in which this sensitivity might have been developed has been indicated by Mircea Eliade in an essay, "Myths, Dreams and Mysteries," where he says "poetic creation, like linguistic creation, implies the abolition of time—of the history concentrated in language—and tends towards the recovery of the paradisiac, primordial situation; of the days when one could *create spontaneously,* when the *past* did not exist because there was no consciousness of time, no temporal duration." "The poet," he goes on, "discovers the world as though he were present at the cosmogonic moment contemporaneous with the first day of the Creation."[8] It is ironic, of course, that what has been regarded as the basic source of such humanistic elements as there might remain in Christianity, namely, the Hellenic classical tradition, was in fact much less humanistic in this respect than the old Hebraic tradition. In fact, it could be argued, as Harvey Cox has done in *The Secular City,* that one sad consequence of the Greek metaphysical mastery over the Hebrew tradition was that it hampered the emergence of a doctrine of man as pro-creator.

A theologian who gave a good deal of attention to this subject was Nicolas Berdyaev. He felt very strongly that the aspect of human activity which has suffered most, and indeed disastrously, from the Christian doctrine of the Fall is man's creativity and artistic endeavor. The customary use in Christian theology of the

analogy (from art) of man as "creature," of the universe as "creation," rather suggests that human creativity as such is necessarily and irredeemably evil. As Berdyaev points out, the use of the analogy "in traditional positive theology . . . is always a desire to humiliate man."[9] Certainly it is true that human creativity always contains, perhaps more than anywhere else, the most powerful stimulus to *hybris,* to Prometheanism. Creativity is, at one and the same time, the possibility of man's humiliation and sin, and also of his exaltation and glory. This is the essence of human freedom. For God to create means that he creates man in true freedom in an act of costly self-giving. This means that, as Berdyaev puts it, man has the tremendous power of freedom, that he is "capable of rising against God, of separating himself from Him, of creating hell and a godless world of his own. The idea of the Fall is at bottom a proud idea, and through it man escapes from the sense of humiliation."[10] Man is really a most exalted creature to be capable of falling away from God and endowed with that kind of freedom and power. "It is curious," says Berdyaev, "that theologians fail to recognize the presence of freedom in artistic creation, and only think of it with reference to the Fall, guilt and punishment."[11] This is a weakness in theology which has retarded the development of a doctrine of art in terms of pro-creation. The very word "creature" has in the Christian vocabulary come to acquire a consistently deprecatory meaning. The creature as such is insignificant, impotent, pitiful, hopeless. It is almost as if in creating the world God wanted to humiliate the creature and demonstrate its nothingness and hopelessness. But, as Berdyaev points out, this is to overlook one of the great fertilities in the use of the analogy of creation. This is putting in another way what is being expressed by man as "the image of God." No work of art is regarded as being poor, low, or insignificant simply because it is created. And to identify creation with absolute fallenness in this way is a great mistake. The idea of "creation" and "creature" as such, says Berdyaev, does not imply a fallen state. Theologians regard "creature" as low and insignificant because it is creature, not because it is fallen. Christians need

to make sure that their deprecation of man is because he is fallen, not because he is a creature.

The thing which belittles the creature is not finitude nor finite freedom but the thing which can result from finitude and freedom, namely sin. As Berdyaev put it, "Neither the created nature nor the uncreated freedom belittle the creature. What belittles it is the evil that springs from freedom."[12] Evil is not a constituent part of its nature. It has not been created by God.

Berdyaev makes the interesting observation that theology has been inhibited in its thinking about creation by working with a wrong image for it (or a distorting interpretation of that image). This image, when analysed, is really inimical to the creative process as such. This is the image of the *actus purus,* having no potentiality, completely self-sufficient. He makes the point that while theologians have had no hesitation whatsoever in using the affective imagery of anger, jealousy, etc., they have never felt free to use the equally affective images which one associates with creation: the images of conflict, tragic self-denial, and so on. In fact there is a moral gulf between perfection in Godhead, which is spoken of in the language of self-regard (self-sufficiency, self-containedness, self-satisfaction, introspective self-contemplation, etc.), and perfection in man, which is spelled out in terms of self-sacrifice and self-giving. "That which in God is regarded as a sign of perfection, in man is considered an imperfection, a sin."[13] Theology has mislead us by failing to stress the logically appropriate qualities of the analogy from creation which are not self-sufficiency, self-satisfaction, and despotism, but rather the need for sacrificial self-surrender. Traditional theology, as Berdyaev hints, has of course been afraid to ascribe change and mobility to God because these were regarded as imperfections. But this is to beg the question whether the traditional immutability and impassibility of God might not have their own deficiencies. Berdyaev feels that tragic conflict in the life of the Deity "is the sign of the perfection and not the imperfection of divine life." Sacrificial love, such as is disclosed in Christ, implies not self-sufficiency but the need "for passing into the other." The Christian God, says Berdyaev, is the God of sacrificial love, and this sacrifice always indicates tragedy.

Berdyaev concludes by saying that to deny tragedy in the divine life is only possible at he cost of denying Christ, his cross and crucifixion, the sacrifice of the Son of God.

The category of *kenosis* is most intimately related to human creativity because of the kind of self-giving involved in the work of the artist. To quote Berdyaev again, "Creative genius is not concerned with salvation or perdition. In his creative work the artist forgets about himself, about his own personality, and renounces himself. Creative work is intensely personal and at the same time it means forgetfulness of self. Creative activity always involves sacrifice. It means self-transcedence, overstepping the confines of one's own limited personal being. . . . It is paradoxical," concludes Berdyaev, "that ascetic experience absorbs a man in himself, makes him concentrate upon his own improvement and salvation, while creative experience makes him forget himself and brings him into a higher world."[14]

It is often assumed that Christianity's failure to develop a theology of art is largely the result of its Hebraic inheritance. The conquest of the pale Galilaean has been especially lamented by those who suppose that the tradition of classical Hellenism would have been a better *depositio fidei* as far as the arts are concerned. This, I think, is very debatable. Hellenism certainly had a more confident doctrine of man as pro-creator, but this was taken to mean anti-creator. Art was inevitably bound to result in a defiance of the gods. The Hebraic tradition, on the other hand, was saved from despair or defection to tragedy not only by the constancy of its eschatological hope but by a positive doctrine of creation, and in its particular approach to the image of God in man had resources to nourish a concept of man as pro-creator which did full justice to his hybristic tendencies without losing hope in their redeemability.

Finally there is a general objection to the propriety of using the analogy from art and the creative activity of the artist with reference to the incarnation. This springs from the fact that art is concerned with the use of impersonal material (e.g., pigment, stone, wood, sound) and is therefore thought to be inappropriate as an analogy for the shaping of human personality or character

where the user coexists with the material. Yet it is not for nothing that common speech uses phrases like the "art of living" (or loving or dying), the "art of happiness," or the "art of scientific investigation." All these phrases have sprung from the belief that there is some similarity between the activity of the artist in whatever medium and that of the human being who is serious in attempting to achieve some significant pattern in his own experience or behavior. The art involved in this case concerns the reducing of experiences, feelings, thoughts, to significant shape by the exercise of control, discipline, and detachment, and when this is achieved one speaks of the "grace" or "style" of a person's life. Human conduct and feeling can be shaped into such integrated patterns as to warrant the epithet "beautiful." Human achievement of personality at its highest does approximate to the work of the artist. Indeed, it is much more difficult to order for any length of time what T. S. Eliot calls "the undisciplined squads of emotion" than the material used by the artist, even words which, as Eliot say, "will not stay still."[15] If there is a tragic quality about all human art because of its impermanence, fragility, and comparative rarity, this is all the more so in the case of the art of living. The artist in words or music, for example, can achieve an end product of some stability in a poem or a symphony, but in human personality and life any significant or impressive configuration cannot be held for long. Almost at once it dissolves into the vicissitudes and vagaries of human mood and behavior. All human creativity, then, and specially that which works on its own nature, bears a significant resemblance to the process of incarnation. This is the theological basis for a Christian belief in Christ as the crown of human culture, as giving meaning and cohesion to the whole artistic enterprise of man.

To summarize the argument thus far: The suitability of art as an analogy for the incarnation is indicated by the very use of the epithet "creative" of the artist. Strictly speaking, one could bring philosophical and theological objections to the notion that the artist is genuinely a creator. Only God, who creates *ex nihilo*, can properly be said to create in the sense of bringing into existence that which had no previous being. The use of the de-

scription of the artist as a creator has meant to indicate, however, that what he does is so like God's creative activity and so unlike the common run of making human artifacts that he can be described honorifically as a "creator." In the case of the incarnation there is real creativity and art. God, through the Spirit, works on an existing material (the human nature taken in incarnation) and fashions a new Adam. God in Christ is creating man afresh in his own image, but now both artist and art form (*eikōn*) coalesce. Any Arian tendency is avoidable by stressing, with Origen, that what happened in Christ is a token of what happens eternally in Godhead, namely that God is eternally acting in the spontaneity and joy of creative love. The sacrificial self-giving in love at the incarnation is the clue both to the creation of the universe and to human creativity. We have some glimpses of the self-annihilation involved in art in the asceticism of the artist, but the Christian sees in the incarnation the furthest reaches of this in the form of a divine self-forgetting, self-giving, and self-crucifixion. St. John's Gospel points up the heights of the being, teaching, and activity of Jesus only to bring home more dramatically the scale of the descent involved for one who can solemnly affirm that what he says and does are not his sayings and deeds but the Father's. Already in the New Testament there is an insight into this factor in the incarnation: that it involved a magnitude of self-forgetting and self-giving which it is impossible for us to imagine even by way of the finest surmise.

ART AND THE LIFE OF JESUS

So far we have been concerned with the analogy between the art form and the incarnation as God's act of becoming man in Jesus of Nazareth. The term incarnation, however, is used to mean not simply the event of Christ's coming, but the whole course of his mission. The Christian religion is centered on the incarnation not only as a unique historical event, but the life and activity of Christ have for the believer paradigmatic significance both as to form and content. In Christian thought and practice the incarnation is seen to have extended meaning in relation to sacraments and the formation of personal life in community. So

I turn now to discuss the actual course of the life of Jesus in relation to the analogy of art.

Here we face first the difficulty raised by the influence of historical scepticism on recent New Testament study, particularly in the area of the life of Christ. Form-critical and other studies led to the assertion that we can know hardly anything about the historical Jesus as compared with the "kerygmatic" Jesus, the Jesus proclaimed by a preaching, teaching, and worshipping church. Furthermore, Barth and Bultmann asserted not only that the historical Jesus cannot be recovered by historical research, but that this ought not to matter. Otherwise faith would be made to depend on the vagaries of historical scholarship. In this attiude it is possible to discern the shade of the old Docetism, endemic perhaps to the German temperament since Kant and Lessing, who could not accept the idea that a religion of universal significance could be compatible with attachment to a particular historical event or person. This particular form of Docetism is a good illustration of the "flight from realism" in that it shrinks from the idea that incarnation meant exposure to the ambiguities and probabilities of the historical process. This is to qualify seriously the thorough-going, unqualified character of the self-giving of God who in the incarnation gave himself over to the hazards of a genuine history. To try to bring about a situation where faith is immunized from exposure to the partialities of historical investigation is tantamount to a denial that Jesus Christ has come *"in the flesh."* Furthermore, to rest the significance of Jesus on his proved potency for moral and spiritual impetus in the Christian community throughout its history is to make him not radically different from a number of other figures (e.g. the Buddha or Socrates) who have provided such resources in other communities.

Extreme scepticism about the possibility of reconstructing a life of Jesus may now to some extent be on the wane, but there remains continuing reserve as to whether one can speak at all about such things as motivation of Jesus, his self-awareness, or his interpretation of his own mission. Over thirty years ago (1939) it was possible for H. G. Hatch to publish a book with the title *The Messianic Consciousness of Jesus.* He would be a brave New

Testament scholar who used that title today, now that it is generally taken to be one of the "established results" of New Testament historical investigation that no material whatsoever exists for a discussion of Jesus' awareness of himself or his mission. This is particularly true of German New Testament criticism, but the opinion would be widely shared by British scholars.

Bornkamm writes, characteristically: "The nature of the sources does not permit us to paint a biographical picture of the life of Jesus against the background of his people and age."[16] Earlier Bornkamm has suggested that to engage in a quest of the self-awareness of Jesus argues either an uncritical method or a fanciful imagination, and can only be carried through "with a lack of criticism which alleges everything to be historical or with a display of an imagination no less uncritical which arbitrarily stops gaps and manufactures connections precisely where the gospels omit them!"[17]

It has accordingly become axiomatic in German theological circles that we can no longer speak meaningfully of "the mind of Christ," but only of the mind of the early church. The whole discussion of Bultmann, writes John McIntyre, "illustrates that since we are enclosed within the resurrection-faith, we are in no position to know anything of the messianic consciousness of Jesus. Any argument which involves knowledge of the pre-resurrection mind of Jesus is based upon a false premise."[18] For Bultmann "the acknowledgment of Jesus as the one in whom God's word decisively encounters man is a pure act of faith independent of the answer to the historical question whether or not Jesus considered himself the Messiah. Only the historian can answer this question—as far as it can be answered at all—and faith being personal decision cannot be dependent upon a historian's labour."[19]

A similar position is adopted by many British New Testament scholars who would agree, for instance, with Professor C. K. Barrett when he says: "to say this [that Jesus saw a special connection between himself and the coming of the kingdom of God] is one thing and to suppose that we can penetrate the messianic consciousness of our Lord is another. For to do this we should have to provide ourselves with a critical tool by means of which

we could distinguish between the historical tradition and the kerygmatic tradition precisely in the area where they overlap, and it is hard to know where such a tool can be found."[20] Barrett adds in a note that it is possible in certain cases to distinguish clearly concepts which are so thoroughly Hellenistic that they could not possibly be part of our Lord's human (Palestinian) consciousness, but he does not give any examples of what he has in mind.

It is not my purpose here to try to show how ill-founded is such historical scepticism, but simply to indicate that previous methods of investigation which consisted of detailed analysis of the titles used of Jesus in their historical background, followed by discussion as to whether Jesus claimed to be any of these personages, have proved to be barren precisely for reasons which become apparent when another line of investigation is pursued, namely, an analysis of the imagery of the teaching of Jesus in general, and, more particularly, the Christological implications of his uniquely parabolic (and "signful") method.

Before turning to this issue, however, one ought to note the kind of embarrassment which has been the necessary consequence of the prevailing negativity about the self-awareness of Jesus. The embarrassment is the disclosure of how persistent and subtle is the Christian struggle with Docetism, and that it is just as difficult for man to get rid of it today as it was for his predecessors.

It will be generally agreed that it is not possible to construct a biography of Jesus if by that we mean, to use the words of Käsemann, "the fabric of a history in which cause and effect could be determined in detail."[21] But, as John McIntyre points out, this is really true of any piece of biography, it being impossible to specify with any finality the ultimate springs of motivation that prescribe action. Because we are in no position to produce a final authorized biography of Jesus, this does not mean that we cannot make "*some* valid historical judgments about the life of Jesus."[22]

Furthermore, St. Paul's phrase, "the mind of Christ," must surely mean some distinctive perspective which has its origin in the outlook of Christ himself. To deny that we can know this seems to me to make nonsense of the greater part of the Christian doctrine of the work of the Holy Spirit which consists of "re-

membering" Christ in the life of his Christians. The facts do not compel us to deny, to quote the words of McIntyre again,

> that we are ignorant therefore of what might be called "the mind of Christ," of how he thought about the Father, about his own death, about men and women. It is not "uncontrolled imagination" (Käsemann's phrase) that speaks of these subjects. Without some fill-in of that kind in our conception of Christ, without some understanding of what he thought or of his motivation, it is difficult indeed to say whom we are speaking about when we speak of Jesus Christ. He becomes simply an X recurring in a series of propositions about the kerygma; an X, moreover, concerning whose internal nature we are forbidden to speak even on the basis of the series of propositions. In short, my reply to such a view would be that if we are unable to speak of the *personality* of Jesus, we are *ex vi terminorum* forbidden to speak about Jesus.[23]

McIntyre is also right when he points out that if the "psychological model" is to be discarded as a tool of New Testament investigation, then this means that modern Christology is on the verge of reintroducing its own kind of Docetism. If we take this position, we are saying that the Word was made flesh in Jesus of Nazareth, but flesh in such a way as to escape all the ordinary psychological observations that one would want to make about a human personality. "The early docetists wished to save the unchanging Logos the embarrassment of change and suffering, while their latter-day followers would save him the embarrassment of psychological qualities and characteristics; he is human but in no way known by us, which is to say in no way at all."[24]

The necessity for trying to understand what form Christ's humanity took on the psychological side was one of the permanent insights of the now much despised liberalism. If there is now general acceptance of the human limitations of the "knowledge" of Jesus—that one must speak of Jesus growing in knowledge and that he cannot be considered as some kind of walking, omniscient God—all this is due to the liberal movement and represents, as McIntyre puts it, a break with those elements in patristic and medieval thought which feared to compromise the omniscience of the divine nature of Christ by allowing any ignorance in his human nature. Furthermore, the liberals brought about a significant shift of emphasis in the interpretation of the miracles of Christ. Hitherto

in Christian tradition they had been regarded as undoubted manifestations of the divine nature of Christ. Liberal theology was, however, prepared to consider the connection of miracles with Chirst's humanity. I am not prepared to argue here in defense of the liberal interpretation of the miracles of Jesus which this approach produced. Nevertheless, it does make sense to me to speak of the miracles as being "signs" to Jesus himself as well as to his contemporaries. A decision of interpretation was demanded of him as well as of them. I am suggesting that how Jesus interpreted the things which he found happening during the course of his life and mission raised basically the same kind of moral demand and spiritual insight which he laid upon his contemporaires.

Christian belief in Christ cannot brush aside the question of the quality of Christ's human character as an irrelevance which can make no possible difference to the central Christian affirmations. Christian doctrine about man which wishes to speak of the re-creation of mankind in Christ; Christian atonement theology claiming the moral victory of Christ over sin and all the things which hamper life; Christ as the pattern for the Christian in his obedience and humility—assertions on all these fronts cannot meaningfully be made unless there is sufficient warranty for them in the sources of our information about the historical Jesus. Discussion of ethical objections to the character of Jesus is a real discussion with sufficient historical facts to form the basis of judgment.

I wish now to turn to a brief review of those investigations of our problem which consist of an analysis of the titles used by or of Jesus. The first title to be considered is "Prophet." Was Jesus regarded as a prophet in his own day? And if so, what did that imply? Did he so regard himself? Perhaps this is the point at which we could settle once and for all the issue involved in the use of the term "the claims of Jesus." An older form of apologetics made a great deal of this—so much so that the "claims of Christ" has become a platform-piece of a certain type of evangelism. This has probably done a good deal of Christological harm in its suggestion of a Christ who is so obsessed with himself and his "claims" that he can think of nothing else. And it has led to the

artificial apologetic "challenge": *aut deus, aut homo non bonus.* There is no evidence that Jesus claimed either to be a (or the) prophet, or a Messiah, or the Son of Man in any *direct* act of proclamation.

As far as the evidence for being a prophet is concerned, I would agree with John Knox when he writes: "the evidence that Jesus applied the term 'prophet' to himself is very sparse; and there is as little basis in the Gospels for holding that Jesus *claimed* to be a prophet as that he claimed to be the messiah. Perhaps the real question is not whether he claimed to be a prophet, or indeed consciously thought of himself as being one, but rather whether his consciousness of God, of God's will, and of God's relations with men and more particularly with himself, was of the kind characteristic of the prophet. It seems to me highly probable that it was."[25]

This seems to me also to be right. Jesus certainly allowed it to be read between the lines of what he said that his activity had a prophetic pattern, and he certainly acted as a prophet. But there is a characteristic elliptical indirectness about the manner of Christ whenever the subject touches his own identity. This manner I should want to characterize as the "irony" of Christ. The mistake in the past seems to have been that men have felt it necessary to have Jesus' own authentication of himself in so many words, without any possible dubiety or ambiguity. But the synoptic tradition is consistent in suggesting that Jesus did not believe that it was for *him* to say whether he were prophet or Son of Man, but for those of his contemporaries with "eyes to see and ears to hear." To show how the synoptic sources, especially a Gospel like Mark, do not infringe the freedom of this necessity more than they do would make a much stronger apologetic point than the traditional "claims of Christ" approach. It is very hard for an evangelist to leave the matter where the central synoptic tradition does! In fact, as John Knox puts it, "The greater the depth and mystery in Jesus' consciousness of vocation, and the more uniquely personal it was to himself, the less likely that he would have been able to define it."[26]

Again, there is nothing in the synoptic Gospels that would properly be called a claim of Jesus to Messiahship. In fact he is

significantly ambiguous, ironical, on the subject of his own messiah-
ship. This comes out, for instance, when Jesus, after initiating a
discussion of the Messiah, adds: "If David thus calls him Lord,
how is he his son?" This difficult saying seems to mean that what-
ever the Messiah is and whoever he may be, he is certainly more
than mere son of David whose physical ancestry can be ascertained!

Christ's Sonship of God is at most quietly implied rather than
explicitly affirmed. The argument for this was presented years ago
in T. W. Manson's *Teaching of Jesus*.[27]

The same thing I take to be true of Jesus and the Son of Man.
I have always felt that Jesus used the term "Son of Man" in an
indirect third-personal way, and that there is nothing in the records
which would give warranty to one saying that Jesus claimed to
be the Son of Man. The "Son of Man" is in fact just as much part
of Jesus' venture of faith as our identification of him as the Son
of Man is part of ours. In fact, the way he deals with the Son of
Man concept is such as to suggest that more is involved than a
mere matter of correct labelling, that indeed the "Son of Man" is
by his very nature and vocation not one who could claim anything
for himself by way of status. It is God, the Father, who alone
brings his Son of Man and discloses him as such in his own time
and way. This is the truth which Jesus, as well as his followers
and contemporaries, must abide by.

A similar conclusion seems to me to be necessary concerning
the question of Jesus and the "Servant." The servant role of Israel
was something which Jesus believed he had to enact in terms of
his own life and mission.

It seems to me, therefore, that a more fruitful way of attacking
this subject is not to go in once more for the traditional analysis
of these titles, but to look at what, from other fields of investiga-
tion, has been proved to be a more revealing indication of a man's
self-awareness, namely, the pattern of imagery which comes out
in his speech, and, in the case of Jesus, one would have to say
also in his actions. There is, it seems to me, a characteristic line
of action just as there is a characteristic form of speech discernible
even in the translated material concerning Jesus which we have in
the New Testament. The claim to certain titles rests upon a pre-

supposition about Jesus' self-awareness and a consciousness of his mission which is in fact contrary to the method which he believed to be incumbent upon him.

The teaching of Jesus, even in the translation in which it has been transmitted, has a recognizable style, and the literary study of style may make it possible to say something more positive about the self-awareness of Jesus than is currently fashionable. This may be briefly illustrated from the parable of Jesus, a particularly significant example from the point of view of the thesis of this essay, since it gives some insight into the way Jesus worked with parable, artist-fashion. As Gerhard Ebeling puts it: "The parable is the form of the language of Jesus which corresponds to the incarnation."[28] The parables were for Jesus not elucidatory or illustrative stories but "signs" indicating the purpose of his mission. There is space only for a brief discussion of the parabolic scheme in Mark, but the points could be illustrated even more forcibly from the Matthaean or Lucan schemes.

The first parabolic saying in Mark, "Those who are well have no need of a physician" (2:17), is best explained as a miniature ironic portrayal of Jesus' mission as a whole to both "righteous" (self-styled) and sinners (designated as such by the former). The irony is (for those who know their Old Testament) that, paradoxically, in Jesus' consorting with "sinners," God's visitation of the widows and outcasts of Israel was being enacted before their eyes!

In the saying about the bridegroom and the marriage feast (2:19–20), we have the indirect suggestion to his questioners, in an allegorical manner, that the messianic marriage festival has begun in their time, had they but eyes to see! Jesus himself is, if one is bold enough to take him as such, the hidden bridegroom of Israel. Similarly, in the cryptic saying about the new patch on an old garment (2:21), there is an indirect self-reference which implies that his mission is not just as a new patch on the old Israel. Is he himself, then, an entirely new Israel? That is for his contemporaries to decide.

The sayings about Satan divided against himself and the strong man bound (3:26–27) constitute an ironic invitation to his

critics to examine their own logic wherein they have attributed
good works to their contrary diabolical source. Taken together
with the ample evidence provided elsewhere in the tradition that
Jesus saw his mission as a contest with the powers of evil (e.g.
"I saw Satan fall like lightning from heaven"), these sayings
amount to an allegorical self-presentation of Jesus himself as the
contender with Satan.

The ironical elements in the parable of the sower (4:3-9)
have been insufficiently recognized in much New Testament
criticism because of the common supposition that few if any of
the parables of Jesus were allegorical, and this particular parable
is indubitably not so. This is the reason why so many scholars
dismiss out of hand the question of the authenticity of the so-called
explanation of the parable (4:13-20). In reality this is no ex-
planation at all, but the parable over again, presenting the allegori-
cal character of the original all the more starkly by identifying
some of the subsidiary details, but not significantly the main
figure—the sower. But if the seed is the Word of God, and so
on, who then is the sower? This is the key question set but not
answered by the parable as an allegorical tale. An "explanation"
of the parable which had its origin solely in the mind of the early
church would not have ended without identifying less ambiguously
the role of Jesus in the story. The reticence about explicit self-
identification points towards the authenticity of the second version
of the parable of the sower.

The probability that this parable was a master-parable which
provided the key to all the others and bears the distinctive marks
of Jesus' allegorical manner of aluding to himself or his mission
is further suggested by its distortion. This feature of so many of
the parables of Jesus has again not been given its proper due be-
cause of the assumption common in much New Testament criticism
of the parables of Jesus that they are "natural and realistic,"
whereas allegory is always "artificial."[29] This view, in addition to
failing to do justice to the concrete detail and verisimilitude of
good allegory, is only a half-truth about the parables of Jesus.
They are based on sharply perceived real life, certainly, but they
are larger than life, artistic distortions of reality for an artistic

purpose. So here in the parable of the sower. The harvest spoken of is anything but realistic, or "a piece of real life." A harvest of thirty-, sixty-, or a hundred-fold would be anything but "natural"—even the lowest, thirty-fold, is wildly unrealistic. Seven-and-a-half-fold would be near the natural average. This extraordinary harvest is a deliberate distortion and suggests an allegorical pointer to the incalculable and inconceivable consequences of the mission of Jesus.

The parable of the seed growing secretly (4:26–29) is important evidence for Jesus' sense of historical continuity with Israel before his day. He is aware of countless mysterious antecedents to his own mission, but he must wait for the harvest. Similarly, the parable of the mustard seed (4:30–32), if, as Dodd admits, the tree stands for Israel and the birds for the Gentiles, seems to point to Jesus himself as the one who is involved in bringing the reunion about.

The sayings about "what defiles a man" (7:14–23) indicate Jesus' awareness of himself as the "end of the Law" as do, in a different way, the mysterious "Amen" assertions. Somehow the mystery of the kingdom of God is bound up with his own person.

The parable of the wicked husbandmen (12:1–12) seems also to be an integral part of Jesus' awareness of being involved in an enactment of Israel's destiny which the Father is constituting "a sign of the times."

The final parable in the Marcan scheme, that of the door-keeper (13:33–37) is a further summons to recognize that what is taking place in Jesus and his mission is a personal embodiment of God's purpose for Israel.

In the Marcan parabolic scheme none of the parables is simply elucidatory. They are cryptic sayings and stories with the emphasis on discernment and being ready, morally, to see what is there and act on it. Further, they all have their background in Old Testament imagery which has as its subject God's purpose with Israel.[30] Finally, the allegorical element is pervasive. It looks as if Mark presents the parables as allegories, the key to which is Jesus' activity as an enactment of the history of Israel. Jesus could well be described as his own first typologist and allegorist in the

sense that he saw Israel's history repeating itself in his own mission and summoned his contemporaries in word and act to see in his life this other story. This means that Jesus had a detached view of himself and his missions which seems to have come from an ability not only to be involved wholeheartedly in commitment to a particular vocation, but also constantly to see this, in a distanced way, in its other dimension.

A study of the actions of Jesus would corroborate this. There is evidence that he took the "miraculous" happenings as "signs," to him and his generation, that the kingdom of God was taking shape in his ministry. Furthermore, as a dramatic symbolist in the tradition of the Hebrew prophets, Jesus deliberately enacted certain scenes as pointers to the meaning of his mission: e.g. the feedings, the entry into Jerusalem, the cleansing of the temple (more likely some kind of messianic demonstration) and the Last Supper. There is an insistence that for those with eyes to see and ears to hear his actions and words take on a significant pattern of a decisively important kind ("Having eyes do you not see, and having ears do you not hear?"; "Blessed are your eyes, for they see, and your ears, for they hear"; "He who has ears to hear, let him hear.").

The tradition about the mission of Jesus provides ample evidence that he took care over the manner of his words and actions, believing that the form of his life and speech were part of the gospel to which he was being summoned. This "style" of Christ one would call that of the "sign"/"skandalon." Hence the necessity for Jesus to be what Karl Jaspers calls "a prophet of indirect communication." He believed that any kind of self-proclamation or self-identification would violate the nature of the task given him. His task was not to proclaim himself or reveal himself. That he believed the Father would disclose in his own time and way. His was the obedience, and the rest—his identification or acceptance—must not become his business, but remain his Father's. The method of Jesus was cryptic (*en krupto* in John), indirect, and allusive. His parabolic and ironic method was central to his purposes because, to use Blake's phrase, it "roused the faculties to act."[31] This "indirect" method of Jesus did not impose

on others, but submitted itself to their free judgment. It is more apposite, therefore, to describe it in terms of art than anything else. Jesus had in a unique degree that detachment from himself which is essential to the artist. Indeed it is perhaps here, in the detachment of one whose self-consciousness was nonreflexive (so that he could speak of "the Son of man" in an objective, third-personal way) that the uniqueness of Jesus is to be sought.

THE INCARNATION AND
THE COMMUNICATION OF THE GOSPEL

If the manner and style of the incarnation are taken to have normative roles for Christian communication, there are significant consequences for our thinking about evangelism and its relation to education and propaganda. Christian evangelism ought never to be in a mode which is out of harmony with the style of Christ. Rather, it will be of a kind "to allow the divine vision to hover around man," as Blake put it, "because the will must not be bended," or in the words of C. S. Lewis, "Christian evangelism should by its very means convey the gospel which heals the wound of individuality without undermining the privilege of it."[32] It is commonly presupposed that Christians, by profession, know what the content of evangelism is and that its form can be left to look after itself. This is to beg the question whether certain types of evangelism may not be so irreconcilable with the style of Christ as to necessitate a drastic process of unlearning at a subsequent stage. Christians are commissioned to be "poets" of the word (James 1:22), to learn the long, hard discipline of working with words and have genuine respect for their behavior, as an act of homage to the Word made flesh. The form of the incarnation makes necessary canons of evangelism criticism in the same way that the work of art leads to art criticism. It is the purpose of both types of criticism to point to the original and not to become a substitute for it.

It is one of the questionable elements of Rudolf Bultmann's "demythologising" enterprise that it assumes the literary form of the gospel to be accidental and of no permanent importance. The particular form of the original may be discarded in the interests

of making the content more immediately relevant to contemporary thought. From the point of view of literary criticism, as students of literature understand the term, Bultmann's procedure is seriously restrictive, since it makes literary criticism "anterior and ancillary to interpretation and evaluation proper."[33] Dietrich Bonhoeffer is much more loyal to the givenness of the literary form and content of the gospels, and indeed his endeavor to find a "non-religious interpretation of biblical terms" in a context of what he calls "concretisation" offers a more promising prospect than Bultmann's "demythologising" which, to use Bonhoeffer's vocabulary, amounts in its practical outcome to a "de-concretisation." The momentum of the human mind, and especially the academic mind, is all towards abstraction, and it needs to be turned again and again back into the concrete and the particular. In a reference to Bultmann's program, Bonhoeffer writes: "I am of the view that the full content, including the mythological concepts, must be maintained. The New Testament is not a mythological garbing of the universal truth; this mythology (resurrection and so on) is the thing itself— but the concepts must be interpreted in such a way as not to make religion a pre-condition of faith."[34]

It is because Bultmann's practice of the method of demythologising ignores these facts and proceeds as if complete translation from one medium to another were a possibility, that many Christians see in it a violation of basic critical principles. There is no doubt about the worthy and strongly pastoral, evangelistic motivation that lies behind Bultmann's endeavor. He is anxious that the Christian religion should not become an antiquarian curiosity, magnificent in its time but now hopelessly obsolete. If, as we have contended, there is a real affinity between the incarnation and a work of art, Bultmann is raising the same kind of problem with reference to the understanding and interpretation of Christ whih T. S. Eliot raised in relation to the contemporary appreciation of a medieval poet like Dante.[35] No translation or "demythologisation" of *The Divine Comedy* could be an adequate substitute for the original, couched though the latter be in the thought-forms of a past age. The task of Dante-criticism is not to find means of leading the reader away from the original in

favor of some modern paraphrase, but to find telling contemporary images and analogies which send him back to the original with fresh resources of receptivity. Art and literary criticism are creative not in their attempts to replace the original but in their capacity so to speak of the original that one is inevitably and immediately sent back to it. What is required of the theological criticism which would foster a contemporary "appreciation of Christ" is not primarily demythologisation of the three-decker universe of the New Testament, its demonology, and so on, but an eye for vivid, memorable analogies and metaphors which bring home to the listener or reader the real nature of the "sign"/"skandalon" character of the person and mission of Jesus. This is not to be located, with Bultmann, in the three-decker universe. Spatial metaphor of the three-decker kind is likely to remain a basic model for religious discourse as long as man remains a finite being in a space-time universe, and this is likely to be his lot in the foreseeable future. For spaceless man another model would have to be found, but until it is demonstrated that spacelessness is to be man's permanent condition, to dispense with spatial or temporal metaphor would be an inhuman and senseless attempt to jump out of our finite skin. The real "offence" of the gospel of the incarnation is not the particular cosmological framework of the gospels but, as St. Paul indicated in his language about the "mystery" of Christ, the enigmatical ambiguity of a Christ who is so identified with the human scene as to be, seemingly, indistinguishable from it except to the eyes of faith. It is therefore possible to mistake the weakness and foolishness of the incarnation for no more than the imperfections of finitude.

The analogy of the work of art is closest to the incarnation in its irreplaceability. Uniqueness renders substitute or paraphrase impossible. Bultmann fails to convince his readers that he believes the incarnation to have anything like its traditional irreducibility. In his system Christ would, in the end, seem to be replaceable since other figures in history (and indeed out of it) have had a potency to transform human beings from "inauthentic" to "authentic" existence and to be the inspiration of new and coherent patterns of living. Bultmann wants to have everything in the gospel

translated into terms of my existence here and now, but this is to place a premium on the contemporary, which it will not sustain. Indeed it is just here that classical Christian spirituality takes on special relevance, namely, that my existence here and now is more likely to be illuminated by standing back from it in "contemplation" and relating it in such detachment to significant moments in the life of Christ. It is precisely this active reciprocal intercourse between past and present that art fosters and that illustrates T. S. Eliot's contention that it is "the historical sense" which makes a person most sharply conscious of the contemporary.[36]

Bultmann is part of the long Christian history of restiveness with the particularities and ambiguities of an historical incarnation. It is one of the paradoxes of this history that the particularity of the incarnation has not prevented Christians from indulging in a *penchant* for what William Lynch calls the "men of the infinite" (who escape from the definite into idealism, romanticism, etc.) as against their natural allies, the "men of the finite" (who have a care for the definite, as historians, positivists, scientists).[37] This often leads to the self-deception where paraphrase into abstract existentialist language is preferred to the original, although at best it is often only saying the same thing in a weaker and vaguer way.

No one in recent times has had a sharper eye for detecting the consequences of the attempt to divorce form and content in the incarnation by transposing it into vague ideals or abstractions than Dietrich Bonhoeffer. His whole theology was based upon a much more thoroughgoingly realistic acceptance of the inseparability of form and content in the incarnation than is the case with, for instance, Karl Barth. Although he does not use the analogy from art, Bonhoeffer saw the incarnation as an artist-like act of unqualified self-giving so that, contrary to Barth, God has in Christ put himself at our disposal. He is "haveable," "graspable," as Bonhoeffer puts it. In one of his Chicago lectures, Ebehard Bethge says that Bonhoeffer would rather have fallen into positivism than into idealism in order not to lose contact with earth.[38] Hence Bonhoeffer's fondness for the myth of Antaeus, who became impotent the moment anyone lifted him from the ground, his whole strength depending on his contact with the earth.

Bonhoeffer sketched the direction in which a Christian theology, ethics, and spirituality would go when based on the incarnation as a unique art form. This appears in his program of "concretisation," his vision of the church as "Christ taking form" and of Christian ethics as the formation of Christ in his Christians.

By "concretisation" Bonhoeffer did not mean "making the message concrete." Rather, it was a way of doing justice to the fact that the message *is* concrete. In other words, it fashioned a mode of response to the incarnation and a way of interpreting it which take one back to the original in the way we have suggested to be the function of art and literary criticism. "Concretisation" is much more than a pedagogical summons. It is a necessary and permanent way of pointing to the most important feature of the divine revelation in Christ—its real embodiment. We have noted that one of the sad casualties of the reluctance to use the analogy from art has been the failure of Christian theology to develop a doctrine of man in terms of his pro-creatorship. In many ways it would seem that what Bonhoeffer was striving after in his concept of "man come of age" was a doctrine of man as pro-creator.

Furthermore, Bonhoeffer's attempt to clarify the link between the incarnation and the Christian life by recasting the ideal of the *imitatio Christi* throws further light on the importance of the analogy from art.

Bonhoeffer sought to press the realism of the Christian's commitment to the world by showing it to be a mimesis of God's entire giving of himself to the world in the incarnation. Just as there has lingered on a residual reservation about the unqualified character of the commitment of God in the incarnation (in Docetism, for instance) so, Bonhoeffer suggests, there has been a holding back in Christian ethics and spirituality (in the form of "religion" or "the sacred") from genuine immersion in the world. Christians have self-consciously held on to "religion" or "the sacred" as a reassuring label of self-identity. But loss of identity of this kind is one of the risks which Christ took ("Behold a glutton and a drunkard"). The identity of the Christian as a genuine imitator must be left to others, as Christ was content to leave his identity to the Father.

Bonhoeffer's reconstruction of the *imitatio Christi* was to proceed with rigorous realism based on an acceptance of a radical *kenosis*. In addition, it was to take further Luther's emphasis on *conformitas* as a way of avoiding the suggestion that the imitation of Christ is either an antiquarian attempt to mimic Christ literally or some kind of Christian moral heroism. The imitation of Christ is the way the believer sees the process, but in the purposes of God it is a case of the Spirit modelling Christians into some conformity with Christ in a way which does not infringe but enhances their individuality and freedom. It is unfortunate that imitation is often assumed to involve lack of originality. The history of painting shows that the opposite is the case. Artists have used the work of other artists in a new, creative, and original way. Within imitation can come real originality. The Christian life as imitation of Christ is a variation on the theme of Christ which the observer may see to have some likeness to the original, and yet remain within a true individuality. The incarnation has the inexhaustible power of works of art, and the person and life of Christ remain unique and seminal, producing a vast progeny of variations. For this reason, to adapt the words of Coleridge about the work of art, the same unwearied form of the incarnation presents itself because, as W. B. Yeats said, "man can embody truth but he cannot know it."[39]

THE INDIRECT COMMUNICATION: KIERKEGAARD AND BECKETT

James D. Whitehill

Both Søren Kierkegaard and Samuel Beckett guard their writings of self-examination and existence with gorgons that should frighten off the scholars' temptation to aggrandize the writings of these two apostle-poets of subjectivity. Surely the Protean complexities and elusiveness of their works coupled with their blatant and penetrating outbursts against professional thinkers and critics would have protected them from the dubious attentions of those whose business it is to make the chaotic orderly, the mysterious understood. How odd it is, then, that Kierkegaard has been delivered over to the professors and the lecture hall and Beckett to the scholars whose pickings and probings occupy ever larger portions of the library shelves. Striving for a communion of subjectivity, Kierkegaard and Beckett find their writings the objects of scholarly scrutiny and statement. No one questions this odd embrace by the scholars, much less the character of its fruits. The assumption in the public of scholars is presumably that Kierkegaard and Beckett are writing to them, offering their writings to those few who can and wish to consume them in a spirit of intricate appreciation to the end of writing an intricately appreciative article in a professional journal. A modest proposal, therefore, is at hand: that we rescue the "existence-communications" of Kierkegaard and Beckett from the scholars and attempt to recover a sense of what Kierkegaard and Beckett are doing for us, a perspective on their writings as communications between man and man.

Kierkegaard and Beckett, I submit, are going about the difficult task of sketching subjectivity to the end of making sub-

jectivity possible for those still capable of choosing themselves in it. Common to both sets of writing is a strategy of communication consisting of a variety of literary tactics in the service of an ethical end, that is, to help a man stand alone before and in his essential solitude. Kierkegaard designated this strategy of communication "the indirect communication" and sketched its outlines for us, in theory and in his "apology" for his authorship. Beckett, on the other hand, places before us an *oeuvre* whose deep workings upon us seem to be illuminated most adequately when considered in the light of the hypothesis that Beckett's writings incarnate a strategy of "indiect communication."

A description of Kierkegaard's theory of indirect communication is made difficult and complex for the same reasons that a description of any Kierkeggardian notion is difficult and complex. A mapping of the conceptual terrain of Kierkegaard produces an ever-changing labyrinth with many entrances and few secure touchstones. The manifold ambiguity of his thought evolves partly from his own intention and accounts for the fact that no generally agreed upon interpretation of Kierkegaard has developed. More often than not, Kierkegaardian scholarship and interpretation end with a work reflecting, only too obviously, the concerns, emphases, and biases of the scholar and interpreter. Kierkegaard becomes an occasion for reflection. This is to say that Kierkegaard, in his effect (and, I think, intended effect), is both thinker and artist, an intellectual provocateur in the service of existence. So it is that in considering Kierkegaard's theory of indirect communication one is drawn into the Kierkegaardian labyrinth and finds oneself lost in a maze of conceptual motions leading nowhere but to explorations undesired. My concern in this essay is to avoid that seductive call of exploration, leaving it to others to speak of the complexities of the theory of indirect communication as it intertwines with Kierkegaard's thought.[1] Rather, my concern is to explore those notions of communication in Kierkegaard pertaining to the establishment of a perspective on the question of communication as it arises within artistic expression. This exploration involves a description of the theory of indirect communication with attention to the following aspects: the intention, the content,

the method, and the relation of communicator and receiver of an indirect communication.[2]

The intention lying within an indirect communication must be distinguished from the specific intentions Kierkegaard held in using and developing this strategy for speaking to other men. If we can accept statements in his *Point of View for My Work As an Author* as indicative of Kierkegaard's intentions, it is clear that he developed the indirect communication as the way to the twofold goal of disabusing men of the illusion that they were Christians and of leading them, hence, to Christianity.[3] Apart from the intentions that may gather about the use of indirect communication, however, is an intention that both defines and determines the use of this literary strategy. The intention of an indirect communication is to confront the receiver with an artistic configuration of human existence in such a way that a rigorous demand is set before him: that he respond to the configuration, the "existence-possibility," *by choosing himself in a positive or negative relation to it*. The end in sight, therefore, is that the communications arouse and nurture the ethical capability, the freedom and choice, of the receiver. Any other effect upon the receiver is incidental and potentially deceptive: aesthetic appreciations, affective and cognitive stirrings, and catharsis—these commonly espoused and evidenced responses to artistic communications are subordinated to the ethical response, for the former responses do not require that we become "self-active," choosing ourselves in self-knowledge and subjectivity. The ethical or indirect response proceeds by what Kierkegaard called a "double reflection." The first reflection is the apprehension of the artistic form by the receiver; the second reflection occurs if and when the receiver appropriates the artistic form in relation to himself as a subject, whereupon the artistic form becomes an "existence-possibility" for the receiver, and he must face and choose for or against it. The intention of an indirect communication consists, then, in the existential activation of the receiver by presenting him with a possibility that he may choose to incarnate in his existence as he attempts to come to terms with it subjectively. This is not to deny that additional intentions may coexist with and even determine this basic intention of the indirect

communication. That it is called an *indirect* communication makes this possible; Kierkegaard, for example, used the indirect method, he tells us, to lead men to a direct communication he would and did make in his *Edifying Discourses*. Needless to say, indirect communication is not necessarily or usually bound to such an epilogue.

A successfully executed indirect communication has as its effect the awakening of thought, the creation of tension, and the opening up of subjectivity and choice in the receiver. But does this effect constitute communication? Communication, in its ordinary language sense, involves the transference of *content* from communicator to receiver. The intention of the communicator is to deliver this content to the receiver with sufficient clarity to avoid misunderstanding and insure against error. For Kierkegaard, however, communication in this sense cannot carry the burden of his primary intention, to bring his listeners to the stage wherein "truth is subjectivity" is existentially appropriated and manifested in their lives. Direct communication is the medium for conveying objective truths between man and man; indirect communication is the medium for the truth which is subjectivity. Thus, while in direct communication a content is delivered to the receiver, indirect communication delivers the receiver into himself as an essentially existing human being. The words that pass between communicator and receiver in an indirect communication are placed under a double demand: first, they must be so shaped that their appropriation, in the mode of a direct communication, is frustrated and hindered at every turn; second, they must act in concert so as to activate reflection—not upon the communicator, the nature of objective truths, the delicacy and grace of the style, the possibilities of writing a historicocritical article for a professional journal exposing the world significance of the communication—rather to activate reflection upon oneself in one's own primitivity and freedom.

The words that make up an indirect communication sketch and compose an artistic configuration of human life. It is this configuration, if anything, that claims the term *content* in an indirect communication. It is characteristic of this ostensible content (language, style, setting, and form) that it is elusive, that it escapes

the receiver's attempts to make it fixed, secure, ordered, understood, and tolerable, while simultaneously seducing him into rapt attention. This essential elusiveness is achieved in various ways and forms, by a variety of literary devices. The language may be convoluted to the point of exasperation (how many have despaired of "understanding" *Sickness unto Death?*). Masks, incognito, mystification, seduction, irony, humor, asides, and digressions—these and other moves are the business that remove the content from an easy, objective appropriation (e.g., "Kierkegaard's concept of the self, transposed through a pseudonym whom Kierkegaard disavows, is that 'the self is a relation relating itself to itself,' " etc.). The effect of such writings, I think, is this: by the time the receiver has come to "understand" what the communicator confronts him with, he has passed beyond the ostensible content and the communicator and, to some degree, into his own inwardness. The communicator has seduced the receiver into standing alone and forced him to choose, at some level, himself.

The method of indirect communication is directed toward its intention (evoking the ethical capability and response in the receiver), its ostensible content (the artistic configuration of an elusive possibility for subjective appropriation only), and its relation between communicator and receiver (independence that affords freedom of self-action). The indirect method involves, first of all, a venturing to the "place" where the receiver is located. Kierkegaard writes:

> That if real success is to attend the effort to bring a man to a definite position, one must first of all take pains to find HIM where he is and begin there.
>
> This is the secret of the art of helping others. Any one who has not mastered this is himself deluded when he proposes to help others. . . . But all true effort to help begins with self-humiliation: the helper must first humble himself under him he would help, and therewith must understand that to help does not mean to be a sovereign but to be a servant, that to help does not mean to be ambitious but to be patient, that to help means to endure for the time being the imputation that one is in the wrong and does not understand what the other understands.[4]

Kierkegaard, in his indirect communication with Christendom, begins with his aesthetic works because the receivers are aesthetic Christians unprepared for his ethical challenge and ethicoreligious

call. Once the receiver is met in the place of his standing, additional techniques may be used to maneuver and seduce him into subjectivity. Two of these techniques are prominent in Kierkegaard's outlines and notes on the indirect method. First, the communicator should personally correspond to the content of the communication. If the communicator seeks to communicate the worth of suffering, he should himself have suffered in the world; otherwise he "refutes" his own exhortation, as Schopenhauer refuted his injunction to suicide by refusing it for himself. The communicator, in effect, presents himself as the artistic configuration of the content he is presenting to the receiver. The receiver responds, then, to both the words and the person in their mutual totality as an "existence-communication." It was with this correspondence of words and existence in mind that Kierkegaard stated Christ to be the model of the indirect method.[5] Another prominent technique of the indirect method was fashioned self-consciously by Kierkegaard from the Socratic method of dialectic. The communicator, acting as "midwife" to the receiver's subjectivity, proposes a possibility-to-be-considered. The communicator proceeds dialectically to confront the receiver with various possibilities that the receiver can appropriate as his own. The confrontation moves inward and brings to light basic difficulties in each possibility that lead, in turn, to a more basic possibility. This process has as its purpose the bringing to consciousness of *the* basic possibility (i.e., for Kierkegaard, standing alone in one's God-relationship).

The method of indirect communication is oriented toward the task of the communicator, which is to drive the receiver into ethical confrontation of subjective possibility and to help him stand alone in his essential solitude. This task requires that the communicator meet the receiver where he is and proceed to drive him into a double reflection. The presentation of new "existence-possibilities" requires that the presentation be in terms of the posture and situation of the receiver and, yet, in terms that lead the receiver into confrontations with new possibilities that lie ever deeper in the receiver's primitivity and that are imbedded in the human condition. This movement occurs if and when the mode of

communication is such that the receiver is deceptively led away from his illusions. Kierkegaard went about his task of educating his public in what it is to exist as a Christian by divesting them of the illusion that they were Christians. This divestment was "accomplished" indirectly, however, through the nature of the communication (one feature of which was Kierkegaard's comporting himself as a pseudonym disavowing any own claim to be a Christian). The direct method of communication would have it that Kierkegaard simply declaim their hypocrisy to the Danish Christians. The indirect method, the intention of which is to bring about an existential communication through the agency of the receiver himself, requires that a strict separation be maintained between communicator and receiver. The truth which is subjectivity is not to be communicated and appropriated directly, so that the receiver becomes a disciple of the communicator or takes a position as an assistant professor expounding his doctrines to lecture hall crowds; rather, the truth which is subjectivity is appropriated in inwardness, in secret, standing alone. Kierkegaard states:

> Wherever the subjective is of importance in knowledge, and where appropriation thus constitutes the crux of the matter, the process of communication is a work of art, and doubly reflected. Its very first form is precisely the subtle principle that the personalities must be held devoutly apart from one another, and not permitted to fuse or coagulate into objectivity. It is at this point that objectivity and subjectivity part from one another.
>
> Ordinary communication, like objective thinking in general, has no secrets; only a doubly reflected subjective thinking has them. That is to say, the entire essential content of subjective thought is essentially secret, because it cannot be directly communicated. This is the meaning of the secrecy. The fact that the knowledge in question does not lend itself to direct utterance, because its essential feature consists of the appropriation, makes it a secret for everyone who is not in the same way doubly reflected within himself.[6]

The secret of the indirect communication, then, is that both communicator and receiver are free of each other: each is in the process of his own becoming and free to appropriate the subjective possibility or to reject it. While it is the case that the communicator "must be pictured as essentially thinking, so that in presenting his thought he sketches himself," it is also the case that the comunicator, in deceptive irony, has freed himself from the

communication because of his inwardness and its indirection. Thus, Kierkegaard could write in pseudonymous modes and claim that the pseudonymous authors existed in their own right (although he problematically and ironically claimed the opposite in his *Point of View*):

> If . . . anybody who is unacquainted with the educative effect of companionship with an ideality which imposes distance, has perverted for himself the impression of the pseudonymous books by an ill-conceived intrusion upon my factual personality, if he has made a fool of himself, *really* made a fool of himself by having to drag the weight of my personal reality instead of having the doubly reflected, light ideality of a poetically actual author to dance with, if with paralogistic insolence he has deceived himself by senselessly extracting my private singularity out of the dialectic duplicity of the qualitative contrast—then this surely is not my fault, . . .[7]

The receiver of an indirect communication is also free from the communication, but in a relation other than the communicator's. Of course, in a sense, he is not free before the communication if he has been attentive toward it:

> Everyone who makes a communication, in so far as he becomes conscious of this fact, will therefore be careful to give his existential communication the form of a possibility, precisely in order that it may have a relationship to existence. A communication in the form of a possibility compels the recipient to face the problem of existing in it, so far as this is possible between man and man.[8]

But, in another sense, because the communication is in the form of a possibility and engenders ethical capability, the receiver is free with respect to it; that is, he has been delivered into his own subjectivity where the choice to appropriate the subjective possibility is solely his. Deceived into his own inwardness, he is by virtue of that inwardness free before the deception, the possibility, and the communicator.

Kierkegaard's notions of indirect communication, when isolated from the context of his thought, compose the outlines of a heuristic perspective from which it is possible to discover and highlight questions of communication engendered by the peculiar character of much of the dramatic work of Samuel Beckett.

Beckett's plays seem to me resistant to the kinds of critical approach customarily used in drama criticism. Those who naïvely find themselves confronting plays without character or plot, plays in which nothing happens in a nowhere inhabited by dissolving personae. That criticism which seeks "connections" between the author and his plays is frustrated by Beckett's essential silence about himself. Structural and archetypal analyses often offer elaborate maps and indexes of the recurrent personae, images, and motifs in Beckett's *oeuvre,* but fail, I think, to account for the remarkable theatricality, the sheer sense of *presence* and *tension,* of *being-there,* to which a Beckett audience will attest. Indeed, it is this sense of quickening and of participation vaguely but deeply felt that occurs in many a Beckett audience that suggests the possibility that we view the plays from the perspective offered by Kierkegaard's attempt to focus on the style of communication between men needed when the content is not such that it would entertain or inform us, but such that it would sketch our very existing, so that we might be drawn into inwardness and double reflection.

A transition from Kierkegaard to Beckett can be further justified by the curiosity one might have that Kierkegaard chose not to communicate in dramatic forms. It may be granted that the style and sense of Kierkegaard's work is agonistic and dramatic and that the total effort of his life possesses a dramatic rhythm (at least he saw it that way); but it is a curious fact that Kierkegaard chose not to emulate two of his philosophical creditors, Plato and Lessing, and attempt the indirect communication in the forms of Socratic dialogue or conventional theater. In the *Concluding Unscientific Postscript,* Kierkegaard suggests reasons for his reluctance to avail himself of these modes of communication:

> The subjective thinker has a form, a form for his communication with other men, and this form constitutes his style. . . . As he is not himself either poet or ethicist or dialectician, his form cannot be that of either directly. His form must first and last relate itself to existence, and in this connection he will have at his disposal the poetic, the ethical, the dialectical, and the religious. . . . But the subjective thinker does not have the poetic leisure to create in the medium of the imagination, nor does he have the time for aesthetically disinterested elabo-

ration. He is essentially an existing individual in the existential medium, and does not have at his disposal the imaginative medium which would permit him to create the illusion characteristic of all aesthetic production. . . . Secondary personalities, a scenic environment and the like, all of which help to maintain the self-sufficiency of the aesthetic production, constitute breadth. The subjective thinker has only a single scene, existence, and he has nothing to do with beautiful valleys and the like. His scene is not the fairyland of the imagination, where the poet's love evokes the perfect. . . . His scene is—inwardness in existing as a human being.[9]

Kierkegaard has in mind here, quite obviously, a certain kind of theater, that of bourgeois titillation, and a certain kind of imagination, that of Platonic fancy. Is it justifiable to suppose, nevertheless, that he would find the form of communication evidenced in Beckett somewhat congenial? Beckett's communications, I submit, present themselves as plays converging upon the intention, method, and effect traced by Kierkegaard in his theory of indirect communication.

The silence of Samuel Beckett does not allow speculation upon whatever authorial purposes have generated his works, what "meanings" any of them have for him (or, by fallacious extension, for us). We are, by virtue of that silence, free to confront the plays without undue asides from the playwright. Further, we are able to discern more clearly the "internal" intention these plays have as communications, as modes of speaking to men. I have suggested that the intention in an indirect communication is best seen in terms of the *effect* it has upon the receiver. While it may be argued as to whether Beckett intends to confront his audiences with an artistic configuration that evokes and sustains the inward and subjective response, it is not easy to argue that such a process of encountering is not the effect of the plays. It is clear that Beckett's intention is not to seduce the playgoer onto a path leading to a later direct communication of Christianity such as Kierkegaard had in mind; but it is evident that the plays affect the playgoer in such a manner that it can be said that he has been driven into a double reflection. After the effort of securing a tolerable apprehension of the play is accomplished, the playgoer has usually gone beyond (or even away from) the play and into his own inwardness through a subjective appropriation of the

play in terms of both the play (the occasion) and himself (the existing subject). The playgoer comes to see himself, or is seen by others, in and by virtue of his relation to the play. The responsive process is as varied as the subjectivities who enter it. Some playgoers, of course, are so overburdened with theatrical expectations of conventional kinds that they appropriate the play by refusing it and walking out. Some quite innocently relate themselves objectively to the play and never see it as a confrontation with themselves, a confrontation not in the sense that it reflects their image or the image of the "times," but in the sense that their *response* reflects who they are at the moment of response.

My observation leads me to propose two types of response to a play of Beckett's, the objective response (corresponding to the first reflection) and the subjective response (corresponding to the double reflection). The objective response is that response where the playgoer's subjectivity lies dormant. The objective response, when articulated, involves reflection simple or subtle upon the play's components, the performances, scenery, the notorious silences, and so forth, or upon such matters as the validity of the play's Weltanschauung, the virtuosity of its language, or its world-historical place in the advance of dramaturgy. This is the kind of response we resignedly expect from the professional critics. The subjective response, on the other hand, is that response that reveals the playgoer's *presence* before and *participation* in the life of the indirect communication which is the play. He has been fully there in and behind the play, recomposing it in the depths of subjectivity in relation to himself; he has participated in the play, not by way of forgetting himself in vicarious identification, but by virtue of the fact that he has been driven back upon himself and chosen himself under the challenges of the play. The aesthetic ambiguities of Beckett's plays (time and place are indeterminate, characterization is incomplete and evanescent, plot is undeveloped or absent) and the relative absence of a perspectival framework (philosophical, dramaturgical, or conventional) within the play combine to draw the playgoer into an interior and secret relationship with the play, such that his articulated responses to the play become, in indexes uncertain, responses to and revelations of his subjectivity

(as well as his objectivity, insofar as his placement of the play reveals the shared and objective structures with which he interprets the play and existence). The theater of Beckett moves through an indirect communication, therefore, in its effect: the playgoer responds in his subjective choice in the manner of revealing himself, if not to himself, at least to others. Playgoers walk out from a play that projects itself through a direct communication because they are dissatisfied with its realization of its own aesthetic intention or because they find its ethical intentions unpalatable. Playgoers walk out from a play presented in the mode of indirect communication, however, because they apprehend it directly (or try to do so) and are confused, or because they are not willing to relate themselves to the play through a double reflection, through the inwardness that is demanded of them. The secret, then, in coming to a Beckett play, is to prepare oneself for its special workings, its twofold strategy of divesting us of our publicly shared expectations and roles and compelling us toward our private and primitive selves.[10]

The content of Beckett's plays, the words and directions by which the play is called into life upon the stage in the shapes, gestures, and murmurings of tramps, clowns, bottled heads, mutes, and other avatars of solitude, conforms with the designing appropriate to an indirect communication. Beckett's stage configurations sustain the delicate tensions between the human and the subhuman, the strange and the familiar, the sublime and the ridiculous, the tragic and the comic, necessary to secure the incompleteness of the play as form, image, and action. The incompleteness is determinative for an indirect communication. On the one hand, it shatters the lines of expectation and thought which would reduce the play to simple statements of its essence or "meaning." On the other hand, the incompleteness demands of the playgoer that he become co-creator of the play, slowly drawn into infusing himself, as a subjectivity, through the play, filling its essential silences and naming its unnameables with his own secret voice, his own secret name. The playgoer is the end of the play: he completes it. His completion of the play consists of his appropriation of the play in terms of his subjectivity and in the mode of a double reflection: he exists as the completion of the play. But, most important, the play

exists now as the mirror in which he introduces himself to himself in the process of becoming and choosing himself.

The method of indirect communication, which aims at the communicator's task of driving the receiver into the presence of subjective possibility, finds a parallel in the techniques of Beckett, who through his plays has, in effect, provoked the playgoer again and again into a subjective relationship with respect to his involvement in the situation of the play. The first rule of indirect communication, that the communicator seek out the "place" where the receiver is, is accomplished abstrusely by Beckett. Presumably, if Beckett's plays were constructed along lines of development that proceeded from the obvious and expected to the mysterious and difficult, then it could be said that the playgoer was met in his "place" and seduced thereafter into a subjective response that reveals him in the act of subjective and existential appropriation. Beckett, however, makes few concessions to us, except in his use of the comic, which has as its precondition a commonly shared ground of understanding about disproportion and contradiction, and thus speaks to the playgoer in his cultural objectivity. But if Beckett utilizes the comic as a common ground of audience involvement, he turns the comic to the purposes of the indirect communication. First, the comic attenuates our tendency to identify with the characters on stage, to forget ourselves in them. As Beckett's characters dissolve and stumble and go on, we are drawn not so much to them as to their situation of waiting and reminiscence, the existence of suffering consciousness, the necessity of speaking. Furthermore, the comic in Beckett's plays, evoking waves of collective laughter, returns to us, within ourselves as we sense the essential pathos of existing, and from the stage as the characters turn to the audience, espying and reporting an enormous bog, a vast waste, or "Zero." Our laughter proves immature until Beckett helps us complete it and ourselves with the pain of the pathetic.

The characteristic techniques and effects of Beckett's plays enhance the workings of an indirect method. The obscurity, elusiveness, irony and sadness, masks and roles, chatter and nonsense, remnants of poetry and philosophy of Beckett's poly-significative

rituals are oriented toward both the expression of the situation-configuration (the playwright's vision and statement) and the involvement of the playgoer in *his* expression of the existential situation (the inwardness he brings to the play). If there are techniques common to indirect communication, there is no rule of method for structuring and plotting the movement of those techniques in the mounting up of the total communication. Kierkegaard, for example, attempted to accomplish his communication by a strategy of gradual seduction in which the reader was led to believe, at first, that a direct expression (e.g., an aesthetic production) was before him, and was gradually led to an awareness that truth is subjectivity—all this to the end of making the direct communciation of Christianity: that subjectivity is the untruth. The pseudonyms, the irony, the fundamental deception of Kierkegaard are always in the background, hovering like avenging angels over those who would appropriate the pseudonymous works directly. Beckett, on the other hand, immerses the playgoer in the midst of masks, of half-lighted consciousnesses struggling to be, set upon a nowhere-everywhere stage and condemned to make their way through an endless confusion. Beckett seduces us by almost immediately setting a mood of monotony and mystery that forces us to struggle within it, hopefully to emerge in subjective response that transcends the play as we become immanent in subjectivity. All techniques of the indirect method coalesce in the focus of this intention to make subjects from spectators.

The argument can be advanced that Samuel Beckett adheres more strictly to the decisive character of indirect communication than does Søren Kierkegaard. Kierkegaard avoided or ignored his dictum to allow the independence of the receiver in relation to the communicator in two ways: first, his work was oriented toward seducing the reader in such a manner that he was ineluctably directed to a confrontation with the untruth of subjectivity in the condition of despair; second, his pseudonymous work was a preparation of the reader for the reception of a direct communication of Christianity in the form of *Edifying Discourses*. The theater of Beckett, on the other hand, strictly preserves the independence of the playgoer because it does not have a secret program other than

that implicit in its effect of disturbing the objective illusions of the playgoer and seducing him into an encounter with his own subjectivity. Beckett provides no solutions, but his theater is one of the better occasions one has for an entrance into one's singleness and subjectivity. The story of the person who attends a Beckett play is often the story of one seduced and abandoned to himself. The essence of Beckett's theater lies in the convolutions of that process by which it draws us into ourselves as it draws us into the "existence-possibility" on stage, and by which it leaves us in a deep self-reflection after the curtain descends. Kierkegaard's motto to *Stages on Life's Way* captures this magical effect and its importance: "Such works are mirrors: when a monkey peers into them, no Apostle can be seen looking out." What, then, is being communicated indirectly in the forms of the indirect communication? Ultimately, it is ourselves.

COMMUNICATION OF
THE CUCKOO'S NEST

James Waddell

Theologians have often utilized novels to serve them in their attempts to communicate the gospel. They seem particularly attracted to novels where a Christ-figure is located. Often the criteria for a Christ-figure are the biographical notes of Jesus' historical life. At other times the criteria are the events of Jesus' life, such as rejection and suffering, which are claimed to be discoverable in the life of every heroic figure who is involved in saving his fellowman. When these criteria are met, the claim is sometimes made that the Christ story is being reproduced.

The danger of this type of critical activity is that there is often a usurping of either the unique identity and work of Jesus or the individuality and freedom of the character. There is a failure to see that "If a man is what he *does* and not merely a bundle of qualities, if identity is what one enacts over a lifetime and not simply a composite of love and roguishness (or any other set of contrasts), then the man Jesus is a unique, inimitable self and so is every other man or literary character."[1] Hans W. Frei develops the same telling critique of literary Christ-figures in the following way:

> The point is to be made . . . that if one identifies the savior figure with a fully human being, the story cannot be retold by substituting somebody else as the hero of it who is then made to be fully identical with that original person. No matter *who* the savior may be, if he is *a* person, once the identification is made he is *that* person and no one else. This must be especially true for that type of fiction which owes so much to the gospel stories in the first place, the novel and short story, for which a personal figure is unique, particular and unsubstitutable within his equally unique and unsubstitutable circumstances. If such

fiction is to remind us of Jesus and tell us his story over again, it must remind us by some other unique, particular person's or people's identity and story.[2]

It is, then, through the story of a concrete person, not through a reproduction of a stylized pattern, that we are more likely to learn something of Jesus in literature. The learning may occur by observing unique literary characters acting "in the mind of Christ"—e.g., on the basis of love of God and neighbor. But it also may through witnessing a particular character's manner of communicating his love for all men which enables them to be confronted by their own individual worth.

In the Gospels Jesus does not primarily present his good news in the style of direct communication, where the intention of the communicator is to transfer content to the receiver wtih sufficient clarity to avoid misunderstanding and to protect against error. Jesus instead uses mainly an indirect style where the basic intention seems to be the nurturing of the receiver's freedom and choice. In E. J. Tinsley's words:

> The method of Jesus was cryptic (*en krupto* in John), indirect, and allusive. His parabolic and ironic method was central to his purposes because, to use Blake's phrase, it "roused the faculties to act." This "indirect" method of Jesus did not impose on others, but submitted itself to their free judgment.[3]

The purpose of this essay is to try to get a deepening understanding of the nature of Jesus' indirect communication by observing a broken reflection of it in the unique life of Randle Patrick McMurphy, the protagonist of Ken Kesey's *One Flew Over the Cuckoo's Nest*. In his concrete literary life, McMurphy does live among the "sick," take his friends out to sea to teach them, overcome temptation, enjoy a "last supper," face betrayal, have his head "anointed," wear a "crown of thorns," lie on a cross, and die. But it is not these events which provide the imperfect mirror by which we can learn something of Jesus. The mirror is found in the total style of McMurphy's communication, by which he attempts to get each man to confront himself. The focus, therefore, will be on McMurphy's style of communication and not on the novel's "themes," "symbols," or "meaning." My supposition is that the focus can best be achieved through a selective and detailed re-creation of McMurphy's story. My critical method will

be, first, to guide the reader in my own and Kesey's words through the story of McMurphy's communication and, second, to comment on its reflection of Jesus' communication.

The setting of *One Flew Over the Cuckoo's Nest* is a mental institution. The narrator is a Chronic patient called Chief Bromden. He is a man who has been treated so long as a thing that cannot hear or speak that he now pretends to be deaf and dumb. He has been silent so long that he warns the reader that the story about the hospital, the Big Nurse, the patients, and McMurphy is going to roar out of him like floodwaters, and the reader will think "the guy telling this is ranting and raving my *God*; you think this is too horrible to have really happened, this is too awful to be the truth! But, please. . . . it's the truth even if it didn't happen."[4]

Part of the truth, thinks the Chief, is that American society is ruled by the "Combine," a huge organization that aims to turn everyone into the same thing. On a fishing trip, the first time the Chief had been out of the hospital in twenty years, he could see signs of what the Combine had accomplished—things like

> . . . a *train* stopping at a station and laying a string of full-grown men in mirrored suits and machined hats, laying them like a hatch of identical insects, half-life things coming pht-pht-pht out of the last car, then hooting its electric whistle and moving on down the spoiled land to deposit another hatch.
>
> Or things like five thousand houses punched out identical by a machine and strung across the hills outside of town, so fresh from the factory they're still linked together like sausages, a sign saying "NEST IN THE WEST HOMES—NO DWN. PAYMENT FOR VETS," a playground down the hill from the houses, behind a checker-wire fence and another sign that read "ST. LUKE'S SCHOOL FOR BOYS"— there were five thousand kids . . . playing crack-the-whip across an acre of crushed gravel. The line popped and twisted and jerked like a snake, and every crack popped a little kid off the end, sent him rolling up against the fence like a tumbleweed. Every crack. And it was always the same little kid, over and over.
>
> All that five thousand kids lived in those five thousand houses, owned by those guys that got off the train. The houses looked so much alike that, time and time again, the kids went home by mistake to different houses and different families. Nobody ever noticed. They ate and went to bed. The only one they noticed was the little kid at the end of the whip. He'd always be so scuffed and bruised that he'd show up out of place wherever he went. He wasn't able to open up and laugh either. [pp. 227–228]

Bromden understands that the Big Nurse's ward in the hospital is a factory for the Combine. She is not alone in helping the patients to "adjust"; it is the nationwide Combine that is the main force. As a high-ranking official for the Combine, she runs a ward in a hospital that is

> . . . for fixing up mistakes made in the neighborhood and in the schools and in the churches. . . . When a completed product goes back out into society, all fixed up good as new, *better* than new sometimes, it brings joy to the Big Nurse's heart; something that came in all twisted different is now a functioning, adjusted component, a credit to the whole outfit and a marvel to behold. Watch him sliding across the land with a welded grin, fitting into some nice little neighborhood where they're just now digging trenches along the street to lay pipes for city water. He's happy with it. He's adjusted to surroundings finally. . . . [p. 38]

The ward, then, is peopled with patients who have not conformed to the Combine's ways. Yet most of the inmates, particularly those among the Acutes, have not been forced to enter the hospital. They have voluntarily committed themselves; they *want* to adjust to the system. In other words, their problem is not that they do not want to conform; it is that they *cannot* conform. Thus they feel safer withdrawing into the hospital to be reshaped. Some patients such as Chief even find it necessary to withdraw further in the hospital into individual, impenetrable fogs.

Into the factory comes Randle Patrick McMurphy, whose distinguishing characteristic is that he refuses to be treated as a thing and believes that everyone has an intrinsic worth which is different from a Combine use-value. From the moment of his Admission we are made aware of his concern for his own and others' personal worth. In his comments to Aide Williams, who tries to measure him with a thermometer, and in his hints to Miss Ratched, the Big Nurse, who intentionally mispronounces his name, McMurphy shows that *he* will not be treated as a thing. And his first actions in the dayroom demonstrate that he is aware of the worth of every person—whether the person is an Acute or a Chronic, a Walker, a Wheeler, or a Vegetable. This advent scene of McMurphy among the "sick" is one of the most representative parts of the book: it sets the tone of the novel and provides a

preview of coming events and demonstrates his style of com-
munication.

The tone is a combination of deadly seriousness and humor.
The background theme of pain and suffering never fades, but
neither the patients nor the reader can resist McMurphy's winks,
nudges in the ribs, and jokes. He brings laughter to the throats of
men who have forgotten how to laugh. The Chief's first laugh,
later in the book, is described as "a squawking sound, like a pullet
trying to crow. It sounded more like crying than laughing." [p.
206] But it is a start.

The scene also previews McMurphy's respect for all men and
his manner of revealing it. After he shakes hands with every Acute,
he comes over to the Chronics as if they were no different. The
Chief watches McMurphy:

> He's there pulling Ellis's hand off the wall and shaking it just
> like he was a politician running for something and Ellis's vote was
> good as anybody's. "Buddy," he says to Ellis in a solemn voice, "my
> name is R. P. McMurphy and I don't like to see a full-grown man
> sloshin' around in his own water. Whyn't you go get dried up?" [p. 21]

Ellis looks at the puddle in pure surprise, thanks McMurphy,
and even moves a few steps toward the latrine before the nails
pull his hands back to the wall. McMurphy then comes down the
line of Chronics:

> He shakes the hands of Wheelers and Walkers and Vegetables, shakes
> hands that he has to pick up out of laps like picking up dead birds,
> mechanical birds, wonders of tiny bones and wires that have run down
> and fallen. Shakes hands with everybody he comes to except Big
> George the water freak, who grins and shies back from that unsanitary
> hand, . . . [p. 21]

McMurphy just salutes him and says to his own right hand, the
hand which would later protect George, "Hand, how do you
suppose that old fellow knew all the evil you been into?" [p. 21]

In this ritual of handshaking we foresee the character of
McMurphy's relationship with everyone: He will support the pro-
tests of Cheswick, who usually stands alone; play Monopoly with
Martini, who keeps seeing "things" all over the board; and watch
the "growth" of the six-foot-seven-inch Chief, who thought he was

small and weak. In all these actions he acknowledges each man's personal worth in the midst of his illness and thereby helps each one to recognize his own worth.

With his awareness of everyone's personal importance, Mc-Murphy is at first puzzled by the character of the Therapeutic Community. Dr. Spivey, intimidated by the Big Nurse, is permitted to explain the theory of the Therapeutic Community to each new Admission. Taking advantage of one of the few times she allows him to run the group meeting, he says that ". . . the goal of the Therapeutic Community is a democratic ward, run completely by the patients and their votes, working toward making worth-while citizens to turn back Outside onto the street," [p. 47] Any grievance should be brought up before this group. One should also feel at ease in the surroundings to the extent he can discuss emotional problems in front of patients and staff. The doctor calls for the patients to talk, discuss, confess. If a friend says something in a common conversation, record it in the logbook for the staff to see. "Bring these old sins into the open where they can be washed by the sight of all." [p. 47] Participate in the Discussion; help yourself and your friends by exploring the secrets of the subconscious.

After his first Group Meeting, where Harding's relation with his wife is explored, McMurphy describes the true nature of the Therapeutic Community. He compares it to a "peckin' party":

> "The flock gets sight of a spot of blood on some chicken and they all go to *peckin'* at it, see, till they rip the chicken to shreds, blood and bones and feathers. But usually a couple of the *flock* gets spotted in the fracas, then it's their turn. And a few more gets spots and gets pecked to death, and more and more. Oh, a peckin' party can wipe out the whole flock in a matter of a few hours, buddy, I seen it. A mighty awesome sight." [p. 55]

And he makes it clear that the pecking, led by the Big Nurse, is not aimed at the eyes. It is aimed at the most vulnerable part of a man, be what it may—his sexual potency, his relation with his mother, his fear of becoming a Chronic. McMurphy is aware of the people who would take away a man's dignity and make a thing of him. He has seen thousands of them. They are both men and women of all ages all over the country. They try to make you

weak in order to make you live like they want. And their technique is to weaken you by getting you where it hurts the worst—to peck, peck, peck.

The pecking has been so effective on the patients that they view themselves as rabbits. Harding says,

> "Mr. McMurphy . . . my friend . . . I'm not a chicken, I'm a rabbit.
> . . . All of us in here are rabbits of varying ages and degrees . . .
> Oh, don't misunderstand me, we're not in here *because* we are rabbits—
> we'd be rabbits wherever we were—we're all in here because we can't
> *adjust* to our rabbithood. We *need* a good strong wolf like the nurse
> to teach us our place." [p. 62]

McMurphy shows the men they are not rabbits. His method is not to lecture them, but to involve them in his gambling style of life. After learning the Big Nurse could send him to the Disturbed Ward for Electric Shocks only if he lost his temper, he bets the men he can get the best of her in one week without her getting the best of him. Harding and some of the others don't understand his offer. "It's simple enough," McMurphy says. "There ain't nothing noble or complicated about it. I like to gamble. And I like to win. And I think I can win this gamble, okay?" [p. 71] He says he came to the hospital because he heard there was money to be won. And he confesses he is in the hospital because he planned it—it promised an easier life than the work farm in which he was imprisoned. The bet is made then that he can place "A bee in her butt, a burr in her bloomers. Get her goat. Bug her till she comes apart at those neat little seams, and shows, just one time, she ain't so unbeatable as you think." [p. 72]

The Big Nurse is greeted the next morning with a song and McMurphy in a pair of shorts of coal black satin covered with big white whales with red eyes. Through butter-racing contests, establishment of a game room, and entertaining group meetings, he slowly involves the men in recognizing their personal worth to the point where each Acute and Chief Bromden take the responsibility of disagreeing with Miss Ratched. McMurphy introduces a motion into the "democratic" Group Meeting to alter the cleaning and television hours so the men can watch the World Series. The Ward policy is that any alteration must be approved by a majority.

On the second ballot all twenty Acutes vote to change the schedule, but the Big Nurse announces that the motion fails and the subject is closed because none of the twenty Chronic patients voted for a change. Incensed by this tactic, McMurphy goes over to the Walkers, Wheelers, and Vegetables and tries to reach one of them through their damaged brains and/or psyches. He finally stands before the Chief, who raises his hand even though he knows he gambles revealing that he can hear and speak. " 'Twenty-one!' " yells McMurphy. " 'The Chief's vote makes it twenty-one! And by God if that ain't a majority I'll eat my hat!' " " 'The meeting was closed,' she says. Her smile is still there, but the back of her neck as she walks out of the day room and into the Nurses' Station, is red and swelling like she'll blow apart any second." [p. 136]

When the time for the World Series comes, McMurphy stops his cleaning, turns on the television, and sits down to watch the baseball game. The Big Nurse goes to the control panel and turns off the power source for the television. McMurphy does not reveal that he knows the picture is turned off. As he ignores the warning of Miss Ratched at the end of Part 1 of the novel, the men, without his saying anything to them, leave their scheduled duties and sit down with McMurphy. "If somebody'd of come in and took a look, men watching a blank TV, a fifty-year old woman hollering and squealing at the back of their heads about discipline and order and recriminations, they'd of thought the whole bunch was crazy as loons." [p. 138] The burr had been successfully placed.

McMurphy commits the greatest offense against the Combine: he is a disturbing factor. At the time of his Admission he tells the men he is a dedicated man, and he adds:

". . . but you know how society persecutes a dedicated man. Ever since I found my callin' I done time in so many small-town jails I could write a brochure. They say I'm a habitual hassler. Like I fight some. Sheeut. They didn't mind so much when I was a dumb logger and got into a hassle; that's *excusable,* they say, . . . But if you're a gambler, if they know you to get up a back-room game now and then, all you have to do is spit slantwise and you're a goddamned criminal. Hooee, it was breaking up the budget drivin' me to and from the pokey for a while there." [p. 20]

In the staff meeting at the beginning of Part 2 the diagnosis of his problem by the resident doctors runs from "Con Man" to "Negative Oedipal." The Big Nurse, however, does not believe he is extraordinary. "He is simply a man and no more, and is subject to all the fears and all the cowardice and all the timidity that any other man is subject to." [p. 149] Give him a few days, she thinks, and he will reveal himself as a braggart and blowhard who will back down the moment there is any real danger to him personally. And then she adds, "We have weeks, or months, or even years if need be. Keep in mind that Mr. McMurphy is committed. The length of time he spends in this hospital is entirely up to us. . . ." [p. 150]

Meanwhile McMurphy goes on his disturbing way. He tries and tries on latrine duty but can't make his mark as "head man of the crappers." [p. 151] But he can leave unsettling messages in the urinals for the Big Nurse. And as he laughs and jokes, the Chief notices that the fog is disappearing, and he quits worrying about the Big Nurse and the Combine behind her. Then comes McMurphy's temptation not to gamble.

At the swimming pool he learns from the lifeguard that the Nurse controls his release from the hospital. "The next day he surprised everybody on the ward by getting up early and polishing that latrine till it sparkled, and then went to work on the hall floors when the black boys asked him to. Surprised everybody but the Big Nurse; she acted like it was nothing surprising at all." [p. 163] He also becomes quiet in Group Discussion and does not support Cheswick, who is dragged off to the Disturbed Ward.

The Chief knows that the Acutes understand: "I can tell by the way they look at McMurphy that morning when he comes in to the day room. Not looking like they're mad with him, or even disappointed, because they can understand as well as I can that the only way he's going to get the Big Nurse to lift his commitment is by acting like she wants, but still looking at him like they wished things didn't have to be this way." [p. 165] After coming back from Disturbed, Cheswick, on the way to the swimming pool, told McMurphy he understood. "But just as soon as we got to the pool he said he did wish *something* mighta been

done, though, and dove into the water." [p. 166] His fingers caught in a grate and he was drowned.

Then, during a quick series of events, McMurphy's face begins to take on a haggard, puzzled look of pressure: Sefelt has an epileptic seizure, Harding's wife comes to visit and McMurphy watches the couple tear each other apart, hallucinating Martini tells McMurphy that what he sees ". . . need you to see thum," [p. 176] and McMurphy sees the results of shock treatments. But what really brings the painful look to his face is the realization that most of the Acutes are voluntary, not committed inmates. Billy Bibbit tells him, "I could go outside to-today, if I had the guts. My m-m-mother is a good friend of M-Miss Ratched, and I could get an AMA signed this afternoon, if I had the guts!" [p. 184] McMurphy had thought the men were all committed and were trying to con him into focusing the wrath of Miss Ratched on himself, but now he realizes they have neither the courage to face the Combine nor the ability to adapt to its ways.

In the next Group Meeting, the Big Nurse announces that the punishment for the television rebellion will be to close the game room. McMurphy stands, stretches, scratches himself. "He was the logger again, the swaggering gambler, the big redheaded brawling Irishman, the cowboy out of the TV set walking down the middle of the street to meet a dare." [p. 189] Stopping before he got to the wide-eyed Nurse, he said that he could use one of his cigarettes that were kept in the Nurses' Station. Then he ran his hand through the glass. With the shattering of the glass, everyone is left at the close of Part 2 knowing that McMurphy has overcome the temptation to play it safe.

From the opening of Part 3, McMurphy intensifies his indirect efforts to communicate his message of intrinsic personal worth. Again, the men are not subjected to well-reasoned arguments, but are involved in activities which involve them in making decisions about themselves. A basketball team is organized to play a team of aides, and even in defeat the team comes away with a feeling of victory. Aide Washington, who leaves the game with a bloody nose given to him by McMurphy, hollers, "He beggin' for it! The sonabitch jus' *beggin'* for it!" [p. 195]

McMurphy goes on to compose more notes for the Nurse to find in the latrine, to write outlandish tales about himself in the logbook and sign them "Anon.," to sleep late, and to respond to the Nurse's reprimands with questions about her brassiere size.

Other Acutes begin to follow his lead. Harding flirts with the student nurses, Billy Bibbit stops writing in the logbook, Scanlon bounces the basketball through the window of the Nurses' Station, and . . . there is a fishing trip.

"Two whores on their way down from Portland to take us deep-sea fishing in a boat!" [p. 212] Ten of the men ignore the Nurse's newspaper clippings about drownings at sea to sign up with McMurphy to go on the trip. When Dr. Spivey sees the one girl, Candy Starr, who does arrive for the trip, he joins the group. It is on this fishing trip in the sea air, with cold beer and with the fighting fish, that the men learn to laugh and to start becoming strong. But it is clear that at this point in the novel McMurphy provides their strength. On their way to the sea the group stops at a filling station. The attendants at the station try to cheat and humiliate them, and Dr. Spivey is intimidated. McMurphy gets out of the car and tells the attendants "we're . . . hot off the criminal-insane ward, on our way to San Quentin where they got better facilities to handle us!" [p. 224] A look at McMurphy's chewed-up hands and at the six-foot-seven-inch Chief were enough to reverse the attendant's behavior. McMurphy leaves the group to buy beer and "By the time he got back everybody was feeling cocky as fighting roosters and calling orders to the service-station guys to check the air in the spare and wipe the windows. . . ." [p. 226]

Yet McMurphy senses the men are not strong because they could not laugh. The Chief wonders whether McMurphy, in his working so hard to point out the funny side of things, is blind to the Combine's work which acted to parch laughter deep down in the stomach. At any rate, the men show at the pier that they are not strong without McMurphy. When McMurphy goes into the bait shack, loafers insult Candy, and her look asks the men why they were not saying something to defend her. "Nobody would answer the look. All our hard-boiled strength had just walked up

those steps with his arms around the shoulders of that bald-headed captain." [p. 230]

McMurphy returns to take the twelve out to sea, and there they learn to see the funny side of things. Four fish are hooked at about the same time, and everyone is falling over each other. Everyone including the doctor shouts at McMurphy to help. But he does not move; he just laughs. When Harding finally sees McMurphy is not going to do anything, he begins to help the Chief bring in a fish. The fish nearly escapes overboard, but Scanlon grabs it. In all the confusion McMurphy laughs:

> Rocking farther and farther backward against the cabin top, spreading his laugh out across the water—laughing at the girl, at the guys, at George, at me sucking my bleeding thumb, at the captain back at the pier and the bicycle rider and the service-station guys and the five thousand houses and the Big Nurse and all of it. Because he knows you have to laugh at the things that hurt you just to keep yourself in balance, just to keep the world from running you plumb crazy. He knows there's a painful side; he knows my thumb smarts and his girl friend has a bruised breast and the doctor is losing his glasses, but he won't let the pain blot out the humor no more'n he'll let the humor blot out the pain. [pp. 237–238]

There will be pain and suffering in life. They will never be completely blotted out. But there is also a funny side to events, and if one can laugh, he may see beyond suffering. And the men do laugh. "And Sefelt and the doctor, and all." [p. 238] They laugh at themselves as well as at each other, and the laughter ". . . rang out on the water in ever-widening circles, farther and farther, until it crashed up on beaches all over the coast, on beaches all over all coasts, in wave after wave after wave." [p. 238]

But the laughter is not enough to sustain the men in the battle with the Combine. McMurphy has to act in a manner which both reveals and empowers. He needs to reveal that one can best attack the Combine by sacrificing his own needs, without violating his own personal worth, to meet the needs of others. Moreover, he has to make this revelation in such a way that the men are empowered to imitate him in living such a life.

He does not undertake the act with a vigorous enthusiasm but with a tired, strained, frantic resignation. The Chief had noticed

McMurphy's exhaustion on the trip back to the hospital. Mc-Murphy had insisted they drive past the place he once lived. He told of the wind catching the dress of his first love and hanging it in a tree for all to see.

> "So my colors were flown, and from that day to this it seemed I might as well live up to my name—dedicated lover—and it's the God's truth: that little nine-year-old kid out of my youth's the one who's to blame . . . Taught me to love, bless her sweet ass."
>
> Then—as he was talking—a set of tail-lights going past lit up McMurphy's face, and the windshield reflected an expression that was allowed only because he figured it'd be too dark for anybody in the car to see, dreadfully tired and strained and *frantic*, like there wasn't enough time left for something he had to do. . . . [p. 245]

From the moment of his Admission he said he was dedicated and "you know how society persecutes a dedicated man." As he travels to fulfill his dedication, the Nurse waits to receive him in the Ward.

In Part 4 the Big Nurse plants the seed in the patients' minds that McMurphy is using them as things for his own ends. Billy Bibbit, who sees McMurphy as his special friend and hero, attempts to defend him. She asks Billy whether McMurphy was one to run a risk without a reason.

> Nobody said anything.
>
> "And yet," she went on, "he seems to do things without thinking of himself at all, as if he were a martyr or a saint. Would anyone venture that Mr. McMurphy was a saint?"
>
> She knew she was safe to smile around the room, waiting for an answer. [p. 252]

At first the Chief did not agree that McMurphy was exploiting the men. "I still had my own notions—how McMurphy was a giant come out of the sky to save us from the Combine, . . . how he was too big to be bothered with something as measly as money. . . ." [p. 255] But he changed his mind when McMurphy bet the men that the Chief could lift the control panel. At an earlier time, when the Chief began to talk to McMurphy, Mc-Murphy promised to make him strong through a special body-building course. Now McMurphy notices, "By God, Chief, . . . it appears to me you growed ten inches since that fishing trip."

[p. 255] He asks the Chief to try to lift the hydrotherapy control panel, which weighs more than four hundred pounds, to see how his growth system is working. The Chief had received no direct instructions on body-building, but he recognized that he had "grown." "I looked down and saw how my foot was bigger than I'd ever remembered it, like McMurphy's just saying it had blowed it twice its size." [p. 255] He still does not believe he can lift the panel, which McMurphy himself had earlier failed to raise off the floor. But he tries, and he does pick it up. The Chief thought McMurphy was going to tell the men how he helped the Chief get back his strength and thus prove that he did not do everything for money. McMurphy instead arranged a bet that the Chief could lift the panel. After the Chief lifts the panel and the men pay their bets, McMurphy asks the Chief why everyone is being cold toward him. "Didn't I do what I said I would? Make you man-sized again? What's wrong with me around here all of a sudden?" [p. 257] The Chief tells him he is always winning things. McMurphy responds, "Winning things! . . . All I do is hold up my end of the deal. Now what's so all-fired—" [p. 257] The Chief answers, with chin jerking, that the men thought his goal was not to be winning things. "Winning, for Christsakes," says McMurphy with his eyes closed. "Hoo boy, winning." [p. 258]

After seeing McMurphy's despairing response, the Chief felt he was more responsible than anyone else for the event that afternoon in the shower room. "And that's why the only way I could make any kind of amends was by doing what I did, without thinking about being cagey or safe or what would happen to me— and not worrying about anything else for once but the thing that needed to be done and the doing of it." [p. 258] The Chief's unselfish act was to help McMurphy protect George from being handled by the aides. The Nurse had decided that the men who went on the fishing trip, given the female company they had had, needed a special shower with a stinking thick white salve. Until now George, who could not tolerate being touched, had not been forced to use either soap or towel in the showers. But everyone knew the aide with the broken nose from the basketball game could not pass up the chance to provoke McMurphy. It was

". . . right at that time all of us had a good idea about everything that was going to happen, and why it had to happen, and why we'd all been wrong about McMurphy." [p. 259] When Washington tells George about the bugs crawling all over him, threatens to put his hand all over him, and then squirts the salve on him, McMurphy, sounding more tired than mad, tells Washington to stop. The aide, telling McMurphy he was beginning to think they might not get down to it, continues to persecute George. Then the naked McMurphy says, "Washington, all right, all right . . ." [p. 261] Everyone heard the helpless, cornered despair in his voice. He shoves Washington away from George, and he and the aide fight in the circle of nude men. When two other aides come to help Washington, the Chief joins McMurphy in the battle. By the time an aide

> came running back in with straps and cuffs and blankets and four more aides from Disturbed, everybody was getting dressed and shaking my hand and McMurphy's hand and saying they had it coming and what a ripsnorter of a fight it had been, what a tremendous big victory. They kept talking like that, to cheer us up and make us feel better, about what a fight, what a victory—as the Big Nurse helped the aides from Disturbed adjust those soft leather cuffs to fit our arms. [p. 263]

McMurphy introduces himself on the Disturbed Ward as he had done on the Nurse's Ward. Exhausted and suffering from wounds received in the fight, he nevertheless stands straight and tall. The Big Nurse hints that he should admit he was wrong so that there would be no shock treatments. McMurphy refuses, and he and the Chief are taken to the Shock Room. When the Chief begins to holler, McMurphy tells him to take it easy; he will go first. The Chief sees he does not look frightened; he is grinning.

> They put the graphite salve on his temples. "What is it?" he says. "Conductant," the technician says. "Anointest my head with conductant. Do I get a crown of thorns?"
> They smear it on. He's singing to them, makes their hands shake. . . .
> Put on those things like headphones, crown of silver thorns over the graphite at his temples. They try to hush his singing with a piece of rubber hose for him to bite on. . . .
> Twist some dials, and the machine trembles, two robot arms pick up soldering irons and hunch down on him. He gives me the wink and speaks to me, muffled, tells me something, says something to me

around that rubber hose just as those irons get close enough to the silver on his temples—light arc across . . . and he's frosted over completely with sparks. [p. 270]

They roll him out, and the technician turns to the Chief. He is strapped to the cross-shaped table, and he tries to think what McMurphy was saying from the table. The machine hunches down on him. The Chief then works for the first time to come out of the effects of the treatment: "They got to me with the machine again . . . I wonder . . . What did he say? . . . wonder how McMurphy made me big again. He said Guts ball." [pp. 274–275] He knows from this point he will never again slip back into a fog. He knows he has the Combine beaten.

During additional shock treatments, McMurphy continues to play "Guts ball," and the Nurse decides to bring him back to her Ward to keep his legend from growing. She thinks he could not continue in his hero role if he were sitting around the dayroom all the time in a shock stupor. The men anticipate her plan and decide his escape from the Ward would be the best for everyone concerned. By the time McMurphy returns Saturday "—footworking into the day room like a boxer into a ring, clasping his hands over his head and announcing the champ was back—" [p. 278] the men have their plan worked out. When he hears the plan, McMurphy says there is no hurry and reminds them of Billy's date. Candy is coming tonight to be sneaked onto the Ward.

Candy arrives late at night with her friend Sandy and a last party of McMurphy with his friends takes place. The atmosphere of this night may be suggested by citing Harding's prayer over Sefelt and Sandy. Sprinkling pills over the awed lovers like clods in a grave, Harding raises his eyes to the ceiling and says, "Most merciful God, accept these two poor sinners into your arms. And keep the doors ajar for the coming of the rest of us, because you are witnessing the end, the absolute, irrevocable, fantastic end." [p. 291] But it is not the end, as Harding goes on to say, to be filled with drugs by Miss Ratched. It is an end to their *thingness*. It is the end of an old life as a rabbit and the beginning of a new life as a man.

In response to McMurphy's question of why they do not escape with him, Harding answers, "I'm not quite ready yet, Mack, . . . I'll be ready in a few weeks. But I want to do it on my own, by myself, right out that front door, with all the traditional red tape and complications. I want my wife to be here in a car at a certain time to pick me up. I want them to know I was *able* to do it that way." [p. 293]

McMurphy does not escape. When morning comes he and Sandy are found together in his bed like two sleepy kids. "It was like he'd signed on for the whole game and there wasn't any way of him breaking his contract." [p. 296]

Word of the party spreads like wildfire: " 'Now what kind of crock are you giving us?' 'No crock. It's every word gospel. I was in on it.' " [p. 297]

Then there is a betrayal. Billy Bibbit is discovered in the Seclusion Room with Candy. And under the pecking of the Big Nurse he is unable to hold on the gain of personal worth and responsibility. "She [Candy] d-did! . . . And M-M-McMurphy! . . . They t-t-teased me, *called* me things!" [p. 302] With these remarks he goes to an office and cuts his throat.

The Nurse confronts McMurphy. "First Charles Cheswick and now William Bibbit! I hope you're finally satisfied. Playing with human lives—gambling with human lives—as if you thought yourself to be a *God*!" [p. 304]

He is brought to his final act. The Chief knows "We couldn't stop him because we were the ones making him do it. It wasn't the nurse that was forcing him, it was our need. . . ." [p. 304] Their need, which kept him going on in his act weeks after his humor had been parched dry between two electrodes, made him smash open the glass door of the Nursing Station, rip open the Big Nurse's uniform, and choke her. Doctors, supervisors, and nurses finally pried him off before he could kill her. He then gave a cry of dereliction: "A sound of cornered-animal fear and hate and surrender and defiance, that if you ever trailed coon or cougar or lynx is like that last sound the treed and shot and falling animal makes as the dogs get him, when he finally doesn't care any more about anything but himself and his dying." [p. 305]

The Chief hung around the Ward for another couple of weeks to see what was to come. McMurphy had been taken away, yet five Acutes signed out and six transferred to another ward. Dr. Spivey, informed that his resignation would be accepted, answered that they would have to fire him to get rid of him. The voiceless Big Nurse tried to get her ward back into shape, but it was difficult with McMurphy's presence haunting the halls, meetings, and latrines.

When an empty form with the tag "MC MURPHY, RANDLE P. POST-OPERATIVE. LOBOTOMY" is returned on a cart to the Ward, the remaining men say it is not Mack. The Chief then does what he has to do, what perhaps McMurphy would have done: he smothers the air out of the thing that has McMurphy's name. He will not allow the Big Nurse to use it as an example of what can happen to you if you disturb the system. After he is finished he takes McMurphy's cap and tries it on. It is too small, and he is ashamed of trying to wear it. Scanlon tells him to "Take it easy . . . it's okay." [p. 309] The Chief then escapes from the Ward the way McMurphy showed him. He lifts the control panel, throws it through the screened window, and steps out into the moon which was "like a bright cold water baptizing the sleeping earth." [p. 310] And he runs. He might go to Canada, but he thought he might stop along the Columbia River on the way. He had been away a long time.

In commenting on the oblique reflection of Jesus' communication in McMurphy's communication, I will use the following four categories of Kierkegaardian indirect communication: the intention, the content, the method, and the relation of communicator and receiver of an indirect communication.[5]

The basic *intention* of McMurphy's indirect communicaton in the whole novel seems to be to place the receiver in a position where a demand is made to either accept or reject his personal worth. The Chief, Cheswick, Harding, Sefelt, George, Scanlon, and Dr. Spivey are among those who react positively to the demand, and the Big Nurse and Billy Bibbit, finally, are among those who

respond negatively. But the point is that each is faced with the necessity of deciding whether to continue to serve the Combine. The Chief, for example, in the World Series vote, the fishing trip, the fight with the aides, and the killing, is confronted with the choice between, on the one hand, maintaining the fiction of his deafness and muteness and inability to act and, on the other hand, revealing that he can be a personal agent who listens, speaks, and acts. He finds himself placed by McMurphy in a similar position to the one in which the disciples were placed by Jesus. A decision is called for in both cases: the individual has to decide whether to follow the ways of the world (the Combine) or to do what needs to be done to meet the needs of others "without thinking about being cagey or safe or what would happen to me." This is not to deny that either Jesus or McMurphy had other intentions. McMurphy certainly uses the indirect method to bring the inmates to the point where he can ask them directly why they did not try to escape with him. Yet his last act of attacking the Big Nurse provides evidence that his basic intention is to provoke others to decide whether or not to choose a life which rejects thingness. This intention reaches beyond the numbing consequences of a lobotomy to confront the Chief with the question of what to do about the thing with McMurphy's name on it which the Big Nurse was going to use as an example of what can happen to you if you challenge the Combine. In the concrete context of the novel, the Chief's act of smothering the thing can be seen as a subjective ethical response to the intention of McMurphy's communication.

In the Chief's act of killing lies his choice to act in a manner which he thinks is appropriate to his acknowledged dignity. Here is the disclosure that the truth of the indirect communication is subjective. McMurphy basically offers no *content* which can be objectively verified any more than Jesus does. Both deliver their receivers into themselves as acting, worthy individuals. When the receivers try to interpret Jesus' and McMurphy's communications in a direct manner, they are frustrated: Is Jesus the "Son of man"? Is McMurphy on the make? What *is* the content of their messages? Their verbal styles lend to the confusion. Jesus is ironic and cryptic; McMurphy jokes and talks about chickens. When their

receivers move from exasperation to "understanding" subjectively what they are being confronted with, they have moved beyond ostensible content and beyond the communicators to themselves. They have moved to the point where they subjectively know that the content of Jesus' and McMurphy's communications has been the receivers themselves. They have been delivered into themselves, and the delivery may shatter the delusions they have about themselves. This was one of Peter's discoveries when the cock crowed, as it was Billy Bibbit's discovery when the Nurse pecked him.

The *method* of indirect communication used by Jesus and McMurphy to achieve their goals first involves locating the needs of their receivers. From the start Jesus had more success than McMurphy in recognizing the needs of his receivers and serving them. McMurphy had difficulty in identifying the critical needs of the inmates. He first thought all of them were forcibly committed to the hopsital; he then seemed to think that if the men could laugh, they would be able to face themselves; he finally realized that their rabbithood was so entrenched that it could be altered only through a radical act of suffering. He then suffered for the inmates through shock treatments and a disempowering lobotomy which rendered his physical death secondary.

His method of indirect communication thus involves more than words. It involves confronting the inmates with an existential model of a man's choosing to meet the needs of others in spite of consequences. In a style which reminds us of Jesus, he confronts his receivers with words and a total life pattern which demand a decision. Neither Jesus nor McMurphy embraces this pattern of life enthusiastically or without temptation, and both utter a cry of dereliction at the end. But what the Chief said about McMurphy could also have been said of Jesus: "It was like he'd signed on for the whole game and there wasn't any way of him breaking contract."

In the course of the whole game they open up a possible avenue of action for their receivers. The communicators have been more than a model; they have also been an empowering model. In their *relationship* to their receivers, Jesus and McMurphy enable them to do something they could not do alone; yet they are not

overpowered or engulfed. They have been presented with the need to render a subjective decision about the character of their lives, but they are free to respond positively or negatively. Harding's positive response reveals the freedom inherent in his choice: "I'm not quite ready yet, Mack. . . . I'll be ready in a few weeks. But I want to do it on my own, by myself, right out that front door, with all the traditional red tape and complications. I want my wife to be here in a car at a certain time to pick me up. I want them to know I was *able* to do it that way." He does not have to be a strict imitator of McMurphy any more than a receiver of Jesus' indirect communication needs to mimic him literally. He has been given the problem of how to live within the possibility McMurphy has presented to him, and the decision of how he responds and how he carries out the decision is solely his. In a similar manner Jesus' receivers need to appropriate his "sign"/ "skandalon"[6] communication. Should they respond positively, their individuality and freedom are enhanced to open up a refreshing life. Perhaps it would be like stepping out into a moon which was "like a bright cold water baptizing the earth."

THE RELATIONSHIP BETWEEN FORM AND CONTENT/ MEDIUM AND MESSAGE IN CHRISTIAN COMMUNICATION

F. W. Dillistone

A small group was discussing the question "In what sense is it meaningful to speak of 'Christian' morality?" One of the participants expressed what be believed to be a widespread difficulty by asking how such an intricate moral question as that posed by the existence and availability of the Pill could be dealt with in a specifically "Christian" way. Modern devices of this kind were entirely outside the range of knowledge of Jesus and his apostles. How could "Christian" guidance be given to those faced by the altogether new problems of the twentieth century?

Another member of the group responded immediately by drawing a distinction between formulated rules and essential principles. Of course the rules of behaviour must be patient of adjustment and change in the light of the emergence of new circumstances. But this need not affect essential principles. Was not the very essence of the "Christian" ethic the principle of *agape,* of love? Could not the way of love be followed even within the maze of behavioural problems that the twentieth century presents?

On the same day that this question had been discussed in the quiet seclusion of a conference centre, another group appeared in the full publicity of a television programme. They were sharing their reactions to a wide-ranging visual survey of the present state of the Christian church which had been transmitted on the opening day of the Fourth Assembly of the World Council of Churches in Uppsala. All agreed that the producer had presented an astonishingly varied series of pictures of cult practices in contemporary Christendom. Abyssinia and Belfast, Kerala and Seville, South

Africa and Bethlehem—here were forms of worship so dissimilar
as to appear at times almost contradictory to one another. What
possible common denominator could be found in the highly elabo-
rated forms of traditional "Catholic" churches—Roman, Eastern,
Coptic, Armenian—and the severely plain forms of many "Pro-
testant" communions—Reformed, Presbyterian, Baptist?

Yet every worshipping congregation would have tenaciously
maintained its right to the name *Christian*. Were the differences
then simply the reflection of varying cultural traits and changing
historical circumstances? Were all these *forms* authentic examples
of man's offering of worship to God through Christ? If so, what
still was the particular quality or essence or content—call it what
we will—that distinguished "Christian" worship from Jewish or
Hindu or Muslim worship? One of the group inclined to the
opinion that there was really nothing to distinguish certain of the
forms of "Catholic" worship which had been portrayed from their
pre-Christian pagan antecedents. Could then a ritual form be filled
with new content while remaining outwardly unchanged? Had the
new Christian wine simply been poured into ancient wineskins—
an operation which Jesus himself had said was bound to lead to
disruption and waste?

One more event of the day in question may perhaps be
recorded. It was a sound broadcast of a shortened version of the
inaugural lecture of the first holder of the Chair of Christian
Theology in a modern English university. How could a specifically
"Christian" interpretation of divine revelation (I offer "interpre-
tation of divine revelation" as a rough definition of the word
theology) be justified in a university concerned to pursue the truth
in whatever direction it might lead? The study of religions, their
history, and even their mythology, could well be regarded as
valid subjects for academic enquiry. Even the study of the de-
velopment in history of the Christian church in its many forms
could be defended. But on what grounds could an interpretation
of the whole of reality in terms of Christ be justified?

These were not the exact terms in which the new Professor
raised what he called "the question of theology," but it was clear
that this was the kind of challenge to which he was reacting. And

this has indeed been the issue lying at the heart of the Christian theological debate over the past half-century. Is there any kind of objective *content* within the multi-varied forms of Christian theological discourse? If the divine has been revealed through the srtuctures and the dynamism of the universe at large, this is something which it is open to all to apprehend by every means possible. But if it is claimed that the divine has been uniquely revealed through the Christ, what forms are to be studied by anyone anxious to discover precisely what the nature of this revelation may have been? The obvious answer may be the New Testament writings. But is it necessary to accept them *in toto,* to examine them in all their variety, in order to gain access to the essence of the divine disclosure through Christ? Indeed, may not the very *form* of these writings, coming as they do from a conceptual world so different from that of our modern scientific age, obfuscate and even conceal the precious *content* which constitutes the all-important revelation of God to man—if this has, in fact, been made?

Such questions have sparked off the most famous theological debate of this century in Christian circles. One effort after another has been made to isolate the quintessential "Christian" gospel, or proclamation, or kerygma. Mythological accretions have been shorn away. Interpretations after the event have been subjected to ruthless criticism. Some have come to regard the witness to certain outstanding events in the career of Jesus—his birth, prophetic ministry, passion, death, resurrection—as constitutive of the essential gospel. Some have narrowed the focus still further to the single event of death-resurrection. Others have regarded the Word itself as the only objectivity to which reference can be made. But common to all has been the quest for the gospel behind the Gospels, the kerygma within the apostolic witness, the saving Word which inspires and governs all other "Christian" words. If only the searchlight of disciplined enquiry can illumine the saving action by which God reconciled the world to himself through Christ, then a criterion is available by which all subsequent theological "forms" can be judged and their right to bear the name *Christian* affirmed or denied.

In ethics, in liturgy, in theology, the debate continues. What is the relation between essential principle and formulated rules, between essential offering and formulated rituals, between essential gospel and formulated doctrines? By what criterion can any pattern of behaviour or confession of faith be rightly designated "Christian"? How can we determine what "forms" are more or less adequate for the communication of the "Christian" way of life within any particular environment or circumstances?

Though many exceptions could be found, it is broadly true that whereas the Catholic tradition has paid special attention to "form," the Protestants' chief concern has been about "content." Part of the success of Catholic forms of Christianity amongst rural and industrial peoples has been due to its presentation of the faith in terms of particular forms of action in worship and ethics. So long as the correct forms are observed and employed, the inner content, it is held, will be safeguarded and its influence ultimately felt. On the other hand, Protestant reformers have seldom been content with form alone (though they have been at times almost fanatical in attempting to construct correct theological formulas). They have insisted that the essential gospel is primary and that forms have value only insofar as they truly set forth the saving message. If challenged by the obvious fact of words having to be translated from one language to another or even changing their meaning from one historical period to another, they tend to answer that though forms may change, the essential gospel remains unchanged. The content is all-important, and by whatever means and at whatever cost this must be transmitted to every new generation and culture.

Thus Christianity today, and to a greater or lesser extent throughout its history, finds itself wrestling with the problem which has usually been described as that of form and content, though whether this is the most accurate and adequate description remains to be seen. A famous recent reformulation of the problem is to be found in the distinction between medium and message, though it would probably be claimed that medium includes considerably more than is denoted by form. What, we may well ask, is the dis-

tinctive phenomenon observed and experienced by man which he has tried to describe in these varying ways? What seems to be the underlying motif governing this constantly recurring distinction?

One of man's earliest inventions was the jar or pot which could serve as a water container. Before the pot some natural object—a skin or a shell or a hollowed piece of wood—must have been used, but the coming of the jar marked a real advance in convenience, in hygiene, and in aesthetics. A jar could be moulded to a particular form: it could be designed to hold a particular content. Thus form and content gained immediate meaning by reference to a static object, the jar or vase. But this invention did not stand alone. There was also the tool to beat or to cut. Again wood and stones had provided useful prototypes, but a real advance was made when iron was moulded by a smith into shapes designed to effect particular purposes. Within the context of man's external activity, the all-important combination is structure and goal. To achieve a certain end, man designs an appropriate tool. Thus form and content in a static context is complemented by structure and purpose in a dynamic context. A further distinction may be noted in that while the jar having been constructed maintains a relatively independent existence, serving the sole purpose of holding fast whatever is poured into it, the tool having been constructed is still dependent on its owner for the energy which will enable it to fulfill its function in any appropriate context. The jar is receptive—we call it a receptacle; the tool is potentially active—we call it an instrument. Moreover, whereas in the case of the jar form and content are intimately related and interdependent, in the case of the tool structure and purpose are less closely related, the ultimate achievement of the purpose being dependent on factors other than the mere structure of the tool, factors such as amount of energy employed, direction of aim, and resistance of the environment. In other words, the jar embraces substance or content and holds it fast within its own existing shape; the tool is apprehended by a living agent and used with great flexibility to effect an end which has been previsioned but can only ever be approximately fulfilled.

In the light of these preliminary observations I want now to

proceed to the arts and art criticism and to enquire how far the two basic experiences of jar-making and tool-using serve to illuminate the problems which arise in the construction of visual and verbal forms. Perhaps I can best illustrate what I have in mind by setting alongside one another two poems, each of which belongs to the early nineteenth century. The very mention of jar-making brings to mind John Keats' "Ode on a Grecian Urn." Here is a supreme symbol of unchanging form:

> Thou still unravished bride of quietness,
> Thou foster child of silence and slow time, . . .

Its painted contours disclose the constantly recurring themes of love and sacrifice. Form and theme are completely consonant with one another.

> O Attic shape! Fair attitude! with brede
> Of marble men and maidens overwrought,
> With forest branches and the trodden weed;
> Thou, silent form, dost tease us out of thought
> As doth eternity: Cold Pastoral!
> When old age shall this generation waste,
> Thou shalt remain, in midst of other woe
> Than ours, a friend to man, to whom thou say'st,
> "Beauty is truth, truth beauty,"—that is all
> Ye know on earth, and all ye need to know.

The urn—silent, receptive, perfectly embracing the cycle of natural life and human love and sacrificial offering, the ageless expression of Greek balance and harmonious movement, symbol of the eternal feminine—here form and content are beautifully interrelated. The form is *given* here on earth. The poet contemplates the perfection of form and pours into it his own liquid feeling, and thereby a new beauty is generated. In the tradition derived from Greece, forms are regarded as preexistent, and into these enduring forms successive generations pour fresh insights, and thereby new beauties are created.

In vivid contrast I place William Blake's "Jerusalem."

> And did those feet in ancient time
> Walk upon England's mountain green?

We sense the growing tension as line succeeds line until we reach the shock of "those dark Satanic mills." Then passion boils over.

The poet seizes his tools, his weapons, the extensions of his own burning indignation.

> Bring me my bow of burning gold!
> Bring me my arrows of desire!
> Bring me my spear! O clouds, unfold!
> Bring me my chariot of fire!
> I will not cease from mental fight,
> Nor shall my sword sleep in my hand,
> Till we have built Jerusalem
> In England's green and pleasant land.

How different is the "feeling" in every line of this poem: no quiet following of a circular path; no acceptance of an already existing form. Instead there is a tremendous thrust to destroy existing structures, to burn up human perversions: the spear and the sword, the chariot of fire, the mobilizing of all human resources, in order to create the new Jerusalem, the city of God's true purpose. Here "form" is hewn out of the existing situation by cutting and hammering and burning. We are in the tradition of the Hebrew prophets and the later apocalypticists. Only through struggle and conflict and the radical remoulding of existing structures can the new Jerusalem be built.

From these two examples I deduce that whereas it is both legitimate and illuminating to speak in terms of form and content when we are relating ourselves to cultural situations comparable to that of ancient Greece, it is a very different matter when we are living in an apocalyptic age and trying to relate ourselves to the dynamic forces surging round us. In this second kind of situation, form and content become almost meaningless terms. Everything is in flux. Tools appropriate to the situation must be employed, and the tools themselves will be affected by the situation. Instead of form and content we can apply the terminology of purpose and technique, of end and means, of media being used as tools to shape the earthly representation of the message already particially apprehended. Instead of pouring content into a pre-existent mould, we think in terms of creating new "form" by hewing and shaping existing material so that it may embody the "content" already existing in the human consciousness.

It is abundantly clear that man will never reach a stage when he can do without "containers" to store his accumulated social experience. There may have been a time when man lived literally "from hand to mouth," snatching up scraps of edible material wherever found, scooping up water from the water hole to satisfy his thirst. But the very existence of hollow shapes in the world and their capacity to hold fast quantities entrusted to them suggested the possibility of moulding plastic material in such a way that it could become the storehouse of goods from the past valued because of their potential usefulness for the future. This construction of "containers" has continued from the very beginnings of man's life-in-society until the present day: "containers" for food and water, "containers" for family functions (the house), "containers" for social experience (law and custom). All these have assumed standard shapes, and the tendency has ever been to preserve valued forms with as little change as possible. In language, for example, whatever developments there may be through the impact of new experiences and impressions, the basic forms of grammar and syntax show little variation through the passage of time. At first sight it would appear that Ernst Fischer's definition of form as "social experience solidified" is universally accurate and justified.

Yet the matter is not quite so simple. Life does not only consist of "containers." Man is an inveterate experimenter. And this may involve not only an adaptation and modification of accumulated social experience, but also a direct contradiction or contravention of that experience. He denies that the "form" of the container has absolute validity. He breaks through in order to explore; he breaks down in order to exploit. He conceives a dream or a vision or a hope and seeks to translate it into outward realization. This is the "energy" of creativity and change, and for the application of this "energy" new instruments must be employed. Furthermore, these new instruments are not of the "container" type, but rather of the "extensive": they are "extensions" of man's experience and vision and suggest a second definition of form as

"creative experience expressed through action." It is through the action that mental "content" gains its "form."

Many of the problems associated with form and content arise, it seems to me, through the confusing of the two contexts or category-situations which I have tried to analyze. In the first context, "content" is dependent upon "form"; in the second, "content" partly determines "form." In the first, "content" shares the relative fixity and inflexibility of "form"; in the second, "form" shares the flexibility and open-endedness of "content." In the first, "form" serves to preserve and safeguard social experience; in the second, "form" is the outcome of creative individual experience and experimentation. In the first, "content" is the fruit of past discovery; in the second, "content" is the substance of future hope. All of this suggests that the terminology of "form" and "content" may not be appropriate within the second context. Perhaps "medium" and "message" are altogether preferable.

I return to the problem with which I began. What is to be said of the "form" of Christian ethics, liturgy, and doctrine in the light of the preceding analysis? Quite clearly there are in the world today many forms of "social experience solidified." Can any of these be called exclusively and specifically *Christian*? So far as I can see, it is impossible to make such a claim. Before Christianity came to birth in the world, there were many "containers" already in existence, containers which we call "cultures" and which can most easily be distinguished by the *languages* used in social relationships. The good news of the Christian *event* did not immediately change the forms of these containers. Indeed, so all-embracing and so firmly entrenched were these forms that the impact upon them of "Jesus and the resurrection" was at first scarcely perceptible. Ethical rules, ritual patterns, aesthetic styles, metaphysical doctrines, were the "containers" shaped by many generations of social experience, and their form, for example in the cultures of Greece and Rome, seemed almost impenetrable. Yet very gradually the new "content" made its influence felt, partly through the medium of dynamic language, partly through the medium of heroic

action. The record of the injection of the Christian message and witness and hope into the "container" of Graeco-Roman culture constitutes one of the most fascinating chapters in the whole story of the expansion of Christianity.

But to attempt to describe this and similar processes simply in terms of changing forms and unchanging content leads easily to confusion. I propose instead to suggest an alternative vocabulary for the second type of situation referred to in the previous section. Whereas in the case of "container" cultures social experience solidifies within a recognizable form and we are justified in speaking of form and content, in the case of "extensive" or "purposive" movements it is preferable to speak in terms of message and medium. "Message" is a word which can be appropriately used within every kind of communication process. Normally it is employed when news or information is sent from one person to another. But it is possible to extend the use and to denote by "message" any meaningful idea or item of information in process of being communicated within a social context.

The message owes its origin to some individual apprehension. It may be a new discovery, it may be a fresh encounter, it may be an emotion deeply felt. For a brief moment it is the possession of the individual himself. Then comes the urge to share the apprehension, to communicate the information, and immediately the question arises as to how this can best be done. What media are available, and what is to determine which medium is to be used?

The most obvious medium has, from time immemorial, been the human voice. By expelling breath through the lips, messages of almost unlimited variety can be conveyed. Yet the human voice has some limitations. Sounds may not be correctly heard; once uttered they disappear into thin air; the range of the unaided human voice is comparatively small; the capacity to convey a message of the emotions differs widely from person to person. It is not surprising, therefore, that man has been driven to invent all kinds of media to transmit the particular message which he desires to share with his fellows: extensions of sound, both into distant space and into future time; similar extensions of images and gestures; the use of rhythm and tone to express emotions.

Writing and drawing, translating and transposing, expounding and explaining, all are means (media) by which man has tried to communicate to ever expanding circles of potential receivers.

The interesting question soon arises, however, as to whether there is any necessary relationship between message and medium. In the case of form and content it seems clear enough that if form is regarded as *given* (e.g., a pot or jar) then variations of content are strictly limited. *Quantity* is fixed and the *nature* of that which can be "contained" only allows minor variations. But in the case of message and medium it is the message that is normally regarded as *given* and the choice of media for its expression or conveyance seems wide open. There are hundreds of languages in the world, there are manifold variations of structures and styles, there are technical aids whose number is constantly increasing. But is every medium suitable for the transmission of a particular message? Take for example the earliest Christian kerygma of which we have record.

> Christ died for our sins
> according to the Scriptures
> He was buried
> He was raised on the third day
> in accordance with the Scriptures
> He appeared to Cephas, then to the twelve.

In the main this consists of plain statements that Jesus died, was buried, and rose again. These could be expressed, presumably, in any language directly and straightforwardly. But the intriguing phrase is *"according to the Scriptures."* A backward reference is suggested as in some measure determining the method by which the message was to be proclaimed. The experiences of men recorded in the Old Testament have a bearing on the communication of the new kerygma. The message is "given," but the medium must be such as to harmonize with the continuance of the ongoing divine purpose to which the Scriptures bore witness.

For as we look back at the Old Testament, we cannot fail to note that amid all the varying elements of legends, social regula-

tions, prophetic utterances, and ritual observances there is an overriding sense of a forward movement in time. To Abraham a promise is given; through Moses a great advance is made; through the prophets men's eyes are directed towards the future. The writings faithfully record many attempts to set up an establishment, to build houses, to create a definitive political structure, to constitute a permanent temple and priesthood. Equally faithfully they record frustrations, disappointments, breakdowns, new beginnings. Without question the all-important message is that God has a purpose for the world of men and that he is acting in such a way as to bring it ultimately to fulfillment. And the medium for the expression of this message is above all *words* which arise out of and share the pattern of those events in time which men of faith believe to be the particular manifestations of the divine in human affairs. The supreme example is the deliverance from the bondage of Egypt through the events of Passover night and the passage through the Red Sea. There is a vivid narrative telling of the notable stages in this deliverance; there are exuitant songs celebrating the deliverance; there are prophetic anticipations of a reenacting of the deliverance; there are regulations for the dramatic memorialisation of the deliverance. All these are media expressive of and consonant with the series of events through which the divine purpose was revealed—a purpose whose ultimate direction was for the salvation of all mankind.

The witness to the saving activity of God was primary and determinative in the Old Testament. Ritual observance and ethical behaviour were secondary and derivative. Essentially ritual observance was designed to celebrate and reenact the pattern of activity revealed in the hour of the great deliverance; ethical behaviour was regulated by the principle of *imitatio Dei*—man in his dealings with his fellows must behave in ways worthy of and reminiscent of God's dealings with him. Thus the message determined the media in art and in ethic. The message brought a tremendous intensity of concentration to bear upon a particular demonstration of saving activity—the symbolic representation of the majestic purpose of God himself. Then out from that central series and governed by its direction, media could radiate, and

through these media the message could be extended into new circumstances and new environments.

The Old Testament, as I have already suggested, shows how the central message gathered into its ambit all kinds of heterogeneous elements which sometimes obscured and even contradicted it. The particular witness to the ongoing purpose of God often had to be given within an environment whose patterns of ritual and social behaviour had been determined by quite different considerations (the validity or otherwise of these is not, for the moment, our concern), and the extent to which the media of original transmission were effected by these patterns is never easy to determine. What seems evident is that if a medium whose whole provenance is forward-moving and dynamic becomes assimilated to forms whose provenance is like that of a jar, cyclic and motionless, it can no longer serve as an adequate vehicle of the message which it was originally intended to transmit.

This tension between a message expressed through media representing the ongoing purposive activity of God and a message encapsulated within forms recognized as inherent within the universe which God has created has constituted both the dilemma and the dynamic of the development of Christianity in history. In the New Testament the distinctive Christian message is expressed not through one unchanging pattern but through *two*. The form already mentioned focuses attention upon the death, burial, and resurrection of the Christ and sees these events as the immediate fulfillment of the purpose of God revealed through the history of the Jewish people (recorded in the Old Testament Scriptures) and at the same time as the pledge of the ultimate fulfillment of that purpose in the salvation of mankind. On the other hand, the form which finds its focal expression in the Carmen Christi of Philippians 2 sets the "death on a cross" (the only reference to an outward event in the earthly time-series) within the framework of self-emptying followed by self-fulfillment, a "form" which is so deeply engraved in the universe at large that it may be said to be one of the archetypal forms of the created order.

This tension already appearing in the New Testament manifests itself again and again in the course of Christian history. The good news of the death, burial, and resurrection of the Christ was proclaimed by the witness of apostolic men who felt themselves under a compelling constraint to move outwards, to engage with new peoples resident in new areas, to employ their languages, to invite them to identify themselves with the all-significant purpose of God of which the Christ-events were the demonstration in the present and the pledge for the future. The message grasped and controlled the new medium; the medium in turn influenced the expansion of the message. But there can be no question about the primacy of the message, the "word-events," the sheer "happenedness" of death and resurrection. It was this that had to be proclaimed as the altogether noteworthy communication to mankind of ther reconciling activity of God. Men themselves, their words, their activities, become constituent parts of the medium through which the message was forever finding its renewal and its extension.

Yet the gospel also began to be celebrated through myth and sacramental rite. In this context *forms* of great antiquity were already in existence. These forms were in many respects jar-like in shape, for they represented a descent into some lower kind of existence—the material world, the tomb of the flesh, the darkness of the waters, death—and an uprising into a realm of purity and light. This pattern seemed to be inherent in the very nature of things, and all human experience tended to be moulded according to this shape. What *seemed* to be a new content found its social expression through being assimilated to this form.

The Christian gospel was undoubtedly *news*. It told of a unique man, the Christ of God, who had identified himself with his fellows even to the extent of submitting himself to the depth of shame associated with the death on a cross. Yet this pattern of human experience was not entirely new. Myths told of the descent of a god-like figure to the world or to the underword. Rites represented the submission of a victim to death, even a painful death. The gospel content could be poured into these kinds of "containers" and could take on their form while, at least in theory, retaining its own distinctive content. But so deeply were the forms entrenched in the human consciousness that naturally and imperceptibly the

content took on their shape and the great Christian "myths" (including creeds and statements of doctrine) and "rituals" (including liturgies and sacred dramas) gradually came into being. Obviously this could not have happened if the Christian gospel had possessed no features comparable to the archetypal forms of Greece and Rome. But the very notes of sharing the common lot, of assuming a humble guise, of learning through suffering, of submission to darkness and death, were so prominent in the Graeco-Roman imaginative tradition that no great difficulty was encountered when it was a case of pouring the Christian content, with its concentration upon a unique figure, into the already existing mould. These forms seemed permanent and universal. The Christian "content" could make them luminous from within, could even gradually eliminate their imperfections. But the "forms" definitely possessed a quality of givenness and were impervious to radical change.

Thus the Christian Eucharist, which originally, like the Jewish Passover, had been the celebration and proclamation of the salvation wrought by God on behalf of his people, early became assimilated to the form of *sacrifice,* the deep archetypal institution in which death was accepted and new life made possible. Christian baptism, which originally, like Jewish proselyte baptism, celebrated the passage through the threat of the death-dealing waters into the freedom of life in the Spirit, early became assimilated to the form of *initiation* into the mysterious, the institution in which a neophyte went down into a watery grave and rose up into a new life of community-in-knowledge and assurance of immortality. It is true that the Christian Eucharist and baptism took on varying shades of meaning with different cultures, but their fundamental shape or pattern remained uniform just because it corresponded to the deepest and most universal of all human needs and strivings. For many centuries Christian initiation and Christian sacrifice were the all-important institutional events within the life of the gradually expanding church.

Whatever criticism may be levelled against Marshall McLuhan's theories in general, there can scarcely be any doubt that his focusing of attention upon Gutenberg as symbol of one of the

most significant changes in the whole history of mankind is both valid and illuminating. In terms of my own analysis, Gutenberg marks the stage when the dual category of form and content began to decline in importance in the Western world while the dual category of message and medium not only regained its significance but assumed an ever-greater importance at an ever-accelerating rate. Whether the rediscovered message created the new medium or whether the invention of the new medium made possible the rediscovery of the message is immaterial. The fact remains that in the Western world (and out from the Western world) from the fifteenth century onwards, message and medium, news and its transmission, the word and its communication, evangel and mission, became the twin focuses of consuming interest.

At first the message was primarily concerned with man's salvation. His eternal destiny was the all-important matter, and the way to attain everlasting bliss must be made known through open proclamation reinforced by the Word printed in the vulgar tongue. Pulpit and printing press were the media whose influence was greatest, and the manner of their control became a matter of deep concern to monarchs, statesmen, and bishops alike. For the possibilities inherent in the new media were such that soon they were being used not simply to convey the good news of eternal salvation, but also to broadcast opinions on political and social organization. Pilgrims on their way to heaven would enjoy the journey to better advantage if they could have a say in the organization and control of their common life on earth.

The story of the development of the culture of the Western world between the sixteenth and twentieth centuries of our era is a fascinating one. In no respect is this fascination greater than in the record of the growing influence of the word, the expanding facilities of intercommunication. In religion, in politics, in economic development, in science, messages telling of new discoveries and new possibilities pass rapidly from man to man. Through pulpit and parliament, through broadsheet and newspaper, through mail carried by stagecoach and steamship and railroad, through translations and expositions, through telegraph and telephone, through code and formula, through radio and recordings, new potentialities

THE ACHIEVEMENT OF MARSHALL McLUHAN: FORMALIST OF TECHNOLOGICAL CULTURE

W. Richard Comstock

Marshall McLuhan presents a perplexing problem to the critic. His explorations of the relation between human consciousness and technology have won the attention of leaders in the interacting worlds of business, entertainment, and communications. In spite of age and establishment connections, he has been accepted by the young as the possessor of a voice resonating with the authentic quality of a new emerging age.

At the same time, his argument is distinctive enough to require some attention from the intellectual community, though here the response is more guarded and ambiguous. Should McLuhan be taken seriously in the sense that he has an important thesis about culture that enhances understanding; or is he rather important as a symptom of the malaise afflicting our society? Are his works evidence of malignant growth or the promise of an effective anodyne? Opinions differ.[1]

What is the source of the suspicion and opposition that he arouses? We can dismiss the many references to incidental imperfections—clumsy sentences, tired puns, a sometimes too apodictic and oracular style. The vigor of McLuhan's thought makes us willing to endure these proofs of fallible humanity, especially when we cannot help but notice similar blemishes in his critics. Furthermore, we can hardly dismiss McLuhan as an insignificant popularizer, since, whatever else he may have done or left undone, his work holds together as the enunciation of an important thesis about contemporary culture that is original and worth considering.

McLuhan's most firm opponents have recognized the presence

of a significant argument which is, in fact, the basis of their vehement rejection. They have correctly perceived that McLuhan's thesis entails the radical rearrangement of a prevailing literary ethos and its transformation into a new ethos centered around the communication and information media of mass culture. As McLuhan sees it, this change does not involve some accidental and incidental features of our dominant cultural style, but developments that are essential, radical, and momentous. In some ways, then, the negative critic has done McLuhan the service of taking him seriously and has helped focus attention on the point at issue more sharply than have those who carelessly enjoy his pop thought without real engagement with its implications.

The familiar story of McLuhan's own intellectual development illustrates the issue in a dramatic manner. As is by now well known, McLuhan is a specialist in medieval education and Renaissance literature who began his career with a typical commitment to the literary ideals of good thought and expression; his subsequent avocational interest in mass communication at first seemed entirely compatible with his membership in good standing in the community of the literati. After all, his published book on the subject—*The Mechanical Bride*—revealed the conventional and respectable eye of the man of taste discerning the banalities and vulgarities of the mass communications world. Then occurred the dramatic and controversial shift in perspective. First in an experimental journal called *Explorations* and then in *The Gutenberg Galaxy,* the movement from the mechanical world of the early modern period to the electronic world of the twentieth century was described in a manner that conveyed the feeling that this change is not an altogether unhappy one for mankind. *Understanding Media* and subsequent works continued the exploration of the electronic age with an exuberance and sense of excitement that caused many critics to interpret it as a celebration rather than an analysis of mass media and a wholehearted acceptance of its standards, style, and human goals.

In this transition, Wyndham Lewis was a crucial figure, for in *Blast* and a number of other literary experiments he demon-

strated how forms of mass media can be converted into strikingly expressive tools for the artist. However, Lewis' tone was not one of bland acceptance of mass culture, but the reverse. He used mass techniques to expose the banality of the mass mind. McLuhan used the techniques of *Blast* but changed the point of view. McLuhan notes:

> Wyndham Lewis was a great influence on me because of his pop-cult analysis. I found Lewis far too moralistic for my tastes. I greatly admired his *method*. Lewis looked at everything as a painter first. His moral judgments never interested me.[2]

Here, then, is the heart of the contention between McLuhan and his humanistic critics. For centuries there has existed a tension between the literary elite and the masses with their unformed and vulgar taste. The increase in mass media of communication and rise of political democracy have brought the tension to a peak of crisis. Mass culture has become so influential and potent a social force in the contemporary scene that the intellectual elite can no longer simply ignore it. Thus some kind of détente between the world of cultivated taste and the world of mass experience is now desperately sought.[3] Here the defender of culture is irenic but cautious. He grants that a place must be made for the mass phenomenon, but in such a way that humanistic values are preserved and the integrity of taste protected from dissolution. The most basic charge against McLuhan is not that he has become interested in mass media, but that he has failed in his crucial task as humanistic critic. As apostle to the natives, he has gone native himself. Instead of saving souls, he has simply confirmed them in their original perdition.

I want to consider certain aspects of this charge and to argue that McLuhan's analysis of the mass culture is more complex than is often recognized and that in many respects he is the defender rather than the vulgarizer of taste. To make my point, I must first state what I think McLuhan is fundamentally trying to do. In this connection, I first want to show that McLuhan's approach to art and the role of the artist in society is an important key whereby both his central focus can be discerned and

the basic issue that divides him from his hostile critics can be most sharply stated.

McLUHAN THE FORMALIST

Although the aesthetic focus of McLuhan's thought is too obvious to be missed, I do not think that either his sympathetic or hostile critics have sufficiently emphasized its crucial importance to an adequate understanding of his position. In point of fact, the most fruitful approach to McLuhan's general account of technology, sociological change, and communication media is to be found in an examination of his basic aesthetic attitudes and convictions. Furthermore, some of the controversial points where he has been most resisted can be clarified and in some cases resolved in his favor when certain aesthetic considerations are brought into the discussion.

To illustrate, let us begin by considering McLuhan's most well-known aphorism—"The medium is the message." This compressed statement is an affirmation of the primary importance of form in all communication media. It is not only what is conveyed that matters; it is how it is conveyed, because the form of the communication is actually an ingredient in the communication. The form is not like a box into which a content can be placed and later removed without having been affected by the container in any way. The form is more like a river which is shaped by the riverbed and would cease to be a river without that determining influence. On this point, McLuhan frequently quotes a passage from Kenneth Boulding's *The Image*:

> We must distinguish carefully between the image and the messages that reach it. The messages consist of information in the sense that they are structured experiences. The meaning of the message is the change which it produces in the image.[4]

Strident objections to McLuhan's position have centered on this formalist bias in his thought. It has seemed to many fantastic and perverse. Can one seriously argue that the content of medium is insignificant, that a communications form has nothing to communicate? Does not the lack of attention to content encourage empty acceptance of all the banalities and distortions of com-

mercial entertainment? Will not trivia, sadism, ugliness, continue to affront the sensibility that refuses to concern itself with moral discrimination of the specific matter communicated by a medium?

Such objections seem at first glance so obvious that many readers are tempted to dismiss McLuhan's thesis as a curious eccentricity, unworthy of serious attention. Further reflection, however, cannot but induce a certain uneasiness. Is it McLuhan who is guilty of such superficial blindness that he cannot see the "content" so obvious to everyone else, or is it the critic who is so obtuse he cannot see something else which McLuhan has noted and proclaimed in his infamous epigram? That "something else," of course, is the pervasive element of form present in content and determining its very being as content.

This point, obvious yet elusive, is the key to McLuhan's particular accomplishment. As a critic of contemporary technological culture, McLuhan's own "content" is not original, but, on the contrary, is dependent on a rapidly accumulating literature dealing with cybernetics, automation, computers, industrial management, and information theory. What is unique and distinctive in McLuhan's approach is that with him the character of the emerging cybernetic world is here filtered through the "form," not of a technical or mathematical mind, but of an aesthetic sensibility. "The medium is the message" is the distillation of the cybernetic phenomenon as it occurs in a mind influenced by the most sophisticated and avant-garde literary and artistic analyses of the last hundred years. The French Symbolists and their English champions, Ezra Pound and T. S. Eliot, *Scrutiny,* aestheticians like Heinrich Wölfflin and Sigfried Giedion are the determining influences. As McLuhan himself points out, he looks at our culture "in the rear-view mirror of Joyce, Carroll, the Symbolists, Adolph Hildebrand."[5]

As a result of the efforts and accomplishments of such figures, it is now a truism to observe that the concept of "form" is a critical factor in almost any contemporary aesthetic theory. Through it authentic artistic quality is distinguished from the vulgar judgments of the Philistine, who seeks in a work of art for literal imitations of the most banal ideas, feelings, and activities. Thus, in the

pictorial arts, it is a cliché of criticism to point to a *major* emphasis on subject matter as certain evidence of lack of taste. To see that the value of a painting is not fundamentally in its subject matter—a lake, children playing, a nude—but in certain qualities exhibited through the formal arrangements of shape, color, texture, is the beginning of any cultivation of artistic sensibility. Poets also have resisted the notion that their poetry is "about" the emotions or their own personality or human ideals. T. S. Eliot, for example, described the poet in a famous essay exactly as McLuhan was later to treat a mass communications medium: "The poet has not a 'personality' to express, but a particular medium, which is only a medium and not a personality—in which impressions and experiences combine in peculiar and unexpected ways."[6]

McLuhan is the formalist of electronic media. The approach is an example of his innovative brilliance and one source of the irritation he has created in the intellectual world. McLuhan obliterates the distinction between aesthetic elite and vulgar masses by applying to mass media the principles supposedly applicable only to those exceptional works by which the man of taste was led to hope that he could escape from mass banality. McLuhan's particular gambit is full of irony and humor in the way that it overcomes a rival position with the rival's own weapons. McLuhan is not the first intellectual to attempt to come to some kind of positive terms with the popular arts, but he is probably the first to base his apology for the lowbrow on the very principles that are supposedly the province of the highbrow.

For example, the typical man of culture is liable to defend the value of his own favored art according to the standards of some variation of a formalist analysis such as we have indicated. In this vein, he will scorn content-oriented art, like a Norman Rockwell painting, and will dismiss a *moral* criticism of high art as irrelevant and misguided. Yet if this same aesthetician is in an irenic mood, he will then allow for some positive use of the popular media that is based almost exclusively on utilitarian moral considerations. After all, television could be used for educational purposes and do much good in disseminating the values and ideals of civilization. Disappointment results when, instead, television

falls short of its promise and disseminates bad content—violence, mindless euphoria, banal humor.

McLuhan's critique, of course, is the exact reversal of this. He is so committed to the problem of aesthetic perception that he cannot discard this focus and go on an interlude of relaxed slumming when he enters the world of the masses. He does not conform to the lowbrow accent on "good content," but rather asks the lowbrow to begin to look at his familiar world of mass media from a highbrow perspective. Observes McLuhan:

> . . . the cathartic, ethical view of art has led to . . . indifference to all popular art. And in the past century . . . the cathartic and ethical school has enveloped the entire world of popular culture in a haze of esoteric nescience, disguised, however, as a profound moral concern with the wider hope and the higher things. . . . Only by a conquest and occupation of these vast territories of stupefaction can the artist fulfill his culturally heroic function of purifying the dialect of the tribe, the Herculean labor of cleaning the Augean stables of speech, of thought, and feeling.[7]

McLuhan is, then, the formalist of popular culture. He is concerned with configurations of shape, color, texture, tone, that the various mass media convey, and how these affect our sensibility, just as a Hildebrand or Wölfflin considers the configurations of an example of "fine art." How strange and comic, then, is the situation that McLuhan's gambit has elicited. Important arbiters of critical taste have been lured into the humorous role of playing dull Philistine to McLuhan's aesthete. Insisting upon content in the one instance of the popular arts and outraged by the thesis that the "medium is the message," they sound like vulgar moralists who are looking in art for lofty sentiments and who do not know that a change in medium changes the message; that, for example, the prose equivalent of a good poem is no equivalent at all.

For purposes of effect, McLuhan at times adopts an extreme formalist position that seems to ascribe an autonomous and autotelic form to each of the mass media. But as McLuhan points out, "You have to push any idea to an extreme, you have to probe. Exaggeration, in the sense of hyperbole, is a major artistic device in all modes of art. No painter, no musician ever did anything without extreme exaggeration of a form or a mode, until he had

exaggerated those qualities that interested him."[8] If we cannot bear the tension of this probe, McLuhan is willing to reassure us:

> By stressing that the medium is the message rather than the content, I'm not suggesting that content plays *no* role—merely that it plays a distinctly subordinate role. . . . By placing all the stress on content and practically none on the medium, we lose all chance of perceiving and influencing the impact of new technologies on man, and thus we are always dumbfounded by—and unprepared for—the revolutionary environmental transformations induced by new media.[9]

There, now we feel better. But it remains mildly ironical that many arbiters of literary form will require this prose amplification of compressed aphorism from McLuhan before their ruffled sensibilities are pacified.

Like any formalist, McLuhan must finally face the perplexing problem of how to relate form to content. As Solomon Fishman convincingly argues in his study of formalists like Walter Pater, Clive Bell, and Roger Fry, a radical formalism denying any relevance to content at all is impossible to maintain. At the very least, it would seem that, as with all polarities, equilibrium between form and content is not found by eschewing one for the other, but in some kind of creative balance between the two. We should look to a "fusion of form and content so complete that neither can be extricated from the other."[10]

In *Understanding Media,* McLuhan played with the notion of how the "form" of one medium becomes the "matter" or "content" of another. Thus "the content of writing is speech, just as the written word is the content of print, and print is the content of the telegraph."[11] Although this notion has irritated a number of critics, it is actually a rather clever extension of the Platonic categories of form and matter to a contemporary setting. Plato (the paradigmatic formalist) describes the relation between form and matter differently in various ones of his exploratory dialogues. One of the most intriguing approaches is to treat these terms as functional correlates rather than as independent ontological substances. On this view, "matter" is that already formed content made out of some prior content which is transformed by a maker into some new form. Thus a tree is the matter which is made into

the form of boards. Boards, in turn, are the "matter" made into the form of a house. On this approach, there is no pure matter existing without form, nor is there a pure form existing without matter. (We omit the metaphysical and probably illicit extensions of this principle which include reference to a "prime matter" without form and a "pure form" without matter.) McLuhan's approach to communication media is clearly related to this particular tactic.

After the publication of *Understanding Media,* McLuhan began to develop another set of categories through which to articulate his emphasis on form. In the introduction to the second edition of *Understanding Media* and in *Toward the Vanishing Point,* we find a distinction between background and foreground, between "environment" and the objects of conscious attention that emerge within it.[12]

McLuhan's refusal to concern himself directly with content is motivated by the fact that "content" almost by definition is that which is easily and readily noticed. The more pressing problem for man is to notice also the underlying environment of form which "has the property of being mainly invisible." We do not really look at the environment, since it is the form through which we perceive, not what we perceive; it is the background out of which the objects of our interest emerge. Whoever it was who discovered water, it certainly wasn't a fish.

According to McLuhan, a new medium creates a new environment "imperceptible except in terms of its content" which alters "the entire character of human sensibility and sensory ratios." A new environment often takes the form or environment of a preceding age as its own consciously perceived content. Thus McLuhan argues that it is not surprising that the Romantic cult of nature and rural values come into focus in a society becoming rapidly industrialized and far removed from that which it appreciated in its conscious art. Again, McLuhan is impressed by the fantastic popularity of "Bonanza" on television. Man uses the form of a contemporary medium to watch the ideal content of the "good old days" of a vanished frontier culture.

We see, then, that McLuhan as formalist has engaged with the problem of "content," but in such a way that it is treated as

an organic function of form and not as an independent reality temporarily inhabiting some particular medium as its accidental container. If we pursue the problem still further, we must consider the point made by Solomon Fishman that formalist thinkers cannot finally avoid the question as to whether form is not in some manner "significant" (Bell) or "symbolic" (Read). But of what? Formalists have sought variously to achieve an autonomous aestheticism (art for art's sake), a nihilistic destruction of culture through dehumanizing forms (Dada), or an aesthetic mysticism in which form becomes the medium for some transcendent communication (surrealism). Paul Klee, for example, saw form as the means whereby "the secretly perceived is made visible."

While nourished and inspired by these aesthetic movements, McLuhan avoids their nonsocial or antisocial focus and instead transforms his own formal bias into an organ of direct and meaningful social critique. The manner in which McLuhan the formalist thus solves the problem of formal significance without recourse to extraneous, non-formal materials is impressive. In turning to society, McLuhan does not abandon his commitment to the principle of form but, on the contrary, extends its field of application into the practical area of human relationships.

In order to accomplish this task, McLuhan assigns to the artist a role in society far different from that of most formalists, yet one perfectly consistent with their principles. To McLuhan, the artist is neither an adventitious ornament to a self-sufficient Philistine society nor an aesthetic recluse constructing his own private alternative world; he is, rather, a vital and functional member necessary for society's well-being and even its survival.

This is so because the artist is peculiarly gifted to accomplish the task of recognizing the cultural configurations which provide the environment in which awareness takes place. McLuhan argues:

Any artistic endeavor includes the preparing of an environment for human attention. A poem or a painting is in every sense a teaching machine for the training of perception and judgment. The artist is a person who is especially aware of the challenge and dangers of new environments presented to human sensibility. Whereas the ordinary person seeks security by numbing his perceptions against the impact of new experience, the artist delights in this novelty and instinctively creates situations that both reveal it and compensate for it. The artist

studies the distortion of sensory life produced by new environmental programing and tends to create artistic situations that correct the sensory bias and derangement brought about by the new form. In social terms the artist can be regarded as a navigator who gives adequate compass bearings in spite of magnetic deflection of the needle by the changing play of forces. So understood, the artist is not a peddler of ideals or lofty experiences. He is rather the indispensable aid to action and reflection alike.[13]

Through this analysis McLuhan turns the tables on the traditional defender of intellectual and aesthetic values against the blandishments of mass phenomena. He causes us to reconsider; is the development of a sharp distinction between "art" and "mass culture" a means of preserving the integrity of art or is it rather a means of depriving art of its true function and "significance"? McLuhan asks: "If it is true that the artist possesses the means of anticipating and avoiding the consequences of technological trauma, then what are we to think of the world and bureaucracy of 'art appreciation'? Would it not seem suddenly to be a conspiracy to make the artist a frill, a fribble, or a Miltown?"[14]

Through this position McLuhan provides his most definitive attempt to resolve the perennial tension between form and content by assigning to the artist the task of turning unconscious cultural forms into consciously aware content. The work of the artist is thus not autotelic, yet its significance is no violation of its own internal formal nature. By rigorously and even exclusively attending to form, the artist accomplishes a functional purpose of great importance in bringing the formal presuppositions of our culture to conscious awareness; in so doing, he still demonstrates how form and content are one, how the medium truly is the message.

McLuhan's own "message," then, is an explication of the forms pervading the formal "environment" of contemporary man. McLuhan, the aesthete, uses the poets as his sources of insight; through their works he constructs a critique of consciousness, uncovering the basic shapes of our fundamental perceptions of our world.

SENSORY RATIOS AND CULTURE FORM

Since McLuhan uses a formalist approach as the key to a critique of culture, we must now consider more closely how

McLuhan understands the category of form. McLuhan relates it in an integral fashion to the concept of "sensory ratio." Adhering to a major emphasis of contemporary thought, McLuhan considers man as in constant communication with his environment. The traditional senses—sight, hearing, taste, smell, and touch—are clearly communication media in the sense that they provide the desired contact between man and his world. The central nervous system is also a communication medium in the sense that it correlates the various deliveries of the senses. The communication media of technology are then extensions of these senses—the telephone of the ear, the photograph of the eye, and so forth. It is McLuhan's argument that, while each sense and each technical extension has its own particular form, the interplay between them and their synthesis by the central nervous system generates a "common sense" determined by the ratio of the different senses in interplay with one another, which then assumes the dominant sensory form by which the person apprehends his world.[15]

McLuhan then proceeds to describe how, in various stages of human culture, various sensory ratios or forms have prevailed, according to the manner in which various media have accentuated one or the other of the senses, dissociated one sense from the others, or generated creative interaction and synthesis between two or more of them.

So stated, the thesis is intriguing but dubious. The difficulty lies in an ambiguity that McLuhan shares with nearly all discussants of the problem of human perception: the notion of "perception" can refer to the fact of immediate human sensation; or it can refer to sensation with some cognitive interpretation added; or it can refer in a more general manner yet to a certain categorical frame of thought by which the members of a given culture are wont to organize their experiences in common.

To which does McLuhan refer? His emphasis on the ratios of the senses seems to commit him to an extremely psychological stance that is mainly concerned with the effect of technological media on the specific manner of sensually perceiving the world directly experienced by each person taken as a separate center of awareness. Thus in an illuminating article, James Carey makes an

important contrast between McLuhan's colleague and mentor, Harold Innis, and McLuhan himself. Innis, it is argued, was interested primarily in the effect of media on the social organization (or form), while McLuhan changed the emphasis to sensory organization. It is then decided that Innis' approach is the more fruitful and viable one.[16] However, Carey later points out that the distinction between sensory and organizational organization is not one of exclusive alternatives. In fact, McLuhan most frequently states his theme as "the *forms* of thought and the organization of experience in society and politics," as a study of "the whole psychic and social complex," "the structuring of the forms of human association by various media," the "metaphors and models" dominant in a given culture.[17]

McLuhan's too frequent emphasis on sensory ratios is consequently misleading and, if literally interpreted, probably wrong. It seems to suggest the notion of people in different climes and periods actually apprehending the world differently on the immediately sensual level. No evidence for such a thesis has yet been produced.

On the other hand, it does seem probable that a given culture entertains certain models which encourage members of that culture to organize their sensual and other experiences according to socially approved categories and models. McLuhan follows the lead of Sigfried Giedion and Lewis Mumford in arguing that the cultural models or forms in ascendancy at a given time are developed out of the interaction between people and the predominant technological devices concurrently in operation. It is not necessary to claim that the technological device permanently alters the biological sensual perception of the individual. However, while the device is in use, it will affect the sensory ratio of the individual for at least that period of time. While one is looking through a microscope or a telescope, the other senses are temporarily diminished in terms of awareness. While listening intensely to sound, especially when augmented by a machine, one can become oblivious to pain. It is then reasonable to assume that these experiences, if constantly repeated, will contribute to the construction of models or forms of cultural organization by which men in given periods are

wont to organize the experience they have in common.

So stated, the thesis is at least worth exploring. The symbolism of the body and of the senses clearly pervades the metaphoric dimension of language, and hence the basic categories and models of thought used in a given period.[18] If technological devices extend, distort, enhance, narrow, and otherwise affect the range of the senses, it is only to be expected that technology would play its part in forming the dominant cultural form and models of a given period.

A major part of McLuhan's work is devoted to an explication and exploration of two such models which, it is claimed, played a major role in the formation of post-medieval sensibility.

TWO CULTURAL FORMS

In McLuhan's writings can be detected the skeletal outline of a grand scheme of the history of Western man as ambitious as any in Toynbee or Spengler. At least four major periods are distinguished according to the sensory form dominant in each. First is the oral society of the preliterates, in which auditory models are ascendant. This is succeeded by the alphabet civilizations of the Western world, which extend into the Middle Ages. These societies have become more visually oriented because of the alphabet and writing (which turns sound into visual symbols), but oral components continue to play an important role. Thirdly emerges the "Gutenberg galaxy," in which the invention of movable type produces a book culture where the visual is heated to such an extent that a radical dissociation of sight from the other senses takes place. This period is now being succeeded by an electronic age, in which sight is cooled and sensory ratios with astonishing similarities to those of preliterate societies return.

The scheme is interesting when accepted as a heuristic probe rather than a settled and exhaustive description of the actual shape of human history. The most intriguing and convincing parts are the descriptions of the post-medieval developments of Western man, which McLuhan describes with ingenuity and documents with stimulating details. What McLuhan has provided is an impres-

sionistic sketch that convinces in the manner of a good phenomenological description displaying power as "a sensitive system for observing signals."[19]

According to McLuhan, a cultural form stressing perspective and lineal sequence has dominated the post-medieval period of Western culture until the last century. This is the period of the mechanical technology based on power sources that move wheels external to one another in various combinations. It is the epoch of the Gutenberg press, when a cultural form emerges exhibited in lineal sequences placing emphasis on clarity of outline and discreteness with which each part of the pattern is perceived. The concern is for univocal exactness of separate detail and not for multidimensional interaction and involvement. Each point in every sequence is clearly distinguished from every other point, and each lineal sequence is separated from every other. Overlapping, interpenetration, inclusive participation, are eschewed in favor of the external succession of discrete parts.

Examples of this form in Western culture are Euclidean geometry; Newtonian absolute space; Aristotelian logic moving from A to B to C; Renaissance development of linear perspective; printed books with their uniform sequential symbols on the page; music that emphasizes a single melody line; the rise of nations composed of homogeneous individuals and groups; the development of homogeneous languages purged of dialects, ambiguities, and eccentricities.

As is well known, McLuhan connects in an essential fashion this form with literate man because he believes that commitment of attention to pages of homogeneous print is largely responsible for emphasis on lineal homogeneous form. He argues that this form of continuous sequence is now being drastically modified.

In physics the image of homogeneous space is discarded in favor of space that is curved and determined by fields of energy rather than Euclidean lines and vectors. The principle of continuous causality defers before the notion of atoms exhibiting discontinuous movement. Art forsakes perspective and in cubism, for example, explores the object from all perspectives simultaneously.

The development of a technology based on electricity changes the entire structure of a gestalt based on the mechanical sequence between movable parts. For electricity means speed. Communication achieves almost simultaneous meeting between sender and receiver; computers bypass the time of many logical sequences to arrive at fantastically rapid conclusions.

McLuhan chooses, then, to emphasize the common form in all these disparate phenomena by the terms "simultaneity" and "mosaic." The dominant form of the electronic age is the simultaneous mosaic in which continuous sequences defer before the conception of the simultaneous interacting field, the montage where all parts are present at once in an act of integral perception.

The contrast between lineality and mosaic simultaneity is an interesting one. Some of the examples cited are more convincing than others. Also, we may suspect that each age exhibits more than one model, or at least that each model itself can undergo many fascinating permutations and transformations and creative combinations with other models. The fact remains that McLuhan's two preferred models are useful heuristic devices that do help us notice the form and shape of cultural change. There may be more to the contemporary world view than mosaic simultaneity. Nevertheless, McLuhan is right in pointing to it as a significant aspect of whatever it is that is reshaping aesthetic, philosophical, and social patterns by which we organize information about our world.

THE MEDIUM AS ICON

We must now consider more closely the relation, as McLuhan conceives it, between technological media and the cultural form in which they are involved. One unfortunate trend in McLuhan's thought is to present the relation as mainly a *causal* one, which, I want to argue, goes against his own best insights.

In *The Gutenberg Galaxy* McLuhan quotes Peter Drucker: "There is only one thing we do not know about the Technological Revolution—but it is essential: What happened to bring about the basic change in attitudes, beliefs, and values which released it?" McLuhan then offers his study of the "Gutenberg Galaxy" as an

attempt to supply the "one thing we do not know." Fortunately, he then adds, "But even so, there may well prove to be some other things!"[20] In point of fact, McLuhan does not succeed in supplying the "one thing," but he does, in the process, uncover some "other things" of great significance.

The problem is that when putting his points into compressed and gnomic utterances, he seems to be interested in a kind of lineal sequential causation that he has himself frequently proclaimed as inadequate to the full complexity of the phenomena being studied. Thus observations like: "the printed book created a third world, the modern world," or "Non-Euclidian space, and the dissolution of our entire Western fabric of perception, results from electric modes of moving information" seem unsatisfactory.[21]

In contrasting lineal and mosaic forms, McLuhan himself calls attention to the growing interest in "field" models among philosophers and scientists at the present time. He argues:

> Proneness to look for mono-linear causation may explain why print culture has long been blind to most other kinds of causation. And it has been the consensus of modern science and philosophy that we have now shifted from "cause" to "configuration" in all fields of study and analysis.[22]

However, in attempting to emphasize the neglected role of technology in the total field of human thought and action, McLuhan tends to lapse into a pattern of lineal causality in which a given medium seems to be the single, irreversible cause of a single passive cultural effect. More convincing would be a description in terms of multiple causal relations in reversible interaction within a field of energy stresses and feedback, so that no single cause can be isolated as the irreversible determinant of a single discrete effect.

For example, McLuhan's student and most able interpreter, Walter Ong, puts the complex relationship between media form and intellectual-social forms during the Gutenberg era in a less simplistic, mono-causal form than McLuhan is wont to do in his epigrammatic statements. Thus, Ong calls Ramism and printing related "epiphenomena." Furthermore, if printing can be called the "cause" of Ramism, it is also true that Ramism and related in-

tellectual developments could be called the "cause" of printing. Ong wonders:

> But why printing in the modern sense was developed when it was and not earlier, since all the necessary elements . . . had been known in western civilization from antiquity, still remains a mystery. The perspectives developed in the present study of Ramism suggest a new line of attack on this intriguing question. The invention of printing . . . had to count as a profound reorientation within the human spirit.[23]

McLuhan would hardly dissent from this emphasis on configurational interaction rather than lineal causation which flows from his own basic "message." But we must now state more exactly the relation that does exist between a technological medium and the dominant cultural form.

We have referred so far rather loosely to "forms" and "models." A form is a distinctive relation among parts. It includes, but is not restricted to, tangible physical or visual shapes. There are mathematical relations, for example, that cannot be visualized and yet are distinctly recognized by the mathematical mind. McLuhan is intrigued by the manner in which a common form can be recognized in a wide variety of phenomena within a given cultural area. For example, consider the form of homogeneous lineality. This form may be recognized in the homogeneity of the printed page, the identical books formed by these pages, the homogeneity of the rows of seats in a typical classroom where those books are studied, the homogeneity of certain social patterns occurring in literate society, the homogeneity of space described by certain literate philosophers and mathematicians.

How are we to describe the relation obtaining among these various examples? A "formal" or "configurational" analysis will apprehend each as "derived" from the other, much like a geometer derives the forms of his cubes and spheres from the forms of his planes (and the reverse) without maintaining any one to be the efficient cause of all the others.

In this connection, Kenneth Boulding argues in a penetrating essay that "McLuhan often makes the mistake of supposing that it is the physical form of the medium which is significant rather than its social context."[24] Boulding asks: Is it the form of the printed page that has contributed to the homogenization of literate

culture, or is it rather the fact of homogeneous multiplication of identical books distributed to a wide audience? Is it the repeatability of the type on a page, or the repeatability of identical books and their social relation to their readers (their "range") that is the significant factor?

This is a perceptive observation that points to the manner in which a form "resonates" in a variety of related, interacting dimensions of influence. However, it may be that McLuhan's emphasis on the physical or aesthetic form of the medium itself is also useful once it is purged of its mono-causal implications. What McLuhan is pointing out is that a given technological medium can serve as the paradigmatic model of the entire set of interacting forms dominating the cultural period. Now a model can assume any form, physical or nonphysical, visual or non-visual; it can be an equation or a pattern. However, it is possible to use a model that is concrete, tangible artifact, like a pulley, or a physical set of relations, like a specific planetary system. Such a model can be called an icon; that is, a physical item used as the paradigm revealing a distinctive form applicable to other phenomena as well.[25]

We may interpret McLuhan, then, as treating technological media as iconic models which provide a given culture with its most influential patterns of behavior and organization.

It is easy to see how the book has served as iconic model for the interacting forms of homogeneous lineality already indicated. But what is the model for the new era presently emerging? In a period of media proliferation, it is difficult to decide on any single one as the paradigm case. Perhaps the phenomenon of electricity itself should be considered as the new model, for it is the technological mastery of this force that has produced a second revolution within the modern industrial age. As noted above, we are now able to distinguish an early mechanical age utilizing sources of energy like steam and operating by means of mechanical objects facilitated by wheels, from the new electronic age driven by electricity and in which electric circuits render the wheel obsolete. The most salient feature of electricity, of course, which has turned a quantitative acceleration into a qualitative transformation, is its speed.

If we look for an iconic model of this new era, several candidates are possible. McLuhan gained the greatest attention from the public for his discussions of television; however, in this connection McLuhan's fertile inventiveness often seems most forced—clever, but not convincing. Thus McLuhan considers the "TV image as a mosaic mesh of luminous points comparable to a Seurat painting" and points to the similarity of the mode of developing an image by means of "light through" rather than "light on" in the manner of a stained glass window or a painting by Rouault.[26] The analogies are intriguing, but it would seem that here Boulding's distinction between the physical form and the range holds true. McLuhan has been suggestive, but he has not really demonstrated how the iconic form of television has itself radically changed our sensibilities. Change in social form wrought by the "range" of television has been indeed tremendous. We will return to this point again.

However, it would seem that McLuhan is actually more interested in another candidate for the role of iconic model of the electronic age. This is the newspaper as it develops under the influence of the telegraph, providing almost instant information from all parts of the world. On the newspaper page a myriad of disparate facts and opinions on a wide variety of subjects are placed in physical contiguity with one another according to a single principle of selection—the dateline. Here in tangible form we witness the breakdown of lineality, specialization, logical continuity in favor of the mosaic, the montage, the development of the gestalt of simultaneity. In many ways the newspaper is iconic paradigm of the new form of social perception operating in the new age.[27]

THE DEATH OF THE LITERARY ETHOS

We are now ready to consider the sensitive nerve at the heart of McLuhan's argument which is the source of most of the pained reaction and resistance to his work. McLuhan is arguing that the turmoil of twentieth-century change involves the death of what I will call the literary ethos. It is important for clarity and understanding that we appreciate exactly what is and what is not maintained in this thesis. An ethos is a configuration of thought, feeling,

and style determined by some focal image or model. The literary ethos has been constituted by the book as iconic model, which imparts to this particular gestalt its characteristic shape and style. The death of the literary ethos means only the demise of the book as iconic model, not the demise of interest in books or literary pursuits. As McLuhan puts it: "The book thrives as never before, but its form is no longer constitutive or dominant."[28]

Actually, more books are printed and read today than ever before; the paperback revolution has added new dimensions of relationship between the public and books. Nevertheless, these facts in no way contradict the thesis that the dominant literary ethos has declined in strength and influence. Books continue to participate in the new mosaic ethos that has emerged, but they do not determine its distinctive quality and shape.

We thus reach the central contention of this paper. I maintain that the achievement of Marshall McLuhan is to have secularized and demythologized the literary ethos that dominated the intellectual culture of the West from the Renaissance till the advent of the electronic age. By "secularize" I mean that he has seriously weakened the claim of the literary ethos to possess some superior (almost sacred) vantage point from which all other cultural phenomena are to be evaluated. By "demythologized" I mean that he has deprived the literary ethos of its dominant mythical drama in which a world lost in barbaric illiteracy is saved by the trinity of literacy, scholar, and book.

No doubt my restatement of McLuhan's theme will be misunderstood as completely as have been McLuhan's own pronouncements. The point being made is not that literacy and books are to be deplored as inferior modes of human activity; nor is it a prophecy that for good or ill, literate pursuits are vanishing from modern culture. Neither of these judgments is correct. What is a fact, however, is that the ideals of literacy and the cult of the book are being forced to withdraw their claims to be the unique source of some kind of human beatification. They must now accept their humble but functionally important status as one participant among many in the development of a new human style of perception and behavior.

McLuhan argues that just as the sixteenth century experienced a painful transmutation in sensibility occasioned by the introduction of lineal type, so the twentieth century is undergoing its own kind of transformation through electronic media. In the earlier period McLuhan observes:

> Had the Schoolmen with their complex oral culture understood the Gutenberg technology, they could have created a new synthesis of written and oral education, instead of bowing out of the picture and allowing the merely visual page to take over the educational enterprise.[29]

A similar challenge faces the educators of today; it is not a question of rejecting the techniques and values of literacy, but of deciding "how to breathe new life into the lineal forms of the past five centuries while admitting the relevance of the new organic forms," of determining "the new configurations of mechanisms and of literacy as these older forms of perception and judgment are interpenetrated by the new electric age."[30]

In a perceptive essay Susan Sontag thus argues that the basic cultural tension of our times is not between humanism and science or between high art and mass art, but between the ethos of a literary world (represented by Matthew Arnold and his notion that "the central cultural act is the making of literature" [as a criticism of culture]) and a "new (potentially unitary) kind of sensibility" that is being described by such disparate but representative figures as Nietzsche, Wittgenstein, Antonin Artaud, C. S. Sherrington, Buckminster Fuller, Marshall McLuhan, John Cage, André Breton, Roland Barthes, Claude Lévi-Strauss, Sigfried Giedion, Norman O. Brown, and Gyorgy Kepes. The new sensibility is being formed by contemporary experiences—of crowdedness, mobility, speed, mass communication, and mass production of art "objects."[31]

In this vein we can see that McLuhan is one spokesman of a revolution in sensibility that is secularizing basic aspects of the prevailing humanist culture of post-medieval modernity. The obvious achievements of this great civilization are still recognized and will continue to be utilized. But the parochial sense that somehow the aesthetic and human values explored in this period can

serve as a kind of absolute norm of how the world can and should be perceived is being dispelled. This, McLuhan argues, is the "message" of contemporary art that has abandoned the ideals of perspective and literal representation of the sensible world to explore new combinations of form bewildering to the traditional spectator. The most interesting contemporary novels, dramas, and movies tend to ignore a conventional narrative line and experiment with unexpected juxtapositions of time and space. Is this simply a cult of perversity or, at best, an honest expression of the disintegration of human value and the baneful loss of a sacred center to our civilization? McLuhan argues that both interpretations are unsatisfactory.

The modern artist at his best is pointing to the possibility and, indeed, the necessity of devising new perceptual ratios that will overcome the restrictive nature of past models. It is not the case that perspective and realism are the norm of human art; on the contrary, they represent a narrow, restricted experiment that has its values but in no sense represents the universal standard for all human apprehension. Neither is a lineal model, with its bias toward the exclusive continuous line, in any obvious sense superior to the iconic mode, in which a myriad of perspectives and dimensions is presented simultaneously. If modern art displays formal similarities to primitive, Eastern, and medieval art as against the art of the post-medieval age, then it is modern art that may in the end seem more universal, and Western perspectival art that may finally assume the status of a narrow experiment, a distortion of the fullness of experience in order to achieve a special effect.

McLuhan's approach has quite deliberately obliterated the distinction dear to the literary mind between the "arts" and mass media. McLuhan points out that every form of communication is a mass medium. The invention of the alphabet was a tool that transformed the mode of apprehending and organizing social experience of all those who utilized its capacities. What is more of a mass medium than Gutenberg's press and the host of identical books it produced which enabled educators to influence the consciousness of a host of students according to repeatable homogeneous patterns of thought? The tension between the book culture

and the electronic culture is between mass media, not between some superior mode of literate apprehension and an inimical technology. The literate mind is itself a function of technology, and its present emerging awareness of this fact is a part of its painful secularization process.

Once stated, the point seems obvious, but it was not obvious until so stated. The defender of the literary ethos may, however, respond that even so, one medium may have certain qualities that render it preferable to others as a form of communication. With this suggestion there can be no quarrel. To secularize the book is not to deny its many obvious values as a power in the self-development of man; it is only to point out that other media have their own particular assets and liabilities as well.

In this connection, McLuhan's discussions of the differences and points of contact between the literate and the electronic cultures is particularly insightful. He points out how the printed book has encouraged the humanist emphasis on the "individual" and "self-development." The controlling image is of the solitary man reading his book silently and undergoing rich experiences of intellectual growth in his interior life. The book enabled the reader to detach himself from his surroundings and embark on an exciting task of inner exploration. Furthermore, the book provided him with the sense of personal control. Defenders of the book frequently point out one of its most obvious and incontrovertible merits: the reader can determine his own rate of advance and can return to passages of special importance according to the dictates of his own will. There is no wonder that the man of the book develops a strong sense of his autonomy, individuality, and detachment from direct involvement in his immediate environment.

Electronic media, on the other hand, enhance a participatory focus. Sometimes, McLuhan argues, the iconic or physical form of the medium itself encourages this stance, as when he tries to demonstrate how the mosaic mesh of the television image forces the viewer to become involved in the "completion" of the image. However, the more obviously compelling argument has to do with the range and speed of the media. Thus the newspaper provides almost instantaneous involvement with events throughout the

world. We do not *read* the newspaper. We scan it, absorb its mosaic constellation of events, then discard it for a later edition that is soon in our hands. The television here becomes the paradigmatic example. In *Understanding Media,* McLuhan was impressed with how the assassination of President Kennedy became an event of global consciousness, viewed on television almost simultaneously by peoples throughout the world. An even more graphic example substantiating McLuhan's point is the now historic space flight of Apollo 11. It is difficult to say which aspect of this epochal event is more impressive: the technical feat of reaching the moon or the presence of the television camera which enabled the world to participate in the landing simultaneously with its immediate occurrence. The world as "global village" exhibiting an interdependent consciousness through the ganglia of the television extension of awareness was here realized. If, after considering this event, the critic still resists the notion of a global awareness as unintelligible fancy, it would seem that further argument is futile. This particular television experience has demonstrated McLuhan's thesis so forcefully that we may consider it a case of "overkill."

What are we to make of this new phenomenon? The literary critic tends, for the reasons noted, to associate his book culture with a defense of the "individual" and the "autonomous self"; to him, the electronic media (which he calls "mass media") have brought about the conformist mentality of the "mass mind." McLuhan urges us to rethink these clichés of nineteenth-century liberal and humanist thought in the light of twentieth-century developments. In *Through the Vanishing Point,* McLuhan makes an extremely helpful distinction between the "public" of the literary ethos and the "mass audience" of the electronic culture, and suggests that the relation between the "individual" and "mass conformity" is more complicated than the traditional critic has recognized. For example, although the book has encouraged the sense of the individual for the reasons already noted, it is also true that the book has been an important instrument in the movement toward conformity that the humanist so much deplores. The homogenization of language and of national groups seems to be

reflected in the reading of homogeneous books. Western religions become involved in an intensified concern for homogeneous dogmas clearly stated in printed form and distributed to the homogeneous believers.

Again, the humanist desire that people participate in a unified educational experience in which they read the same "great books" in common is hardly exempt from some kind of conformist bias. McLuhan notes:

> For the man of the printed word another man has to run on the same rails with himself in order to be in the same world at all. So that paradoxically, this highly specialist, lineal individualist exacts a high degree of conformity from his fellow travelers.[32]

The literate man of the last centuries has thus existed in a more paradoxical situation than he consciously recognized. A private individualism has interacted with a public conformity, and both are polar constituents of the same process.

Nevertheless, assets and liabilities go hand in hand, and the development of electronic media has introduced a new set of virtues and defects into the human situation. McLuhan argues that we are now "confronting an electric technology which would seem to render individualism obsolete and the corporate interdependence mandatory." He points out:

> The immediate prospect for literate, fragmented Western man encountering the electric implosion within his own culture is his steady and rapid transformation into a complex and depth-structured person emotionally aware of his total interdependence with the rest of human society.[33]

Instead of a literate "public" we now have an electronic "mass audience." The mass audience is less detached, more actively involved with one another and with the artist. Nevertheless, it is an unwarranted cliché to see the mass audience as a sinister conformist group in a way that the literate public supposedly is not. "The highly literate and individualist liberal mind is tormented by the pressure to become collectively oriented. The literate liberal is convinced that all real values are private, personal, individual. Such is the message of mere literacy. Yet the new electric technology pressures him towards the need for total human interdependence."[34]

There is no doubt about the fact of this trend, but only about its interpretation. McLuhan argues that the electronic culture has transformed but not eliminated the paradoxical relation between the private individual and public conformity that existed during the literary age. Thus the old humanist self had his problems with the "public," as Kierkegaard noted, and the new human person has his own relation to the "mass" formed by communication media.

> ... whereas "the public" as an environment created by print technology consisted of separate individuals with varying points of view, the mass audience consists of the same individuals involved in depth in one another and involved in the creative process of the art or educational situation that is presented to them.[35]

McLuhan is not here asserting that the new cultural form emerging necessarily and automatically ensures a benign social relationship among its members. He is simply pointing out that the new form seems to have as many or more possibilities of achieving the proper equilibrium between individual and social needs as did the superseded lineal form. It is inconsistent of the humanist to deplore the mass effects of electric media without seeing the conformist elements in his own beloved book culture. Consider music:

> ... the pre-electric music of the concert hall (the music made for a public rather than a mass audience) was a corporate ritual for the group rather than the individual. This paradox extends to all electric technology. The same means which permit a universal and centralized thermostat in effect encourage a private thermostat for individual manipulation. The age of the mass audience is thus far more individualistic than the preceding age of the *public*. It is this paradoxical dynamic that confuses every issue about "conformity," "separation" and "integration" today. Profoundly contradictory actions and directions prevail in all these situations.[36]

In such a passage, McLuhan challenges us to recognize the complexity of media forms. Book culture gave to man both an inner freedom and an outer homogeneous bondage. Electronic media gives to man the freedom of greater awareness of an involvement in the social process at the same time that it takes away his freedom to detach himself from the unrelenting pressure of

action, reaction, interaction, in the dynamic field of global society. The task of our time is to provide an adequate mixture of media in which both kinds of freedom are enhanced and both kinds of bondage are diminished.

However, one thing is certain: although such a "media mix" may involve the book in an important manner, it will not be accomplished through a return to book culture in its older dominant form. In that sense, the literary ethos is dead.

TOWARD A CONCLUSION

McLuhan has been characterized as the purveyor of a "cut-rate salvation," an advocate of totalitarianism, a bizarre obscurantist, an apostle of twentieth-century irrationalism, the author of a "Summa Popologica." The basic complaint is that he is espousing an electronic utopianism in which man is to be saved and made whole through mass media, without human act or conscious decision of his own.

Is this interpretation of McLuhan's intent a fair one? Does he really mean that suddenly, by the emergence of mass electronic media, the problems of our culture have been solved and the millennium about to be realized? Has McLuhan, in eluding the dull negations of Cassandra, simply transformed himself into the Pollyanna of pop?

In fact, McLuhan aspires to neither role. The appearance of sanguine optimism is caused simply by his refusal to cooperate in the heavy-handed denunciation of modern civilization promulgated by many humanists and existentialists. McLuhan's aesthetic formalism has taught him to be profoundly suspicious of moralism. On this point, as we have pointed out, the irony of the situation is that it is an elitist ideal of moral circumspection which McLuhan now counsels his indignant humanist critics to apply to the current situation. Cool understanding should precede hot evaluation. He recommends the very traditional Western scientific method of reserving judgment until all factors of the situation have been adequately noted. A premature pressing of the panic button is no contribution to humanist wisdom. He even urges his critics to live up to some of the best features of the literary ethos.

Those who panic now about the threat of the newer media and about the revolution we are forging, vaster in scope than that of Gutenberg, are obviously lacking in cool visual detachment and gratitude for that most potent gift bestowed on Western man by literacy and typography: his power to act without reaction or involvement.[37]

Nevertheless, it cannot be denied that McLuhan's writings, especially *Understanding Media,* do convey the sense of easy optimism. Some of this is generated by a tone of gusto and exuberance permeating his account of the mass media. As Mc-Luhan points out, "any attention to new media which are in the ascendant, whose gradient is climbing rapidly, is considered as an act of optimism."[38] More than that, McLuhan imparts the feeling that he is enjoying his explorations, just as one may be exhilarated by a roller coaster ride in a crass amusement park, or as Shakespeare took pleasure in the vulgarity of his clowns and rabble. McLuhan has a bit of the aura of the missionary gone native or the folk doctor who has become careless about procedures to protect himself from infection from those to whom he ministers. Yet we may wonder if some of the dour critics offended at this casual breeziness have not themselves on occasion smiled at the antics of Mae West.

There is one technical point, however, where I think an error in emphasis on McLuhan's part has contributed to his reputation as a facile optimist of pop culture. I refer to his frequent association of the book with the "dissociation of sensibility" and his implications that electronic media have a built-in propensity to encourage wholeness and depth participation. Thus we are told that "Print asks for the isolated and stripped-down visual faculty, not for the unified sensorium," while "the cool TV medium promotes depth structures in art and entertainment alike, and creates audience involvement in depth as well." Here it is not sufficient for McLuhan to assert that he is offering a description and not a moral judgment, for we feel that something is wrong in the description. What is it?

I think the answer is that here McLuhan the formalist has failed to distinguish adequately between the formal limitations imposed by the physical configuration of a given medium and the formal arrangements of the artist working within those limitations.

Thus, for example, oils and canvas are a medium that imposes certain limitations on the artist; yet within those formal limits of a physical kind, the artist can adopt a variety of formal styles—realism, mannerism, impressionism, etc. So also in the case of communication media, we must distinguish between the physical limitations (the formal frame) of the television screen and a variety of formal possibilities that may be conveyed within that formal frame.

I am not suggesting that McLuhan is unaware of this obvious distinction. Indeed, one of his points is to urge the artist to conform his own formal explorations to the physical, formal frame of the medium he is using in order to achieve the maximum possibilities inherent in it. Thus, for example, he has interesting notions of the kinds of materials that are and those that are not adaptable to the television medium.

However, having made this distinction, McLuhan tends to obscure it, especially in his important discussions of tactility. By "tactility" McLuhan means the sense of dynamic contact with the environment that is generated by an active interplay of all the senses. He argues that the literary ethos diminished tactility by encouraging lineal visual models in which the other senses are ignored or undervalued. However, even if this is true of the particular cultural form we are considering, we must avoid the error of associating a loss of tactility in some essential way with the eye or the book, just as we may also doubt whether electronic media have, by the mere fact of their particular formal frame, reinstated it within human consciousness.

McLuhan obtained the concept of tactility from aestheticians like E. H. Gombrich and Heinrich Wölfflin. Bernard Berenson is quoted: "The painter can accomplish his task only by giving tactile value to retinal impressions."[39] Does not this observation imply that painting as a formal frame is capable of conveying both tactile and non-tactile impressions according to the individual formal style chosen by the artist? By the same token, may we not suppose that electronic media like television and radio are capable of conveying both tactile and non-tactile "messages" and are not inherently associated with one possibility only?

McLuhan argues that the literary ethos of *The Gutenberg Galaxy* can be characterized as hypnotized by the iconic model of the book, with a corresponding loss of tactility. McLuhan documents this judgment with his account of the trends toward the purification of language and the elimination of Rabelaisian grossness that marked the ascendancy of literary man. However, this hypnotic aspect of the literary mind need not be attributed to any inherently non-tactile quality of the book itself. McLuhan offers many interesting examples of how the book is capable of conveying a tactile experience. By the same token, we must recognize that the eye is no more or less tactile than the ear or any other sensory organ; indeed, the eye has tactile quality and sensual feel in its response to color, shade, and depth (through binocular vision).[40] Furthermore, there is no intrinsic reason why a lineal sequence could not be apprehended with tactile awareness, any more than a simultaneous mosaic might not somehow be capable of losing its tactile quality.

McLuhan is more convincing in demonstrating certain benign effects of the electronic media on human consciousness when he connects the thesis with his analysis of the hypnotic effect of a single medium on human awareness. McLuhan argues that "Our private senses are not closed systems but are endlessly translated into each other in that experience which we call con-sciousness."[41] However, a communication device has the effect of extending one sense inordinately, causing a corresponding diminution in attention to the others. The result is a dissociation of the sensibility, a kind of amputation of consciousness as the tactile interplay of the whole has been fragmented into an intensified concern for a part. This condition can be called "hypnotic," since hypnosis depends on the emphasis of one sense only to the exclusion of the others.

For these reasons McLuhan's more acceptable argument is that *any one* medium will tend to exert a hypnotic effect by accentuating one sense to the neglect of others. In this vein, we see that the radio can have a hypnotic effect as well as the book, and that television can be the source of narcotic trance as well as haptic deliverance. The hope for release is to be found in the development of a dynamic interplay among many media, which

will encourage a corresponding tactile interplay among the senses of which they are an extension. Consequently, freedom from the hypnotic effect of an extended sense in one direction is to be achieved by the counter-extension of another sense through a different medium. In other words, once man undertakes the venture of extending his senses through technology, he can only hope to regain tactility through an interplay of media—a media mix.

The advent of electronic media has had a benign effect on human consciousness, then, not because of some essential quality in their own distinctive forms, but rather because they have provided alternate avenues for sense extension that have broken the hypnotic effect of Gutenberg type. Although the new media will in turn generate fresh problems, there is a sense of exhilaration and heady optimism at the moment that the hypnotic trance of the past is broken.

In describing the shape of our emerging electronic culture, McLuhan is most convincing when he turns from analyses of the specific formal frames of each medium and examines the general social form of the media interplay as a whole. Here his emphasis on the speed of electricity is sound and important. Another source of the suspicion that McLuhan is an easy optimist is the fact that he accepts the new mode of speed as a possible one for man, whereas many traditional critics of contemporary trends fear that the new accelerated rhythms will dehumanize man and destroy his relation with the less frenetic patterns of the cosmos as revealed, for example, in the gradual seasonal shifts of the year.

An intriguing discussion between Wyndham Lewis and the futurist Filippo Marinetti is a case in point. According to Lewis, Marinetti asked:

"Have you ever travelled at a kilometre a minute?"

"Never." I shook my head energetically. "Never. I loathe anything that goes too quickly, it is not there."

"It is not there!" he thundered, for this had touched him on the raw. "It is *only* when it goes quickly that it *is* there!"

"That is nonsense," I said. "I cannot see a thing that is going too quickly."

"See it—see it! Why should you want to *see*?" he exclaimed. "But you *do* see it. You see it multiplied a thousand times. You see a thousand things instead of one thing."

I shrugged my shoulders—this was not the first time I had had this argument.

"That's just what I don't want to see. I am not a futurist," I said. "I prefer *one* thing."

"There is no such thing as *one* thing."

"There is if I wish to have it so. And I wish to have it so."

"You are a monist!" he said at this, with a contemptuous glance, curling his lip.

"All right. I am not a futurist anyway. *Je hais le mouvement qui déplace les lignes.*"[42]

In response to this juxtaposition of values, we may simply observe that McLuhan is surely right in refusing to make premature moral judgments. It would seem that man is a very pliable animal who lives a fulfilled life with either permanence or change, stability or speed, in a closed or open society; in each instance, we may suppose that some have found their lives unsatisfactory and others profoundly satisfying. We may suppose a traditional man happy in the uneventful routine of his cyclic existence. We may also suppose the astronaut exultant as he reaches the moon. If one of us hates the noise of the city, another enjoys its music. If one of us craves the peace of creative routine, another longs for adventure and the exploration of the unknown. Let each of us have his preferences. Let the intellectual provide various models of existence for our possible adoption. But it is time to abandon the parochialism by which a given form of existence, usually our own, is presented as the norm of all human excellence.

This is not to say that McLuhan is incapable of adopting the mantle of Cassandra when the situation requires it. It is curious that so many critics interpret McLuhan as simply celebrating the interdependence of the electronic world as the matrix of benign Utopia. Evidently words like "global village" and "participation" evoke tones of positive fulfillment in many minds. McLuhan, however, repeats with great frequency the warning that "as our senses have gone outside us, Big Brother goes inside. So, unless aware of this dynamic, we shall at once move into a phase of panic terrors,

exactly befitting a small world of tribal drums, total interdependence, and superimposed co-existence." He observes that literacy allows for "some gaps and some islands free from the unremitting acoustic pressure and reverberation."[43]

But the present situation is more complex than the traditional kind of literary critic makes out. Participation is not the same thing as conformity, and neither is it a synonym for harmony. "There is more diversity, less conformity under a single roof in any family than there is with the thousands of families in the same city. The more you create village conditions, the more discontinuity and division and diversity. The global village absolutely insures maximal disagreement on all points. It never occurred to me that uniformity and tranquillity were the properties of the global village. It has more spite and envy."[44]

It is in such a passage that the secularizing tendency of McLuhan's thought is most forthrightly present. The point is not to defend or attack any one medium as the sacred source of human good or the profane cause of our problems. Each medium has varying capacities, and it is up to us to determine the proper "mix" of media that will best enhance the particular blend of individual detachment and social participation that we consider humanly desirable. This point leads us to the most important suggestion in McLuhan's analysis. He argues that the electronic culture has produced a new situation by affecting the nervous system directly in a total assault that it is impossible to elude. Whereas technology in the past affected one or the other of the senses in special ways, the speed of electricity has created an electronic environment which pervades and affects every aspect of our consciousness in a total manner. Liberation from the literary model is thus supplanted by a new "numbness" that we are forced to adopt as a defensive measure: "We have to numb our central nervous system when it is extended and exposed, or we will die. Thus the age of anxiety and of electric media is also the age of the unconscious and of apathy."[45]

McLuhan is quite aware of and sympathetic with the fear that electronic culture is an age when autonomy is lost and man is manipulated in trance-like state by the operators of the media or

perhaps by the media themselves. What is to be done? In *Understanding Media,* McLuhan is content in the main to describe the situation, but, as we have already noted, in subsequent articles he has developed a promising category in his distinction between environment and anti-environment. Release from the hypnotic and numbing effects of an environment is never achieved by a mere act of willpower. It requires the creation of an anti-environment that provides an alternative point of reference from which one can for the first time bring his environment into conscious awareness and, it is hoped, under his conscious control.

Here, of course, McLuhan looks to the artist, whose role is to create forms that, as we have seen, are not escapist in intent but, on the contrary, functional in liberating consciousness. However, the electronic environment is so inclusive and overwhelming in scope that the creation of this anti-environment is more difficult than ever before. Thus, for example, "Today what is called 'Pop Art' is the use of some object from our own daily environment as if it were antienvironmental."[46] However, such art seems less likely to accomplish a liberation from the environment than a deep immersion in it. In focusing attention on the environment, the artist faces the danger of himself becoming hypnotized and numbed by it. McLuhan observes: "The function of the artist in correcting the unconscious bias of perception . . . can be betrayed if he merely repeats the bias of the culture instead of readjusting it."[47] We thus find the work of the contemporary artist ambiguous so far as this task is concerned. Are the products of pop art in the creation of a genuine counter-environment or, as seems more likely, the extension of the environment into the counter-world of art itself?

Furthermore, it would seem that in an age when the technological environment has become total, the release will not be accomplished by the private individual working alone, but by the creation of an anti-environment on a social and global scale. McLuhan summarizes his basic "message" as follows:

> From the development of phonetic script until the invention of the electric telegraph, human technology had tended strongly toward the furtherance of detachment and objectivity, detribalization and indi-

viduality. Electric circuitry has quite the contrary effect. It involves in depth. It merges the individual and the mass environment. To create an antienvironment for such electric technology would seem to require a technological extension of both private and corporate consciousness. The awareness and opposition of the individual are in these circumstances as irrelevant as they are futile.[48]

We may well wonder what such an extension of "both private and corporate consciousness" would be like. In any case, McLuhan seems to be on the right track in suspecting that homilies about maintaining the existential self as an island of autonomy within the sea of electronic influence are superfluous. Real freedom from the baneful effects of the electronic world will be achieved through the corporation and social decisions of mankind or not at all.

PROSPECTS FOR THEOLOGY

In conclusion, let us continue McLuhan's unfinished exploration of our dynamically changing environment with some observations about its possible relevance for theology. Theologians are often divided on the question as to whether theology should accomplish a "correlation" with culture or, on the contrary, preserve its own autonomy in the face of possible entanglements with cultural forms. Probably we have here a false dichotomy, since, unless theology has some autonomous identity of its own, there is nothing to correlate with culture, and once autonomy is achieved, some kind of relation with the culture in which it exists is inevitable. McLuhan is helpful to the theologian in his concern with either autonomy or correlation.

By pointing to the pervasive influence of dominant forms on consciousness, he warns the theologian that what he takes to be his autonomous reflections on his faith may be more culturally conditioned than he suspected. Thus I think it can be argued with some cogency that the difficulty that many contemporary theologians face is generated by the inextricable association of theological pursuits with the literary ethos.

This can be illustrated by the extreme emphasis on revelation as a book that has dominated the Protestant mind. The historical relation between the rise of Protestantism and the printing of the Bible is obvious and important. The focus of personal piety on

Bible reading and an intense suspicion of any other revelatory form besides the printed word are distinctive marks of this period. The loss of sense for mythic complexity and levels of meaning with a corresponding emphasis on a single literal meaning in every Biblical text is another example.

Furthermore, it can be argued that Christian theology of the post-medieval age has tended to identify its own concerns and fundamental orientation with the literary ethos as a whole. Thus missionaries have felt that, apart from the communication of the gospel, their greatest gift to the people with whom they worked was the impartation of literacy. Here also we observe the frequent alliance of the theologian with the humanist and existentialist in encouraging the development of the individual self.

These brief observations in no way are meant to imply that all of these tendencies were misguided. They are meant to suggest that contemporary theologians would do well to consider whether the waning of the literary ethos is necessarily a blow to any funda-mental theological concern. As we have already pointed out, this is not to say that literacy is not a great value or that the book or The Book will cease to be important in the new ethos being formed. Indeed, it may be that we will now recover the ability to read the Bible as a haptic experience of total involvement rather than as the reception of some fragmented lineal information.

The theologian can only profit from the insight that his interests and values are not identical to those of the literary world. The new electronic form of consciousness now emerging will dis-close many features that are harmonious rather than antithetical to the theological concern. For example, McLuhan points out that myth, defined as story containing multi-levels of significance, is no doubt regaining respect in an age open to the simultaneous inter-play of disparate phenomena within a mosaic field.[49] We may well wonder, then, if the demythologizing theologians are not operating in terms of an older literary sensibility that is fast being eroded.

However, the theologian would make a serious blunder simply to accept unquestioningly a new social form for an old. On the contrary, it is at this point that the theologian would do well to ponder McLuhan's question as to how a counter-environment can

be constructed in an age of total electronic environment. Might it be that theology and religion will thereby discover a more vital cultural function than ever before in history? In the past, various technologies have created partial environments for which artists and religionists have provided counter-environments of varying effectiveness. McLuhan observes: "As long as our technologies were as slow as the wheel or the alphabet or money, the fact that they were separate, closed systems was socially and psychically supportable. This is not true now when sight and sound and movement are simultaneous and global in extent." We now face a "crisis quite new in human history."[50]

Might theology find within its sources the means to construct a counter-environment global in scope and oriented to the dimension of our social interdependence rather than our individual solitude? Could it at least make a significant contribution to the formation of this liberating stance which no doubt, if McLuhan is right, will require a total rather than a fragmented response of the corporate body of mankind as a whole?

At this point McLuhan makes an astute observation: "Blake's counterstrategy for his age was to meet mechanism with organic myth. . . . Had he encountered the electric age, Blake would not have met its challenge with a mere repetition of electric form."[51] The problem is more difficult than we suspected. It is not enough simply to note the congruences between some electronic and theological forms. We must find the counter-model which will enable us to live in our environment as men who are not the passive objects of media forms but who through those forms can actualize a world in which it is possible to be truly human.

PERSONS AND PLACES: PARADIGMS IN COMMUNICATION

W. H. Poteat

We in the Western world have for a very long time common-sensically and primordially taken space to be that within which objects are enabled to be the particular objects which they are and, what is correlative to this, the medium within which these objects are distinctly separate—and indeed separable—from one another. Space, as we say, along with time, is one of the two fundamental coordinates by means of which we can make an identifying reference to any particular as *this* particular and also to make a *later* reference to a particular as *the same particular* (as one to which reference has hitherto been made).[1]

This has meant, of course, philosophical sophistications aside, that space as a field of action is the medium within which I *orient* my own body, whether in motion or at rest, to other bodies—be they animate or inanimate ones. I especially remark the words "later" and "orient" above because their very inexpungible presence in the text presents the theoretically sophisticated view which underlies our modern common sense with some paralyzing inco-herencies.

Since on its face it would be difficult to imagine, let alone prove, that our apprehension of the world of objects could be different from this commonsense view, as Kant seems definitively to have shown our tradition in arguing to space and time as neces-sary forms of sensibility for the appearance of any object whatso-ever, we must suspect that any incoherencies, if such there be, must have a profound rather than a superficial source in the paradigms undermining the structure of our imagination. Such is in fact the case, as I shall argue.

It has been observed often that Western sensibility in general and the Western epistemological tradition in particular have been peculiarly in bondage to models fashioned upon the characteristic quality of visual perception in their discourse about *all* perception as such and even for discourse about knowledge. The history of this bondage lies quite beyond the scope of the present essay, but the manifold instances in our tradition of exceptions to such a generalization should not persuade us that there is not a telling truth in this claim.

Let us observe. The Greek verb *aisthanomai* means "to perceive, apprehend by the senses, to see, hear, feel." The Greek ancestor of "perception" is not by itself over-committed to vision as a paradigm. And even when this radical sense is given over to a derived metaphorical use, there is no obvious prejudice favoring visual experience, for Liddell and Scott give as their second meaning for *aisthanomai* "to perceive by the mind, understand, hear, learn." There is as little comfort for this view in an analysis of the Greek verb *epistamai* which is clearly affiliated with a *skillful doing*, with, in contemporary philosophical idiom, a *knowing how* quite as much as with the perhaps more statically conceived and less obviously "embodied" *knowing that*. To be sure, when we come to the compound of *episteme* and *logia* from which we derive "epistemology," the *Oxford English Dictionary* gives "the theory or science of the method or grounds of knowledge"; a new move is made. Since the word epistemology itself is a late invention to single out that branch of philosophy concerned with the theory or grounds of knowledge, and has thereby affiliated *logia,* as it appears as the ending "-logy" in many English compounds designating theories of or inquires into sundry matters, with "theory" from the Greek *theoreo*, "to look at, view, behold; to inspect, to look at" and "to know (that)"—for which emphasis perhaps Plato is chiefly responsible[2]—beholding (as a spectator), perceiving, and knowing form a real, even if not wholly stable, alliance. *Perception, knowing,* and *"spectation"* are linked.

It would be ludicrous of course to place too much weight upon this far too cryptic characterization of the valences which connect "perception," "skillful doing," "knowing that," "theory,"

and "theory of knowledge" as if they might be strung together like beads, leading straight to the alliance of models of *perception as such* with visual perception. Yet let us not be misled from a true insight by demanding a meaninglessly rigorous test of what will be allowed to induce such an insight!

The complex interrelations among these tokens and their changing uses and linguistic affiliations are quite beyond a detailed explication, even perhaps by historical philologists. But our perspective upon these questions must be clear: these affiliations are surely the result of something more than mere coincidence and something less than explicit convivial consent. The logical resources conveyed by the linguistic elements in our tradition have surely conspired to make these matchings seem "right" as we have moved along. And as they have seemed "right," they have seduced us into certain ways of beholding the world when other ways were once still possible, and insofar have committed us to talking about what we behold and what constitutes the act of beholding in certain ways rather than in others.

Even if it is not true without qualification, therefore, that Western sensibility in general and the Western epistemological tradition in particular have been peculiarly in bondage to a reliance upon the characteristic quality of visual perception as a source of models for discourse about all perception as such and even for discourse about knowledge, it must be admitted that a very strong bias in this direction does exist; and that even when tactile, aural, and visual experience are examined as distinct, there is seldom an inclination to distinguish *tactile* space from *aural* space and to distinguish both in turn from *visual* space. The inclination is rather to assimilate the former two to the latter.[3]

One thing is quite clear: even without a detailed collation of the ingredient models functioning at the most radical level in the analyses of perception and of knowledge in, say, the writings of Locke, Hume, Kant, even Berkeley, one can become intuitively aware of the superordination of a certain view of the characteristics of visual perception as a paradigm for solving puzzles of perception as such. Who can read Hume's analysis "Of Self-Identity" or "Of Causality" without recognizing the extent to which the

problematics and the solutions are a function of Hume's having defined the conceptual limits of these discourses in terms of a particular model of some characteristics of visual experience?

It is not then a case of our commonsensical belief that space is that within which objects are enabled to be the particular objects which they are and the medium or form within which these objects are distinctly separate being false or even dubitable. It is rather that we have taken this (as I shall say) *derivative* notion of space and made it *primordial*. And the bias toward using the characteristics of visual experience as an epistemological model has had its part to play in this development. It has, if you will, provided an epistemological sanction for an uncriticized and therefore increasingly uncriticizable ontological presupposition concerning the radical nature of space and hence of the nature of those entities which "occupy" space, namely, bodies. The consequences of this bias, as I shall undertake to show, have not been trivial by having a merely theoretical bearing, but are on the contrary malign, indeed fateful, because they have shaped contemporary man's common sense. If this fateful issue is not as yet clear, it is nevertheless not premature to suggest that, with other influences, it has conduced to substitute in our commonsense conceptual repetoire the notion of this same "space" for that of "place." And when more has been said, I shall be able to contend that where the concept "place" becomes problematic, that of "person" becomes so too.

The model of spectation, statically, impersonally and discarnately conceived, has had, however equivocal it may have been, a peculiar hold upon our imaginations.

Yet further preliminary observations remain to be made.

It is not enough merely to remark the extent to which a commonsensically unexceptionable conception of space has been allowed to become the ontologically radical conception; or even to observe the ways in which the visual models often finding their way into determinative roles in our epistemologies have interacted with this ontological bias so as to make them mutually reinforcing with this bias. One must go further and risk the simplification that

the "subject" of the visual experiences from which these models are drawn is not only curiously passive—a *mere* spectator, as we might say—but a mere eye; in fact, a disembodied eye which is oriented from no body of its own.[4] Indeed, it is a general characteristic of modern theories of knowledge, Kant's First Critique being a suitable example here, to take knowing as an accomplished fact and then undertake a "transcendental analysis" of its necessary conditions, rather than to observe particular feats of the acquisition of knowledge to determine the processes which in fact enter into them. I have written elsewhere[5] concerning the wider implications of this motif. But it is only necessary for present purposes to say that a preoccupation with knowledge as an accomplished fact instead of concern with the processes of its skillful achievement, however useful and just it may be in itself, disposes the imagination toward a static rather than a dynamic picture of the noetic situation and therefore toward a passive rather than an active image of the "subject" of knowledge, the knower. And it is just this disposition which in due time makes us able not merely to tolerate but even to take as quite natural, because we take it quite unreflectively, the absurdity of the "visual experiences" of a disembodied eye.

I am not at all suggesting that in our epistemology and ontology we have consciously decided to operate with these absurdities. The fact, on the contrary, is that they inhabit our imaginations at so primitive a level and in such an equivocal fashion that, even when the presuppositions of these inquiries are quite explicit under review, such factors are almost never even vaguely sensed, and even when sensed are not recognized as being significant.

If, across a conceptual landscape dominated by models drawn from visual experiences—visual experiences, in effect, imputed to the disembodied eye—we find ourselves in due course arriving at the paradigm of a knower which is a god, this should in no way surprise us. On the contrary, it is any alternative issue which would be surprising.

However, in this piece of intellectual, historical, detective fiction, let us double back once again.

What we take to be *our* commonsense view of space—and I am far from proposing that we abandon it—seems to have its roots in two special forms of *spectation*: that of those Renaissance painters and architects to whom we credit the recovery (more likely it is a *dis*covery) of linear or geometrical perspective (etymologically, "clear seeing"); and that of the Platonically oriented — that is, geometrizing and, later, mathematicizing — physical theorists. The relations between these which must have existed, even if only tacitly, in the ethos of Florence and then Pisa and finally of Padua cannot be detailed since any important mutual influence would necessarily be unspecifiable. So much at least can be said: Italian artists of the fifteenth century were struggling experimentally to represent (i.e. cause to be *clearly* seen) three dimensions upon a two dimensional surface as their own eyes beheld Roman copies of Greek sculpture (often as bas-relief on sarcophagi), and to do this in terms of some formalized principles; Italian Platonists—chiefly Galileo—were undertaking, initially through reflection alone (i.e. intellectual spectation), to comprehend the motion of bodies in terms of number. While painters were trying to produce a visually homogeneous pictorial-space—a space into which "movement" guided by a clear and visualizable prospect could be imagined, the Platonic physical theorists were trying to evolve an intellectually homogeneous universe-space for which number would provide a formalized scheme for conceiving the motions of bodies.

Whether these enterprises had any significant explicit relation to each other at the level of reflection, it surely must have incited and confirmed the imagination of Galileo to behold the buildings of Brunelleschi and Michelangelo, the paintings of Masaccio and Piero della Francesca, all about him. The sensibility which conceived and the skill which executed Masaccio's *Trinity,* its incredible barrel vault forcing the surface of the walls of the Church of Santa Maria Novella in Florence, cannot be imagined as having no affinity with the intelligence which, relying upon mathematics, authored Galileo's *Dialogue on the Two Greatest World Systems* while he was lecturing on mathematics at Padua.[6] And even if the connections are so subtle as to defy explication, can we imagine

as unrelated the fact that Marsilio Ficino's translations of Plato should begin to appear in Florence in the generation after Masaccio mysteriously disappeared from that city forever; or can we put down to mere coincidence the growing influence of a logician such as Zabarella at Padua, who was so to stimulate Galileo? Nor can we lay it to mere chance that by the seventeenth century the ideas, however modified, of a philosopher like Plato, whose paradigm of true knowledge was that which is alone vouchsafed to a soul raised above history, *genesis* and *aisthesis* in pure, godlike epistemic vision of the very forms of things as they are, should nurture a revolutionary of the magnitude of Descartes, methodologically conceiving himself to be a discarnate intelligence viewing and accrediting the clear and distinct ideas made known only through such an ascesis; and enjoining all true science with him to embrace such an ideal and such a method.

And so here is our irony: our "common sense" conception of space which has become our primordial conception of it has its inception in artistic and mathematical spectation and achieves its consolidation in the model of a "discarnate," godlike knower for whom, it would seem, all knowledge must be an accomplished fact. And thus it happens that we, in the tradition, in the subtlest of ways, imagine ourselves as (at *least* in principle, we are careful to say, thereby begging the most staggering question of modern sensibility) godlike knowers viewing the homogeneous universe from which has been eliminated the heterogeneity of qualitative differentiation which as mere incarnate knowers we find forever obscuring the view.[7]

Let me now turn from these altogether too fragmentary observations to state quite boldly my principal thesis. It is this: When the notion of *place* is assimilated to that of space—in that sense I have been delineating above—or when *place* is preempted by *space,* in this sense the concept of a person falls into grave jeopardy. It is my contention that precisely this inversion is a creature of modern sensibility, and that an intellectual enterprise undertaking to propagate a new personalism which does not con-

jure with this grim fact can accomplish nothing more than its own self-deception. It is no part of an anti-Copernican obscurantism to say categorically that persons live in "the qualitatively differentiated and concrete world-space"; and if their conception of the world, even down to what they regard as the world of everyday spatiality, is deeply infected by a profoundly inimical view, such as that of geometry, then they are on the way to cultural insanity.

As against the view which I began by calling the common-sense view, the conception that space is primordially that within which objects are enabled to be the particular objects which they are and the medium within which these objects are distinctly separate, I shall maintain that it is primordially that by means of which I orient myself, or, more exactly, by means of which I am oriented from within my body.[8] To such a view my orientation to my body as an object or from my body as an object among objects to others is derivative. Space is primordially a pre-reflective vectorial orientation, and this precisely is my body in its pre-reflective integration into a world. My body is a "system of anonymous functions," to use a happy phrase of Merleau-Ponty. It is within an oriented *whence* that primordial spatiality lies, and it is from within this *whence* that all orientation derives. It there is no such orientation from within a pre-reflective *whence,* then there is and can be no reflective orientation. In short, our so-called commonsense conception of spatiality presupposes as its *conditio sine qua non* this pre-reflective uncommon sense.

In contrast to this, let us examine Cartesianism. First, my self as a thinking being is absolutely distinct from (though it remains equivocally joined to) the body. "Thus extension in length, breadth and depth, constitutes the nature of corporeal substances; and thought the nature of thinking."[9] And again: "We clearly perceive that neither extension, nor figure, nor local motion, nor anything similar that can be attributed to body, pertains to our nature, and nothing save thought alone; and consequently, *that the notion we have of our mind precedes that of any corporeal thing,* and is more certain."[10]

Thus we have a thinking mind, in every particular different from body or extended things, and of which we have both an

indubitable and antecedent notion to any we have of corporeal things. Since mind is in every particular different from corporeal things, and since our notion of mind *precedes* our notion of body and is indubitable, it follows that our notion of *our* mind as "ours" has no reference to or dependence upon any *particular* body (which must render the genitive pronoun "our" incoherent!) and also has no reference to or dependence upon the one and only body which is the entire universe or alternately the *notion* of body as such. And even though, rather embarrassingly, Descartes takes it for granted that there is some way in which these radically disjunct entities are joined, we have here in fact a discarnate mind and an insensate body.

But there is yet in store an at once more primitive and less explicit embarrassment to the whole Cartesian enterprise. He says: "In this way we shall ascertain that the nature of matter or of body in its universal aspect, does not consist in its being hard, or heavy, or coloured, or one that affects our senses in some other way, but *solely* in the fact that it is a *substance extended in length, breadth and depth.*"[11]

It is here that the paralyzing incoherence appears. For the concept of homogeneous quanta of space by means of which an extended "substance" is defined does not of itself provide us with the grounds for imputing *substantiality* to it; and in the repertoire for the mensuration of mere quanta of spatiality, there are no resources by means of which to specify that the spatiality has within it vectors, is inherently vectorial—having length, breadth, and depth as radii from some point of orientation. The price of defining mind in such a way as to deprive it of any incarnate existence is to deprive it of the very powers required for it to establish that extended things are *substantial* and that their spatiality is vectored—having length and breadth and depth; it is, in short, to deprive the mind of orientation. In a Cartesian world of extended objects, strictly speaking (and Descartes is often surprisingly lax with himself), not only do "length," "breadth," and "depth" have no meaning; neither, strictly speaking, have "extended" and "object." The lack of a primordial *whence* of orientation that is anonymously *in* Descartes' world antecedent to his

reflections upon the two kinds of substance open *to* reflection deprives the "substance," "length," "breadth," and "depth" of the *conditio sine qua non* of their having a meaning.

Now before such an incoherence as this, an imagination not already debauched beyond recovery would founder. Instead, faced with such an affront, the sensibility of the last three hundred years has been acquiescent and complacent. It is surely as Koyré has said: "It is a revolution so profound and so far-reaching that mankind . . . for centuries did not grasp its bearing and its meaning; which even now, is often misvalued and misunderstood."[12]

These three hundred years have not been without their dissenters, to be sure, as Hiram Haydn has documented in detail.[13] But no one saw so early or with a comprehensive equal to the import of these events as Descartes' younger contemporary Pascal. Descartes' *Principia Philosophiae* was published in Amsterdam in 1644. It appeared in French in Paris in 1647. Sometime between 1656 and 1662 Pascal jotted down what we now know as Fragment 72 of his *Pensées,* and in it he set down the first and the definitive statement upon the radical incommensurability of *space* and *place*. He writes:

Man's disproportion. . . . Let man then contemplate majesty, and turn his vision from the low objects which surround him. Let him gaze on that brilliant light, set like an eternal lamp to illumine the universe; let the earth appear to him a point in comparison with the vast circle described by the sun; and let him wonder at the fact that this vast circle is itself but a very fine point in comparison with that described by the stars in their revolution round the firmament. But if our view be arrested there, let our imagination pass beyond; it will sooner exhaust the power of conception than nature that of supplying material for conception. The whole visible world is only an imperceptible atom in the ample bosom of nature. No idea approaches it. We may enlarge our conceptions beyond all imaginable space; we only produce atoms in comparison with the reality of things. It is an infinite sphere, the centre of which is everywhere, the circumference nowhere. . . . What is a man in the infinite? . . . Who will not be astounded at the fact that our body, which a little while ago was imperceptible in the universe, itself imperceptible in the bosom of the whole, is now a colossus, a world, or rather a whole, in respect of the nothingness which we cannot reach? He who regards himself in this light will be afraid of himself, and observing himself sustained in the body given him by nature between those two abysses of the Infinite and Nothing, will tremble at the sight of these marvels. . . . For what in fact is

man in nature? A Nothing in comparison with the Infinite, an All in comparison with the Nothing, a mean between nothing and everything.[14]

If the foregoing observations have substance, then, let me repeat, the commonsense view of spatiality which has come down to us from the fifteenth through the seventeenth centuries and which has tacitly become for us the ontologically *primordial* view is radically incoherent. What is worse, its incoherence is humanly intolerable. Persons have *places*. The conception of space under review systematically preempts the notion of *place*.

I have argued that "extensions" or the perception of "extended" things presupposes a pre-reflective oriented *whence* from which radiating vectors distinguish length, breadth, and depth, which is to say that "extended" things are derivative, while the pre-reflective oriented *whence*—what we may now call *extension*[15]—is radical.

All this then means that for me, existentially, as the concrete person I am, *extension* is not first of all space, but rather is *place*, even as *extension* and *place* are the very ground of my being in the world through my body as I move toward its many horizons of thought-action.

What then is *place*? *Place*, one must say, the original place, is the *extension* which is the *conditio sine qua non* of my ever coming to have my own and very particular somatic existence. Place is the *where* of my body in order that there may be a "where" of my "body," to which I have the most fundamental of all relations, and is the condition of my having any "relations" whatsover. The "where" of everything else which more or less determinately inhabits the ambience of my being in the world is secondary: that is, it has its "meaning" in the "where" of my "body" with *their* meaning in the where of my being in the world. Even my "body" as *my* "body" is not in space. For in space every "extension" is interchangeable with any other of equal magnitude. But even with my "body" I have a relation that is privileged and inalienable— privileged and inalienable, that is, providing I do in fact *have* a "body"; providing, in other words, I have not abdicated it through pathology of some sort, such as catatonia. My relation to my

"body" is, you might say, *logically* inalienable. Such, indeed, is the condition of calling catatonia a form of pathology. It is quite ordinary to say: "I seem to have mislaid my hat." "I seem to have mislaid my 'body'," requires some elaborate exegesis.

My body is a *place* and therefore it is possible for my "body" to have a "place"—a "place" which is privileged and inalienable in the same way that my "body" is so; and that by reason of the fact that my "body" and its "place" are logically correlative. As "I seem to have mislaid by 'body' " sounds queer, so "I seem to have lost my 'place' " sounds so.

The space occupied by my "body" is a "place," and this is so because my body is pre-reflectively a *place*. Indeed, the "place" which is my "body" is *the* "place" *par excellence;* and the "extended" world which is arranged around my "body" is not spaces but "places."

In all these "places" are the familiar satisfactions of my "body," all the goals I seek, all the objects of my personal fulfillment, all the ends of my very personal moral action.

A "place" is where I feel at home, full of objects and of relations upon which I have left my very personal stamp, expressed my own idiosyncrasy, part of my unique history. It is a domicile for the love which issues from the very center of my own person.

Space can never belong to me, nor I to it; but "places" can belong to me and I to them. It is out of the deep pathos of the inalienable relation between a person and a "place" that there issued from Pascal, facing a universe of mere spatial magnitudes, "the center of which is everywhere, the circumference nowhere,"[16] his best remembered words: "The eternal silence of these infinite spaces frightens me."[17] It is out of this same pathos of our human identity with a "place" in the heterogeneity of concrete world-space that the author of Job speaks when he says: "He who goes down to Sheol does not come up; he returns no more to his house, nor does his place know him any more."

To be of no *place* is therefore to lack the grounds of becoming a person; and to have no "place" is to lack the minimum

conditions for remaining a person: a "place" which is the where of my "body."

This is not the only way in which we may understand "place," however—though in making these next moves we shall be trading (quite legitimately and surely with exact phenomenological accuracy) upon the multiple metaphorical or derived ways in which we unselfconsciously use the word "place" in ordinary speech.[18]

"Place" may be the where of my "body" and to such an extent a necessary condition of my remaining a person. But a where for my "body" is not the sufficient condition of my remaining a person. Place is also to be understood as *status*. My place is a *whereon to stand,* a platform from which an action may be launched. A body which cannot be the medium through which intentional actions become progressively determinate is not the where of a person.

Thus place is the where of my body and the whereon to stand of my will; it is status. But place is also more than these: it is *room*. To be and remain persons it is necessary that we be able to carry at least some of our intentions to completion, to be, in short, the authors of actual and not merely of possible acts. If we cannot exercise a genuine moral will through having full sovereignty over some of our acts, we cannot be fully personal. Now, in fact, we are *not* fully personal, and this is in part because we cannot command this full sovereignty. Yet it remains so that the extent to which we approach to personhood is a function of an exercise of such sovereignty. For such an exercise we require *room*.

There is a particularly important and interesting elaboration on this theme which is more substantial than the pun upon which it appears to turn. In an important sense *room* is required no less for our making the world intelligible to ourselves—and here room means both time and distance and all variations upon these in their literal and derived meanings and the points at which these literal and derived meanings intersect. Time, room, distance, are necessary if we are to comprehend, to order, to hierarchize, and to integrate the immediacies of our fugitive affective lives and of our no less fleeting perceptions. Our contemporary obsession with

immediacy causes us to overlook how genuinely unedifying sheer ecstasy or the blank stare of the shock of horror are. We cannot be persons when we have no room within which to comprehend our experience. Indeed, we cannot, lacking time and distance, properly have experience. We are condemned rather to the mere suffering of whatever happens to us. Existence becomes one un-differentiated happening. The liturgical shaping of a humane perception through art and ritual in order that we may comprehend love and death are to be replaced by the "real things"—as we now are taught to fancy it.[19]

Status and room have always been secured by ritual, which mediates the world, others, and ourselves even, to ourselves. The contraction within modern sensibility of place, status, and room have naturally been accompanied by the substitution of sheer spontaneity for the time and distance which is given in ritual—as Robert Coles so eloquently says:

> . . . Ritualization among men, which has had a certain stability, even through all the changes in history, may well be breaking down now in a very critical way. . . . Psychoanalysis is a ritualized form of be-havior. I hear people say to me now . . . we haven't got time, time for long analyses; we must confront one another at the moment, im-mediately, in an overwhelming way. And I find myself feeling old-fashioned, and saying, but we *have* to have time—time to get to know one another, slowly, tentatively, suspiciously, gratefully, surely, con-fidently. It *takes* time. . . . Wars can take a moment, and the world can be destroyed. And what do we get in art? . . . We get Brillo ads on canvas. . . . Maybe we can connect all this through that word "ritualization"; and wonder whether there isn't a breakdown affecting the artist, the writer, the warrior, the political leader, the psychiatrist, anyone, affecting the educator with his computor, which he's told he must use, and affecting some essential aspects of humanity, having to do with words and experiences like "distance" and "respect" and "sensibility," and a sense of carefulness. And the word "craft," which means *time* and thought and leisure—whether that, too, isn't so fatally collapsing that there is a breakdown in what you call ritualization.[20]

Surely it is obvious then that, the inalienable relation be-tween persons and places being what I have claimed, the Cartesian image of extended things, which has come increasingly to dominate even our view of everyday spatiality, is profoundly inimical to personalism. For it is evident that place as the where of my body, as status and as room, is very far from being congenial with the

abstract notion of infinite and homogeneous spaces which has so dominated the modern imagination—whose eternal silence Pascal found a weight hardly to be borne.

Let us here make the important concession. It may be appropriate and heuristically productive—who, observing the theoretical and technological prodigies of the sciences of the last three centuries could, short of being mad, deny this—to abstract ourselves from the heterogeneous aural, tactile, proprioceptive spatiality of the concrete world by means of the feats of spectation already described—whether this be the contemplation of the orbital paths of the planets as if from the sun rather than from the earth, as with Copernicus, or the contemplation of the nature of finite substances as if from the skeptically induced discarnate *ascesis,* as with Descartes. That is to say, it is appropriate to do so when we recognize what we are doing, that it cannot be both strictly and coherently done and, therefore, that it cannot be allowed to become the ground for the subversion of our unsophisticated confidence that the world is just as we know it to be. In such terms it is safe enough to concern ourselves with mere *things* which occupy space.

But a person has to be able to feel that the nature of things confers on him a place, room to become what he is, a "whereon" to stand that is commensurable with his imagination and with the power of his moral will. To be deprived of a place is to become disincarnated, to be driven mad, to become an alien—to have no home or not to be at home. To think of oneself as a thing in space is to take oneself to be a *mere* thing—an observation that will seem not worth making only to those unacquainted with the scholarly literature in which there abound feats of intellectual ingenuity devoted to reducing man to an animal and animals to mere biochemical and physical integrations of varying complexity, all in the service of these "Cartesian" absurdities. To be deprived of a place is to become depersonalized, as Kafka represents it to us with both poignancy and terror in his story of Gregor Samsa, awakening one morning to find himself transformed into an enormous cockroach, his human mobility frozen by his crusty underbelly, his speech changed into the grotesque noises of a giant

insect—which terrorizes his parents—but in whom there still remains the feeling for the pathos of his loss.

The man who has no place is first David Riesman's "outer-directed" man in a "lonely crowd"; then he falls into despair; and finally he disappears. J. D. Salinger's Holden Caulfield, shipped from "old Pencey Prep," the third private school to which he has been sent by parents, who find his presence at home too demanding, wanders down Fifth Avenue, crowded with Christmas shoppers and Salvation Army Santa Clauses, and muses:

> . . . I kept walking and walking . . . without any tie on or anything. Then all of a sudden, something very spooky started happening. Every time I came to the end of a block and stepped off the goddam curb, I had this feeling that I'd never get to the other side of the street. I thought I'd just go down, down, down, and nobody'd ever see me again. . . . Then I started doing something else. Every time I'd get to the end of a block I'd make believe I was talking to my [dead] brother Allie. I'd say to him, "Allie, don't let me disappear. Allie, don't let me disappear. . . . Please, Allie." And then when I'd reach the other side of the street without disappearing, I'd *thank* him.[21]

And so it is with us!

Whatever consolations Pascal may subsequently have found in Christianity, had he lived to complete the apology for which his *Pensées* were the notes, he was clairvoyant as to one matter: The human condition would have to find its ground and good in something capable of overcoming the human incommensurability of mere infinite space.[22]

More than a generation earlier Donne, having heard of Galileo's telescope and imagined what its discoveries might imply, wrote:

> And new Philosophy calls all in doubt,
> The Element of fire is quite put out;
> The Sun is lost, and th'earth, and no man's wit
> Can well direct him where to looke for it.
> And freely men confesse that this world's spent,
> When in the Planets, and the Firmament
> They seeke so many new; they see that this
> Is crumbled out againe to his Atomies.[23]

Kierkegaard knew with a lyricism all his own that Christianized man, no longer Christian, was caught in a demonic

struggle with infinity, most powerfully expressed in the essentially musical idea of Don Giovanni, when he speaks of the overture of Mozart's opera:

> The overture begins with a single deep, earnest, uniform note that at first sounds infinitely far away, a hint which yet, as if it had come too early, is instantly recalled, until later one hears it again and again, bolder and bolder, louder and louder, that voice, which first subtly and coyly, and not without anxiety slipped in, but could not force its way through. . . . But soon it comes again, it grows stronger; for a moment it lights up the whole heaven with its flame, in the next the horizon seems darker than ever, but more swiftly, even more fiery it blazes up; it is as if the darkness itself had lost its tranquillity and was coming into movement. . . . There is apprehension in that flash, it is as if it were born in anxiety in the deep darkness—such is Don Juan's life. There is dread in him, but this dread is his energy.[24]

We are not the first age in which man has felt that he has lost his place. The disintegration of the *polis* launched a flood of deracinate men upon the Aegean and Mediterranean world. But we are the first age in which man has felt the radical *contingency* of every place, felt, indeed, that the very notion of place has lost its meaning.

In fact, as we can now begin to see, the whole of modern culture could be described as an assault upon place, status, and room for personal action by the abstracting intelect. Before these developments reached their climax in Descartes' program, this assault was the source of great exhilaration and joy. Giovanni Pico, Count of Mirandola, wrote in 1486, in his "Oration on the Dignity of Man," putting these words into the mouth of God:

> "Neither a fixed abode nor a form that is thine alone nor any function peculiar to thyself have we given thee, Adam, to the end that according to thy longing and according to thy judgments thou mayest have and possess what abode, what form, and what functions thou thyself shalt desire."[25]

The spiritual impulse behind these reflections is easy to find: it is angelism—the aspiration toward a deliverance from every particular place, every particular status, and the ambiguity of every particular moral action. The necessary and therefore fateful character of my *actual* place and time, of my *actual* status and of my *always* ambiguous moral action is neutralized by abstract thought and becomes wholly contingent.

Classical thought did not really have a developed idea of contingency. Only in a universe which is viewed not as an eternal cosmos but as a created world which God might have chosen not to create is there a place for a conception of contingency.

It is clearly with such an idea that Pico wrote, believing that God had created the whole world and every particular in it. Thus one's station was not conferred by an eternal cosmos but by a providential God, who marks the fall even of a single sparrow.

What then began as a belief that my place is contingent in the sense that God might have called me to any of a number of other places (than the one to which I was in fact called) becomes the belief that my place is contingent in the sense that I might *choose* any other place—indeed, any place at all—and ends in the belief that my place is contingent in the sense that one place is just like every other, and that therefore none is any more *mine* than any other. Heterogeneous places have been transformed conceptually into homogeneous spaces.

Almost overnight the fifteenth-century joy of Pico turns to the mordant seventeenth-century anxiety of Pascal. He writes:

> When I consider the short duration of my life, swallowed up in the eternity before and after, the little space which I fill, and even can see, engulfed in the infinite immensity of spaces of which I am ignorant and which know me not, I am frightened, and am astonished at being here rather than there; for there is no reason why here rather than there, why now rather than then. . . . Man has fallen from his true place without being able to find it again.[26]

This attrition in the conception of contingency introduced into our sensibility through the Christian doctrine of creation reaches the point of exhaustion, and it is Jean-Paul Sartre who articulates the mood of the twentieth century when his Orestes, in *The Flies,* answers Zeus' threat that his words and actions are insubordinate by saying:

> Foreign to myself—I know it. Outside nature, against nature, without excuse, beyond remedy. . . . Nature abhors man, and you too, God of Gods, abhor mankind.[27]

Lest any reader be seduced by my argument into a nostalgia for a pre-Cartesian world, or alternatively—what is more likely,

if I am right in imputing these views to him—becomes irate at what he may take as a hankering archaism in me, let me be quite clear: I do not propose that we return to the fifteenth century, merely that we come to ourselves.

For it is important to recognize the extent to which this displacing of man from the world is a correlate of the proclamation in the Western world of the incarnation faith. We have already seen the relation between the propagation of this faith and the emergence of the conception of contingency. The motif of displacement is, however, ubiquitous in the images of both the Old and the New Testaments. Abraham was called out of his place in tribal life, which always remains in intimate alliance with the fertility of what is believed to be the cycles of nature, tied to its rhythms of birth, death, and regeneration. From this tribal life Abraham left Ur of the Chaldeans and set out for the land of promise, thereby becoming not only the patriarch of Israel, but a paradigm deep in the Western imagination.

Though birds have nests and foxes have holes, we are told, the Son of man has no place to lay his head. Jesus, a Jewish bastard, an apprentice carpenter, and a companion of harlots, was without status. In death, even the tomb was no *place* for him. For each of us who would meet the Lord, there is no place where this must or even will more probably occur, for the Lord's place is wherever he chooses to manifest himself—which means it is no more *here* than *there*.

The incarnation faith deprives a man of his place in nature, in the city, in historical memory, in order to give him a place before the Lord. This means, of course, that my *place* before the Creator, whom I always meet at particular times and in particular places in nature, in the city, and in history, *displaces* me from these particular times and places. That is to say, all become contingent for me because God, who acts as he will, might have chosen to meet me in any of many others. Nevertheless, the call is one always issued to my very particular life in a particular place in nature, in the city, and in history. This is my own vocation. My *place* is now no longer necessary, but *neither is it like every other place*. It is the one particular place to which *I* have been called.

Henceforth, neither nature nor the city nor history can be a place for me unless I have been called to it, unless, that is to say, I find myself placed before the Lord.

It also means that when the God who calls men to their particular vocations, who *places* them before himself, is no longer heard, then every place becomes for each man just like every other. Place has become radically contingent. The world becomes "de-placed," and each of us is displaced.

And this, I suggest, is where we find ourselves: Not knowing or having a place in nature, in the city, or in history, and finding our "vocation" at least ambiguous, we are a rootless, restless, placeless people—seeking with increasing desperation a place which, however tentatively, shall be ours.

This essay is not the place, nor do I feel an obligation, to undertake an answer to the state of affairs I have described. It is perhaps possible to say that what I have described is nothing less than the progress of a massive cultural psychopathology, and that the place to begin is with the admission that this is so.

The cure of insanity is sometimes achieved just by the re-tracing of one's inner history in order to re-perceive the world at those fateful junctions in that history where one came first to mis-perceive it. Whether this is so for us, I cannot say.

But this at least can be said. However moved we may legitimately be by the pathos behind the Sartrean Orestes' romantically and despairingly "willing to be himself"; however touched by the earnestness of the equally romantic "death of God" theology or "man's coming of age" or the "new hermeneutics" or whatever new variation upon the old theme there yet remains unexplored within the essentially fixed Cartesian terms, and is therefore currently chic or is just on the point of becoming so among all the theologians and savants, there is really, in the end, no alternative to calling these affecting laments by their right name: absurdities—absurdities borne of a fateful reliance upon a misconceived model of human knowing, human doing, and human being, for which the only cure is the disclosure that the model is both plainly wrong

and lethal; absurdities to which we need not remain in bondage forever.

But this self-liberation will require a disciplined, arduous, relentless, painful, and patient process of seeking a post-Cartesian intellectual equilibrium, working at every point against the grain of our entire culture, denying ourselves the respite—and the sweet pleasures—of rushing into the streets every fortnight with some new messianic word.

ARCHITECTURAL ENVIRONMENT AND PSYCHOLOGICAL NEEDS

Peter F. Smith

Perhaps the Platonic ideal which is still farthest from being realised is the contention that a city is the ultimate expression of civilisation, designed primarily to facilitate the happy life. Implicit in this urban philosophy is the belief that the city is designed to meet human needs, both on the physical and psychological planes. Since then the concept of the city has been radically modified by the traumatic effects of the Industrial Revolution. Nevertheless, this may turn out to have been something of a refining fire consuming the historic concept to make way for the rebirth of the city into a form and scale commensurate with the demands of third-millennium man.

In recent years criticism of modern environment has been mounting. In Britain it was Ian Nairn who began a campaign in the mid fifties against insensitive architecture and town planning. His weapons were personal, subjective, and emotionally charged. The word "Outrage" still induces an anxiety state in many architects and planners.[1] More recently, a certain amount of professional expertise has been thrown into the assault.[2] Sociologists and psychiatrists were very critical of the first batch of postwar new towns to be built in Britain. They certainly did not provide the anticipated consumer satisfaction. On the contrary, a new phenomenon presented itself to psychiatrists, the "new town neurosis." New houses in semi-rural surroundings did nothing to stimulate a sense of community. Sudden transition from high density slum conditions to low density suburbia which was neither town nor country proved a disastrous experience for many, especially for

those who would not take the initiative in establishing social contacts. Despite the "Coronation Street" image of British television, social fluidity is fairly rare at the working end of the class spectrum.

As a reaction against the mistakes of the Garden City approach as applied to slum rehabilitation, the City Architect of Sheffield (England) in the late 1950's and early 1960's, Lewis Womersley, built a citadel of multi-storey housing within ten-minutes' walk from the city centre. Amenities were provided within the building, including shopping facilities, a social centre, and medical services. The Housing Department endeavoured to preserve existing social units by translating whole streets to one pedestrian level on the high-rise development. The scheme, which accommodated people at a density of two hundred to the acre, was at first greeted with enthusiasm by architects and sociologists. A survey made between 1959 and 1961 by a sociologist, Mrs. J. F. Demers, indicated that the great majority of the first tenants found the move a stimulating experience, especially as the general standard of amenity was much higher than previously experienced.[3] Communal facilities were fully utilised, and there was a strong sense of community amongst the majority of residents.

Recently another survey has been made and the results have been almost totally reversed. There are several explanations. The development has now lost its pristine freshness; the local authority does not allow any individual external expression, such as a personal hue to one's front door; in the ten-feet-wide access balconies, the old slums have been reborn. For the "founder" tenants who remain, the novelty of the social amenities has worn off, and the very fact that flats have such a high standard of internal convenience has encouraged residents to turn inwards behind a firmly shut, though peeling, front door. Second generation residents make little use of social amenities, especially as there is virtually no encouragement from the founder inhabitants. To sum up, initial promises have not been fulfilled. Hyde Park and Parkhill, though to some extent pacemakers in the field of housing redevelopment, seem to have failed. To appreciate why, it is necessary to understand more about human needs. As the Sheffield venture caters to physical needs, its shortcomings must be largely psychological.

One of the most stimulating articles to relate the problems of

environment to psychological theory appeared in the July 1967 issue of the *Journal of the American Institute of Planners*.[4] It is a trenchant condemnation of much of contemporary architecture on the grounds that it does not satisfy certain basic psychological needs related to visual perception. At the centre of the essay is the criticism that the contemporary style in architecture is inherently unable to offer the richness and diversity which is necessary to the well-being of the mind. Simplicity so often means montony, and monotony is death to the psyche.

The following essay is an attempt to suggest ways in which town environment can answer some of the psychological needs which seem to be inherent in human beings. No particular psychological method is employed, but information is extracted from the various areas of psychological study which impinge upon the problem of built environment.

It was recently said, in a theological context, that the contention "seeing is believing" ought to be reversed to "believing is seeing." The inversion is equally valid in the less exalted realm of visual perception. It implies that before an object is seen, certain psychological conditions have to be fulfilled. It is only comparatively recently that the operation of seeing has been recognised to be such a complex sequence of events.

In suggesting some of the factors which contribute to a perception of architectural environment, it is not the intention here to consider specific buildings, but to investigate the psychological impact made by the milieu of objects and spaces comprising a given environmental sequence. The Gestalt psychologists made the point that environment is perceived as an organic, interrelated whole, in fact, as a "gestalt." Certain objects may attract attention, but they do so because of a context which enables them to be prominent, against which they can stand out. Any psychological probe into the relationship between form and content in architecture must be made on that assumption.

At this point it will be convenient to define terms. In an architectural context "function" has two aspects. First there is the design function, which involves the tasks which the building has to perform. It is concerned with the mechanical control of space and climate to facilitate the efficient operation of activities

prescribed by the client. The other aspect of function concerns the psychological impact upon the consumer, whether experiencing the building internally or externally. As this is primarily an attributed factor, it might more accurately be called interpretation. The crucial relationship in modern architecture is therefore between form (which is largely a product of the design function) and interpretation on the part of the consumer. The former is, in theory, under the control of the architect; the latter, at the moment, is in the lap of the gods.

It is the concern of this essay to analyse the consumer angle, to touch upon those processes within the mind which shape interpretation of that milieu of architecture and space, artifact and nature, which comprises urban environment.

Certain areas of mental activity regulate the interaction between an individual and his environment, and these are summed up by the general term "perception." Sensory powers of apprehension develop in answer to an every widening array of needs. At first these needs are largely concerned with satisfying the physical organism. With developing maturity a second stratum of needs develops which is more singularly psychological. On the former level it is the principle of balance, or homeostasis, which conditions mental drives. Symbolic and intellectual needs are the determinative factors on the second level of perception.

Visual perception is regulated by three activities of the central nervous system. First, and perhaps most important, is *motivation;*[5] secondly there is *learning,* and lastly *memory*. Motivation is first because it must precede the other activities chronologically. The ability to see is not innate. There is no direct correspondence between the image which falls on the retina and neural activity which goes on in the cortex. Space has meaning because the mind has first learnt to see.[6] In a child a combination of homeostatic and exploratory drives provides the motive force necessary to stimulate the learning process and overcome the disincentives of childhood catastrophes. Almost from earliest infancy the two levels of motivation operate. The need to satisfy the physical organism naturally takes priority, but as soon as this is achieved, the exploratory drives come into operation. These are sometimes called "psycho-

genic" drives as opposed to the "biogenic"[7]—another term for homeostasis. These goals are not usually strongly defined, but consist of images and symbols. As a person gains control over the means to satisfy homeostatic drives, the psychogenic needs take over, and a great deal of man's mental energy is allocated to the pursuit of these ends. Psychogenic drives are almost infinite in their variety. In one person they may be harnessed to achieving power and status; in another to creating an environment which is secure; whilst a third feels compelled to sail, single-handed, round the world, or climb unconquered peaks.

Such is the power of these psychogenic drives that they condition the manner in which we perceive environment, in its human as well as inanimate aspects. Perception is the slave of need. When that need is obsessive, as in the case of one lost in the desert, it is capable of inducing in the mind fantasies—mirages—which have every appearance of reality. If another aphoristic inversion is permitted, it is a commonplace to say "we need to see," but it is probably nearer the truth to conclude that "we see what we need."

The second activity of the central nervous system that has a direct influence upon perception is *learning*. At the crawling stage this is very much a matter of trial and error, of adapting to the physical world and learning to predict the correct sensorimotor responses to a given set of visual stimuli. Later, symbolic material comes into the learning process. Special importance and sanctity are ascribed to certain objects, for example, Buckingham Palace, the White House, or Fort Knox, if you are prosperous. Religious buildings are universally invested with mystical "ambience." Inculcated attitudes have a great deal of influence upon the perception of environment. For example, people tend to be reluctant to step into the "sacred" area in a church surrounding the altar, regardless of their theological position. Inhibitions are a far more effective obstacle than communion rails. If one accepts the Jungian position, the reason has to overcome the accumulation of a few million years of group religiousness bringing pressure to bear.

Thirdly, *memory* plays an important role in the function of perception. It seems there are two basic types of memory. The first is concerned with meeting short-term requirements, and it

has been suggested that the brain achieves temporary storage by creating electrochemical circuits which soon lose their potential. Long-term and permanent storage seems to involve a different mechanism. Recent neuro-biological theory suggests that this type of storage involves the actual generation of memory cells.[8] There are various ways in which visual data are selected for long-term memory:

1) Environment associated with the formative years of childhood.
2) Data impressed into permanent storage through repetitive stimulation.
3) Environment associated wtih a determinative experience or with the satisfaction of deep-rooted mental needs.

It is evident that data committed to the first and last categories of memory assume an emotional component which increases in strength the more they are recalled over the passage of years. Hence childhood memories have considerable emotional colouring for the aged. The memory mechanism also seems to be selective, suppressing unpleasant aspects of experience. The result is that the past is frequently idealised, and former times become "good old days."

The problem next emerges as to how this stored material functions both on the conscious and preconscious levels. There still does not seem to be any better model for long-term memory than F. C. Bartlett's concept of the "Schema." He describes it as

> . . . an active organisation of past reactions, or past experiences, which must always be supposed to be operating in any well-adapted organic response. That is, whenever there is any order or regularity of behaviour, a particular response is possible only because it is related to other similar responses which have been serially organised, yet which operate not simply as individual members coming one after the other, but as a unitary mass.[9]

Memory seems to consist of an organic latticework of information organised into categories or sub-schemas, and when one or two items within it are activated by visual stimulation, they act as cues to the whole of the sub-schema, which operates unconsciously to influence the mind's response to the visual array.

Bartlett was at this time concerned with explaining how physical operations are soon learnt and remembered and henceforth carried out unconsciously. Nevertheless, his model seems appropriate to the field of symbolic and conceptual as well as sensorimotor response. Material selected for long-term memory assumes a highly organised structure which behaves as a "unitary mass" and unconsciously colours the interpretation of new sensory intake. This elaborate schema is the standpoint or the datum from which new experiences are assessed and visual data accepted or rejected. One's attitude to information within the schema of memory directly affects one's attitude to material perceived through the senses.

As stored data behaves as an organic whole, so do the three activities associated with perception. Motivation, learning, and memory are intimately involved together in determining how the mind interprets visual sensory intake.

The question which must next be considered is why the external world is attributed with meaning. Buildings and spaces have symbolic significance imposed upon them; it is not intrinsic, but a product of the human mind. Such attributed meaning may coincide with the intentions of the architect and planner. This tends to be the case when the environment is the product of the collective mind of the community, perhaps evolved over a period of time. The evolution of the Panathenaic Way in Athens is one of the finest environmental expressions of community symbolic needs. In more recent years there has often been a dichotomy between design and attributed symbolism, well exemplified in the rebuilt Coventry Cathedral. When the building committee formulated the competition brief, their intention was to inspire a building which would symbolise both the historicity and current validity of Christianity. It also required that the ruins of the bombed church should be preserved as a kind of resurrection symbol. For some this symbolism is still efficacious. For others, perhaps the majority, the building now symbolises a failure to aspire to the demands of the twentieth century. It is a Gothic cathedral thinly disguised by a modern veneer, symbolising an attitude which looks nostalgically backwards after paying lip service to the present. As for the petrified ruins, they hardly symbolise the resurrection.

A more eloquent message is "Look what we suffered under those terrible Nazis."[10]

The word *symbol* is capable of numerous definitions. In this context it is an object or an organisation of objects and voids which has a meaning beyond that suggested by its superficial expression. A symbol acts as a probe into subconscious or unconscious areas of memory, opening up a link from past to present. Nor is a symbol only involved in reactivating a memory trace, a playback mechanism. Its real significance lies in its ability to release emotions engendered by past experiences. A symbol has, it would seem, the ability to release emotions associated with man's collective primal experiences, his first objective transactions with environment. These symbolic cues may reach the mind through any combination of receptors. A particular building may trigger a whole complex of feelings associated with a past experience in which a similar environment was involved. A particular ensemble of form and space may have the capacity to excite our primordial nerve ends and release emotions both profound and incoherent.

The contention here is that symbolism is superimposed on environment for reasons which range from the personal to the collective—even possibly to the universal. In the Jungian system there are symbols which, it is claimed, are capable of expressing the deepest of human needs. Because of their elemental nature, these needs have found parallel symbolic expression in cultures totally insulated from each other by time and space. Anthropological studies by scholars such as Mircea Eliade[11] have reinforced Jung's contention that the human mind contains predispositions towards a limited number of set symbolic expressions—the archetypes. Some of these archetypal symbols are concerned with spatial environment, like the sacred cave or holy mountain. It certainly seems that at the deeper psychological level some highly sophisticated architectural compositions express this archetypal pressure.

The possibility must also be considered that man's response to certain symbolic configurations is the consequence of a programme inherent in the human psyche—a mechanism whereby man can respond to divinity. Such an idea opens up many possible avenues of thought, but this is not the place to explore them.

Space therefore presents three pictures. First there is the image falling upon the retina—the sensation; then there is perceptual space—meaning which is inferred from the information offered by sensory receptors and described by George A. Miller as that "which provides a frame of reference for everything we see, hear or touch as we go about our daily business . . . the indispensable guide for all our movements and manipulations."[12] Thirdly there is symbolic and conceptual space—a structure of meaning imposed on the visual array as a result of learning and possibly heredity and innate predisposition. Symbolism is the interposition of a pattern of meaning between subject and object, going back to the time when man was first able to objectivise his environment and project his thoughts into the future—perhaps the point of origin of the species.

The whole question of the symbolic overlay which the mind imposes on architectural environment hinges on the belief that its elaborate mechanism is the consequence of internal psychological needs; that it has been constructed to satisfy certain mental drives towards specific goals. It is therefore only possible to make an interpretation of the symbolism of environment after these goals have been defined. Even then the information is only of some value if there is general argreement within the community as to the nature of these goals. The history of architecture certainly confirms the view that man has been directed in his building enterprises over the centuries by a relatively narrow band of symbolic needs, and the needs which inspire design will also influence interpretation.

To complete this introduction, it remains to examine those psychological goals in which visual environment seems to be so intimately involved. Psychological evidence suggests that there are two groups or constellations of mental goals, bipolar in essence. One of the most recent clues as to their nature comes from Miller, and his proposition is worth quoting in full.

> An organism works to reduce its primary drives, to bring its tensions to an absolute minimum, to return to homeostatic equilibrium. If social motives (including motives conditioning man's transactions with environment) are learnt by primary drives, it seems reasonable to

assume that they will also manifest this self-terminating characteristic. When this pattern of tension reduction is imposed on social motives, however, it leads to an odd distortion. The simple truth is that social action does not always reduce tensions. To imply that it must suggests that persistent diligence and hard work are symptoms of maladjustment . . . that nirvana is the only goal anyone could image in this life. But this is nonsense. No sane person would reduce all his motives to a minimum. . . . Instead, when homeostasis gives us a chance, we constantly seek out new tensions to keep us occupied and entertained.[13]

According to this statement, two principles control the operation of the mind. One can be regarded as a mental equivalent of physical homeostasis. E. J. Murray suggests that the principle of homeostasis might equally be applied to the psyche as well as visceral functions. It searches for safety and stability, order, consistency, and predicability. At the opposite pole is the principle which impels the mind to seek out new experiences and ever changing sensations, described as "intrinsic motivation."[14] An aspect of this principle is the urge to widen conceptual schemata. To quote Miller once again: "Surprise is an essential to mental health and growth. . . . It is not enough merely to have energy falling on our eyes, ears, skin and other receptors; the critical thing is that the pattern of these energies must keep changing in unforeseen ways."[15] That is, mental health requires the constant disturbance of environmental schemata, the deliberate introduction of tension to undermine the achievements of the homeostasis principle.

These two principles of motivation assert themselves in early childhood. One system of drives seeks total self-indulgence and pleasure uninhibited by restraints. Counterbalancing this (from time to time) is the desire for security and passive dependence on other people. From the psychoanalytical point of view, this dichotomy is the source of all man's discontent. It goes back through the ages, via Augustine's "cor . . . inquietum," to the tension between Apollo and Dionysius. To the Freudian school it is the source of energy which has kept in motion the whole process of history, which is not necessarily synonymous with progress.

As is so frequently the case, the psychological theory behind it all goes back to Freud. Quite early on he concluded that bipolarity was the operational principle behind the human psyche,

as indeed it seems to be a fundamental principle of matter. He concluded that there is "an eternal conflict between two distinct and completely opposed forces, one seeking to preserve and extend life, the other seeking to reduce life to the inorganic state out of which it arose."[16] This constant tension between the drive towards "the life proper to the species," ultimate self-fulfilment, and what may be called the death instinct, was by Freud's definition "the dialectic of neurosis."

Applying this binary principle to personality, Freud's rather deviant pupil C. G. Jung introduced the terms *introversion* and *extraversion* to describe two of the poles between which the human personality is held taut.[17]

Under the guidance of each motivational principle, the mind seeks, through the medium of the senses, and in particular the eyes, to discover symbols which suggest on the one hand security, order, stability, and consistency, and on the other symbols of indeterminacy and adventure, symbols which point out beyond the present to an indefinable but tantalising future. The central idea of this essay is that external objects can be interpreted by the mind to represent an internal situation, and the symbolic relationship attributed to these objects can influence the relationship between the bipolar principles operative within the psyche. This potential of external environment to influence the mental state is of great importance, especially as the whole operation is usually unconscious and bypasses the filter of reason. It now remains to discuss how the milieu of architecture and space, form and void, comprising the town presents symbols which are aligned into opposite camps through this bipolarising tendency of the human mind.

Considering first the security and homeostatic demands of the psyche, there are numerous ways in which these can be satisfied by architectural stimulation. Obviously it is the surface expression of buildings which makes the initial impact. Because building types and their modes of expression fall into certain conceptual categories, the idea of a "style" emerges. It is usually applied to the consensus of architectural expression within a fairly clearly defined

period of time. The term *conceptual* seems appropriate to describe that level of symbolic stimulation which derives from the surface expression of buildings. It is this stylisation of surface treatment which enables buildings to be categorised and pigeonholed into the schematic matrix of memory. The overall schema of architecture is composed of a lifetime of impressions of building types and styles, some of which have an additional emotive content resulting from associational experiences. The symbolism of certain types of architecture might also be enhanced by mental attitudes, acquired or inculcated. For example, to anyone within the climate of thought of the ecclesiologists of the last century, Gothic architecture possessed ultimate veracity, not through any intrinsic merit, but on account of a moral overlay. Conversely, classical architecture was anathema because its origins were pagan.

However, underlying matters of prejudice and personal experience there is a broad stratum of symbolism ascribed to architectural objects simply because they conform to the overall conceptual schema. Certain building types have a positive conceptual subschema, and preeminent in this is the style of the church. Pugin's dictum that Gothic is the only true religious architecture still reverberates through all Western denominations.[18] The modernised Gothic of Coventry has been mentioned, but there are many churches considered to be advanced architecturally which nevertheless pay subtle deference to the "Gothic demand." At the opposite end of the functional spectrum are such buildings as courts of law. For them a combination of Greek logic with Roman justice is the symbolic message of the heavy classicism of the Old Bailey or the emasculated neoclassicism of the Manchester Courts of Justice. The Supreme Court building in Washington, D.C., heads an impressive line of classical judicial buildings in the United States.

Buildings which conform to a particular sub-schema or concept induce feelings of security and well-being for several reasons. By displaying good manners and obeying the rules of architectural etiquette, they satisfy an internal need for discipline, conformity, and predictability. One side of the mind opts for the suppression of the individual personality beneath the will of the group.[19] New

architecture which is essentially conformist symbolises this tendency. Environment which is ordered and familiar satisfies the mental need to operate within a situation which confirms the internal model. There are no problems of adjustment and processing, activities which the mind needs but nevertheless finds, to varying degrees, painful. Nonconformity in architecture, as in other arts, is often received with animosity because it is symptomatic of impending changes in society which will irrevocably shift the status quo. As any innovator knows to his cost, the greater part of the community grants the status quo an almost sacred validity. But the totally new artifact is a rarity. Even the most advanced architecture never completely breaks the thread of tradition. Romanesque origins are clearly visible through the sophisticated Gothic of Chartres, and the logic and discipline of the Greeks is reincarnated in the architecture of Miës van der Rohe.

The motivation behind this attitude to environment is the desire to impose a pattern of consistency upon the objective world, to make the external world reinforce internal expectations. From the point of view of perception, most people have a tendency to select information which confirms their schema. This activity is occasionally carried further when incoming information is adjusted and even falsified to fit in with the schema. From time to time everyone imposes a selective filter upon perception, even manipulating the input in the interests of a desired psychological state.[20]

A variation on this theme is the sense of security experienced whenever the validity of a particular tradition is reinforced. For many the efficacy of certain beliefs and practices is directly proportional to the time which has elapsed since they originated. The same can be said for a style in architecture. That this efficacy is attributed rather than intrinsic does not seem to reduce its potency. Almost any artifact acquires in time an aura of sanctity. Continuity with the past implies the possibility of some measure of control over the future; phenomena which ratify tradition also offer a measure of security by guaranteeing the future. They imply that "God's in his heaven: all's right with the world."

The revivalist compulsion shows up most clearly in the architectural philosophy of the first half of the nineteenth century

in England. First A. W. N. Pugin, then the ecclesiologists displayed an irrational nostalgia for the medieval period of history, which they inflated into a golden age when Christian virtues were commonplace and all men lived peaceably under the shadow of their cathedral. It is clear that they were using archtiecture to set in motion what may be called the "Eden chain reaction." Upon one level Gothic architecture symbolised the monolithic Christianity of the Middle Ages. But the mind does not differentiate past time which is remote from experience, and this symbolic process, once started, can only terminate in the innocence, tranquility, and irresponsibility of the Garden of Eden.

The tendency to idealise the past was not the prerogative of the nineteenth century. It manifests itself with particular force whenever times are uncertain and the existing order threatened. This mental make-believe which mythologises the past may be the result of two things. First, man has generally been dissatisfied with his present state. To account for it historically he assumes some kind of Fall, and to alleviate it existentially he projects his thinking towards an idealised future. Add to this the universal psychological tendency to suppress unpleasant aspects of memory, and it becomes almost inevitable that some ideal condition in the past will materialise, especially when the idealisation process gains momentum through the memory of the group and then the culture. So the past is idealised by means of the selectiveness of memory, and the future because of the optimistic, teleological bias of the psyche. The snag lies with the bit in the middle, the present. The mind can be set off in hot pursuit of either goal, the retrospective or the "prespective" paradise, by certain symbols, some of which are expressible in architecture.

Thus that expression of buildings which falls into the mind's conceptual schema of architecture satisfies security drives by confirming expectations, consolidating the internal space model, and endorsing tradition. The roots of the matter might well reach down to the ultimate, prenatal security of Eden, when all wants were satisfied and the serpent had not yet appeared.

On a more superficial level, environment may offer security by suggesting enclosure. Whilst towns no longer offer physical pro-

tection against an enemy, symbolic factors continue to operate long after events have invalidated them. Thus, a town in which a sense of enclosure predominates satisfies security needs. Further satisfaction is derived when the architecture has the appearance of stability and permanence, when mass dominates void. It is part of the disturbing effect of contemporary architecture that it has not the appearance of permanence and stability based on a few thousand years' experience of traditional building materials. New criteria of stability will only be established when people have become familiar with the strength-to-mass ratio of modern materials.

A persistent activity of the mind in the homeostatic field is the search for order and harmony. As its goal is the reduction of tension, it will seek satisfaction through symbols of reconciliation. In architectural terms this will involve all the devices known to designers for reducing the tension between opposites. In terms of art this is an aspect of the classic tendency. The classic-romantic tension involved in the shaping of cultural objects and institutions has been analysed in some depth by Jacques Barzun.[21] It is to be expected that this classic tendency is best illustrated in classical architecture, but the two must not be confused. Classic motives have conditioned expression in all styles of architecture, not least Gothic.

Greek architecture of the time of Pericles demonstrates the highest degree of sophistication which architects have achieved in response to the psychological homeostatic demand. The architectural programme of the Greek temple was limited and proscribed by severe discipline. Therefore, artistic development followed the course of refinement towards the ultimate ideal of hamony. The conflict between opposed axes, between external and internal space, and between cylindrical and rectangular forms was negated by numerous design motifs. The contrast between the verticality of the perimeter columns and the entablature above was softened by the capital, which also served to effect the transition from a cylindrical to a rectangular form. The rotundness of the columns was modified by fluting, which also had the effect of drawing vertical lines on the columns, thus integrating them with other linear elements in the design. It is often assumed that the perimeter

colonnade served primarily a structural purpose. This is debatable, as the internal walls of the cella did most of the work of supporting the roof. The columns serve the psychological purpose of creating a transitional semi-architectural space between the secular world and the sacred interior. The force of this device can only be appreciated in the context of the Greek sun, which throws sharp shadows against the brilliant white of the marble columns.

The colonnade was firmly fixed to the ground by means of a three-tiered base, or crepis. The same ingenuity in reconciling opposites is displayed in the integration of the eaves of the pitched roof with its gable end. The entablature defining the eaves continues round the front of the temple, but at the change of direction divides to follow the profile of the roof, forming the pediment.

The timeless appeal of Greek architecture owes a great deal to the manner in which it symbolises ultimate harmony by bridging gulfs and reconciling opposites. The romantic side of the Greek artistic personality was expressed in the siting of these buildings, in either an urban or a rural context. The asymmetry of the Athens Acropolis was incomprehensible to the Romans, who followed the Greek temple style but related it to the rigidly axial forum. The measure of artistic discrepancy between the cultures is caught in the contrast between the Acropolis and Forum Romanum.

The homeostatic demand asserts itself upon architecture of every age. Romanesque architects expressed it with great subtlety, reaching a pinnacle of grace in the eleventh-century Cathedral of Saint-Lazare, Autun, where vertical and horizontal, solid and void, plain ashlar and rich sculpture are held in superb equilibrium. The Gothic equivalent of Autun is the Cathedral of Chartres, where a classical austerity of architecture contrasts with sumptuous stained glass, creating a dialogue of great poignancy.

There are other ways in which this aspect of the psyche receives drive satisfaction through architectural symbols. From earliest times man has been obsessed with the need to impose order upon chaos. The mind is constantly seeking to discover patterns of meaning. It imposes patterns upon the most mundane phenomena, even down to a telephone number. Spearman's neogenetic law maintains that the mind is always seeking to create

patterns with the phenomena it encounters. For instance, man has until the last century attributed a geometrical order to the universe, and in classical, medieval,[22] and Renaissance[23] times sought to incorporate this order into architecture, thus bringing to man's consciousness the rhythm of the cosmos. The aim was theological. Since the gastronomic indiscretion of Eve, the world has known only chaos, whereas formerly the unity and order of the cosmos prevailed on earth, and man knew the meaning of peace. This cosmic harmony could possibly be reestablished on earth through the medium of architecture. The intervals of musical harmony became the basis of architectural proportion. These rhythms and proportions were regarded as part of the essence of God, and therefore a measure of unity with God might be achieved through their visual and auditory expression.

Without doubt the need for rhythm and pattern penetrates deep into the psyche. When expressed environmentally, it has the effect of clarifying the individual's position in space, of providing a mechanism by which he can relate himself to his particular microcosm. It seems to set up sympathetic reverberations within the mind which induce a profound sense of harmony between subjective experience and objective reality. Historically it was assumed that the visible harmony of architecture would create in the soul a state of concord with its Creator, thus facilitating communion with God—a much more sophisticated version of the modern "numinous" atmosphere. Even today man derives great satisfaction from rhythms of diverse shape superimposed in a variety of ways, perhaps because there is a subconscious suggestion that it places him in phase with the basic rhythm of life. To be in tune with the cosmic order is to achieve the ultimate in mental homeostasis. To this end, environment can play a significant role. Even though we might be skeptical about the theory, it might well constitute an important factor in prerational interpretation.

Finally, within the conceptual framework of symbolism, built environment transmits suggestions of security when its constituent elements are clearly defined and boundaries accentuated. The Palazzo Thiene, Vicenza, by Andrea Palladio, illustrates this aspect of design. The building is firmly secured to earth by a heavily

rusticated ground floor in which openings are plain holes punched into the masonry. The corners are accentuated on this floor by providing extra weight to the rustication, and on the first floor by the doubling-up of pilasters. Windows on the first floor are made prominent by flanking rusticated Ionic columns capped by pediments. The whole composition is held down by a deep entablature. The effect is of a building with fully integrated parts well defined and firmly related to its context—at first glance a building in repose. However, on closer inspection a subtle rhythmic counterpoint emerges between the principal Corinthian order and the subordinate Ionic, the latter being complete with entablature which runs behind the principal order. This design of 1556 points the way to the superb rhythmic tension of the facade of the church of Il Redentore, Venice, designed in 1576. The Palazzo Thiene was perhaps the last breath of the High Renaissance, already severely weakened by the Mannerism of Michelangelo. From then on, architecture was to become taut and restless.

The symbolic field so far described has derived its meaning from the design expression of buildings—style and the interplay of styles within the overall environment. Its psychological meaning is largely an attribute of learning and experience, with perhaps the exception of the rhythm demand. Certain traditions in architecture, however, sub-stratify style and culture. Professor Eliade has offered plausible suggestions for the primary symbolic programme behind ancient cities:

> Every oriental city was standing, in effect, at the Centre of the World. Babylon was Bab-ilani, a "gate of the gods," for it was there that the gods came down to earth. The capital of the ideal Chinese sovereign was situated . . . at the intersection of the three cosmic zones, Heaven, Earth and Hell.[24]

Apparently the name Babylon was also related to *bāb-apsū*, meaning "gate of the waters of chaos before creation." The temple at Jerusalem was not only the place where man made contact with Jehovah; its foundation rock was believed to cover the mouth of the waters of Chaos, or the "mouth of tēhom," as the Mishna described it.[25] Eliade concludes:

These cities, temples, palaces, regarded as Centres of the World are only replicas, repeating ad libitum the same archaic image—the Cosmic Mountain, the World Tree or central Pillar which sustains the planes of the cosmos . . . Vedic India, ancient China and Germanic mythology, as well as primitive religions, all held different versions of the Cosmic Tree, whose roots plunged down into hell and whose branches reached to heaven.[26]

This somewhat elemental binary symbolism was soon incorporated into Christian imagery, for example, in the Byzantine liturgy for the Day of the Exaltation of the Cross, which affirms that "the tree of life, planted on Calvary, springing from the depths of the earth has risen to the centre of the earth . . . and sanctifies the universe unto its limits." This kind of symbolism can be regarded as abstract because it is sufficiently basic to be independent of the concepts of style, type, and fashion. It aims at resolving the ultimate conflict between life and death. French Gothic cathedrals represented on one plane a "type of heaven," a symbol of paradise. But at the same time, the east end was, according to W. Lethaby, a half-martyrium, with the high altar occupying the position of tomb.[27] In religious architecture of all cultures, symbols of life and death coexist in constant tension. The same symbolic dialogue, clearly expressed in the foundation imagery of prehistoric towns, is apparent in cities of classical and medieval times.[28] It is almost inevitable that such an environmental tradition should condition to some degree the contemporary interpretation of built space. If it is admitted that modern man is still capable of reacting to archetypal symbolism, then the abstract control of space and light within the city is of paramount importance. Even though today's culture is reluctant to recognise these primordial psychological drives, it is nevertheless conceivable that they are operative and that they release emotions bound up in the primal reservoir of feeling. They condition the attitude of the psyche to its environment and account for what is often diagnosed as irrational behaviour.

From most primitive times, therefore, man has created symbols which help him to come to terms with the life-death dichotomy. He has not done this by attempting to escape from the reality of death. Only in very recent times has the fact of death

become unmentionable and its fruits disguised beyond recognition (if we are to believe *The American Way of Death*). Architecture, art, and drama (including religious liturgy) were the objects upon which man projected his internal needs. Historically death was vanquished by being faced and symbolically experienced. Dr. Dillistone has drawn attention to this death-life tension in the universal religious symbolism surrounding the rite of sacrifice.[29] But this was merely one aspect of the whole environmental emphasis upon this theme. A few thousand years of interpreting environment in this way cannot be irradicated overnight. Some argue that, as life and death are the intrinsic polarities of the human situation, man will always require objects which symbolise their reconciliation. It also seems fundamental and universal that man associates darkness and constricted space with death, and spaciousness and light with life. Biblically, deeds of death are associated with darkness, and light with life. There is no more eloquent expression of the life-giving potential of light than the theory of divine luminosity which inspired the incredible multicoloured curtain walls of cathedrals like Chartres, Reims, Amiens, and York.[30]

Modern man is just as susceptible as his ancestors to the symbolic significance of space. When light is reduced and space severely constricted, there is one aspect of the psyche which derives satisfaction. Death may offer release from the privations and incessant challenge of life. It promises dreamless sleep. Psychologists have identified it as a desire taking many forms. The most common is the "return to the womb" syndrome—that prenatal state, similar in some ways to Eden, in which all needs are satisfied and aggressors held at bay. Drives having such a goal can be regarded as to some extent morbid, and so the symbols from which they gain satisfaction can be called "morbid abstract." Such symbols are present in most towns, created by design or accident. The medieval Italian piazza is invariably approached from narrow, canyon-like streets which possess a hypnotic attraction once within the brilliant light of the square. The nature of the Italian climate brings out the contrast between light and shade. The pitch black of the open doors of a church within a town square has irresistable

magnetism. A narrow street flanked by high buildings can have the same effect to the point of disquiet. This symbolism is most pronounced when the end of such a street is dark and ill-defined. The arcades of Bologna's narrow streets offer this sensation; so does the central square of Villefranche-de-Rouergue, flanked by high buildings in proportion to the area of the square, and circumscribed by a continuous low, dark arcade. Part of the enchantment of some of these bastide towns of France is the high level of drama they achieve between light and shade, space and constriction, within a restricted urban spread.

Conceptual symbols of security and homeostasis and abstract symbols of self-negation all operate within the same broad psychological field. They suggest degrees of security, right down to the ultimate security of Nirvana. Strongly active throughout history has been man's "participatory tendency"[31] which impels him towards submerging his personality into that of the group, seeking security by self-negation. This array of symbolism might be considered as a force system creating a field around a single pole which is the goal of perfect harmony and the elimination of all tension within the internal environment of the mind and the external environment of nature.

Whilst Dionysius is present in all of us, there are few who do not also possess something of Prometheus. Stealing fire from the gods has always been a psychological if not physical preoccupation of the human race. It was this outreach of the mind towards ultimate reality to which Louis Pasteur referred at his election to the Académie française: "The Greeks understood the mysterious power of the hidden side of things. They bequeathed to us one of the most beautiful words in our language—the word 'enthusiasm'—*en theos*—a god within. The grandeur of human actions is measured by the inspiration from which they spring. Happy is he who bears a god within—an ideal of beauty, and who obeys it, an ideal of art, of science. All are lighted by reflections from the infinite." Here Pasteur is pointing to that aspect of the psyche which looks longingly towards a dimension of being which transcends the human and predictable, that realm of understanding

which, according to Bertrand Russell, "will link into human life the immensity, the frightening wondrous and implacable forces of the non-human."

It hardly needs saying that the aspect of the psyche which gains satisfaction from symbols of security and homeostasis must be offset by needs driving towards an opposite goal. Second-generation analytical psychologists followed Freud in asserting that there is a strong prospective and exploratory side to the psyche. According to Jung these drives bring about the process of individuation: "nothing less than the optimum development of the whole human being."[32] This aspect of the psyche was the particular interest of Adler, who developed the theory of Individual Psychology:

> The science of Individual Psychology developed out of the effort to understand the mysterious creative power of life—that power which expresses itself in the desire to develop, to strive, to achieve—and even to compensate for defeats in one direction by striving for success in another. This power is teleological—it expresses itself in the striving after a goal, and in this striving every bodily and psychic movement is made to cooperate.[33]

For some this creative power is a "god within," for others it is a demon, but it is universally a restless, prospective, exploratory, radical, self-fulfilling demand which impels the personality along a positive path which may or may not be considered as progress. Whilst one side of the psyche strives after perfect order and equilibrium, another seeks to introduce tension. It achieves a measure of fulfilment in a linear rather than a nodal manner of life, that is, a life which is teleological and has no abiding resting place. The organisation of architectural environment can do much to offer drive satisfaction within this psychological field. Architecture can help to satisfy Miller's condition for mental alertness: sensory stimulation must constantly change in unpredictable ways.

There are various ways in which built environment can satisfy this condition. They include complexity, ambiguity, surprise and shock, and conflict. First of all, complexity in relation to built environment is regarded here as being synonymous with intricacy. Numerous experiments have been conducted which suggest that

the psyche enjoys a visual field which has a degree of complication and which takes time and some effort to perceive.[34]

Architectural environment offers two levels of complexity. In the first place there is the intricacy restricted to a particular building. The idea of a facade originated because of the desire to concentrate interest upon the principal elevation of a building to enhance its dignity. Never has this been realised on a more monumental scale than in the west fronts of several Gothic cathedrals. Perhaps Reims and Tours top that particular league table. Baroque architects used the classical vocabulary to produce an entirely unclassical architecture. The facades of the sixteenth- and seventeenth-century churches of Rome are extremely complex and taut. The intricacy of the interiors of many eighteenth-century baroque churches in Bavaria and Austria is almost mesmeric in its effect.

Secondly, complexity may be the product of spatial relationships. This may apply within a building or within a town. The Romans achieved considerable drama and sophistication in their later prestige buildings, such as the thermae and royal villas and palaces.[35] In more recent times, baroque-rococo architects such as B. Neumann, in his pilgrimage church in Vierzehnheiligen, Franconia, achieved a complex interpenetration of space equivalent in many ways to the music of Bach.[36] This church has a variety of axes and spaces producing one of the most tensile and fascinating interiors of all time.

On the level of macro-environment, complexity may be the result of diversity of style within a particular environmental field. A town which has been modified over many centuries almost inevitably posses this quality. By the same token, it is obviously very difficult to achieve it in the contemporary new towns, where perhaps there is only one architectural team. But even here interest may be maintained by an imaginative intersection of building planes, diversity of texture, material, and colour. A town built on hills enjoys a great advantage. The plan of San Francisco offers little of intrinsic interest, but it is transformed by the local topography. Even Sheffield, England, largely a product of the industrial revolution, offers a wealth of visual interest due to its situation

within the foothills of the Pennines. In addition, frequent glimpses of the Peak District National Park from what John Betjamin described as England's finest suburb make this a stimulating city to inhabit.

The ever changing complexion of nature imposes subtle but profound changes on the face of environment. Buildings change their appearance according to the season of the year and the quality of the light, or according to whether they are framed by cloud or blue sky. The state of the vegetation encompassed within the total field of view also has a considerable influence upon the character of buildings. Some architects have designed in relation to summer foliage, with the result that the starkness of winter is shared by their architecture.

Such environmental diversity and richness has perhaps rather obvious appeal on the intellectual level. There is also a symbolic dimension to it. Complexity is symbolic of life. When the receptors are totally engaged in picking up information and the mind is preoccupied in processing it, the result is a complete involvement in life. The human mind abhors a vacuum. The anxiety experienced by the students at McGill University who volunteered to submit to total sensory deprivation was perhaps ultimately a fear of death. Rapport between the psyche and the objective world is one of the guarantees we have that we are truly alive.

The second characteristic of urban stimulation is *ambiguity*. This can be distinguished from complexity because it involves the faculty of imagination. The mind has a preference for situations which allow a variety of interpretations; it derives satisfaction from building its own pictures from a limited number of cues. Similarly, it looks for problems to solve. Open-endedness and indeterminacy seem to be of the chief characteristics of a great deal of contemporary creativity. They correspond to "economy" in Arthur Koestler's book *The Act of Creation*. This characterises works of art which give hints instead of statements, which leave the observer to bridge the gap and interpolate. This is the opposite to the classical approach to design, in which the total effect is conceivable at once, the environmental experience instantaneous rather than cumulative.

One of the best examples of architectural ambiguity is the Gothic cathedral. Internally it reveals itself in stages, especially in the more attenuated cathedrals of England.[37] Space unfolds laterally and vertically. Externally the cathedrals of the Continent were an integral part of the urban fabric, only conceivable from a distance, from where they assumed their ultimate role of providing the visual as well as the spiritual apex to the city. This quotation from Allan Temko's book *Notre-Dame of Paris* sums up the quality of ambiguity which the Gothic cathedral possessed:

> In the medieval city no man saw the cathedral in its entirety—hence no man saw it like his neighbour. Because of the nature of the medieval city, each could see only portions, which were tantalisingly incomplete and which changed continually as the individual changed his position, compelling him to add the parts to form a total image in his mind.[38]

This underlines an important characteristic of ambiguity: it offers scope to the imagination. Hence an imaginative person will find an ambiguous visual presentation acceptable, even desirable, because it presents him with the opportunity of building a total picture from the clues which are present.

It is only possible here to hint at the psychological implications of the ambiguity demand of the human psyche. The individual's freedom of choice is maintained by objects and symbols which are open-ended. The shape, pattern, or image which is evolved from the inference is the result of a transaction between subject and object, but it is an active not a passive transaction.

The subject injects life into the skeletal framework, so producing something finite. In short, ambiguous stimuli trigger off the creative process in the minds of those who have this potential. That aspect of the psyche which seeks self-expression and a greater intensity of "being" derives satisfaction from such visual stimulation. There is also a degree of teleological symbolism involved, for ambiguity involves a degree of mystery, expressed most eloquently in the Gothic church. Environment which unfolds implies that it is unfolding to a plan, that a purpose is gradually being revealed. It is a pointer to the eschatological city in which man will achieve his full status and realise all the powers which he feels to be latent within him. That this need is acutely present at this point in time

is attested by the ambiguous nature of most modern art. This is the whole point about abstract and partial abstract painting. At best it is designed to stimulate the perceiver's imagination, to act as a thread around which the subject can crystalise his own images and symbols.

The third ingredient necessary for visual, architectural stimulation is *surprise*. To quote Miller once again, "Surprise is an essential to mental health and growth,"[39] and surprise implies tension. In relation to town environment, this need is usually satisfied by buildings which lie outside the normal field of expectation, which are not part of the secondary space schema. The mind has no ready-made conceptual pigeonhole in which to file them and label them "safe." Such objects may be described as neo-conceptual because, despite their unfamiliarity, they have a sufficient number of anchorage points fixing them to a particular category or sub-schema within the overall schema. If monotony is to be avoided, the normal individual requires constant stimulation of the neo-conceptual kind, which disturbs the equilibrium of the schema. Individuals vary in the amount of surprise, novelty, and tension which they can accept. The optimum neo-conceptual material which an individual can accept without resorting to avoidance is termed his "ideal."[40]

Postwar problems of urban renewal in Britain, aggravated by the blitz, have brought into focus the whole question of introducing new architecture into an established setting. Though not affected by the blitz, one of the most fruitful environments of this kind is to be found in Cambridge. The decision in favour of modern architecture within the sacrosanct gardens of the colleges was taken in the Senior Combination Room of Queens' College in the early 1950's. A new residential building was to be erected on the banks of the River Cam, the Backs, and adjacent to the historic President's Lodge. An earlier decision to build in the style of Queen Anne was reversed in favour of an uncompromisingly modern building, for which Sir Basil Spence was commissioned. Fortunately the new Erasmus Building was a success. The architect displayed considerable tact in uniting his building to the existing environment by an identity of materials and scale, as well as by

taking full advantage of the formal garden comprising the site. From then on it was generally conceded that modern architecture did not inevitably devour venerable and prestigious neighbours. In the same key is the Cripps Building recently completed for St. John's College by Powell and Moya—one of the finest pieces of contemporary architecture, entirely modern yet sensitively related to its environment. Far from detracting from the existing milieu, it has immeasurably enriched it.

Such buildings may be regarded as neo-conceptual or neo-schematic. This is because they reach out towards the future, yet have sufficient ties with the past for them to be related, by the unconscious process of looking for consistency between the external world and the internal model, to the memory schema. It is this degree of contact which makes tension possible. In a sense, the "ideal" relating to an individual is the maximum amount of tension he can cope with at a given moment, or put another way, the optimum ambiguity and unfamiliarity his mind can process. This optimum acceptance or perceptual rate tends to lie within a comparatively narrow band of variation in people generally, according to Streufert and Schroder,[41] and has been termed the "consensus" or "consensual" point.[42]

If an individual was never confronted with objects which exceeded his particular ideal, the ideal itself would decline; due to habituation his optimum perceptual rate would fall. Obviously the opposite is desirable: that the ideal should develop and be able to embrace a higher degree of surprise and unfamiliarity. For this to be possible there must be contact at regular intervals with objects which deviate even more radically from the schema. In psychological language these are called "pacers." They contain a degree of unfamiliarity which exceeds the limit imposed by the ideal, yet not sufficient to cause rejection. Regular exposure to pacers induces growth in the ideal, until eventually the pacer itself becomes the ideal, and so on. This applies to the individual and to the community ideal, the consensus point. The conclusion to be drawn is that pacers, particularly in terms of built environment, have a crucial part to play in the intellectual development of a community.

Recent experiments suggest that an environment rich in complexity, ambiguity, neo-schematic and radical objects, may have a measurable effect upon the human brain.[43] It is still only marginally recognised that the nature of a person's environment can either stimulate mental growth or lead to regression. Monotony is not a negative thing; it is positively harmful.

One of the most notable buildings of the postwar years to qualify for the title "radical" is Le Corbusier's pilgrimage church of Notre Dame du Haut, Ronchamp. At first the architect was reviled by the more conservative end of the social spectrum for committing religious as well as architectural heresy. In fact, for most people, it exceeded the ideal and therefore went beyond the consensus point. However, quite soon it was accepted, and so became part of the ideal. Now, for many people, it is an accepted element in their concept of a church; it has become schematic. Thus it has passed through the three stages of perception, from radical to ideal to schematic. The result of its notoriety is that it virtually became the basis for a new, postwar church style, and mini-Ronchamps sprang up in various parts of Europe, all lacking the touch of the master. Today it is almost universally acclaimed with the exception of a prominent Italian structural engineer who refuses to enter it because of the conviction that its collapse is imminent—and has been for a considerable time!

Even a radically new building, with all the attributes of a pacer, can entirely rehabilitate an established and rather mediocre environment. This is very well demonstrated by Denys Lasdun's Royal College of Physicians in Regents Park, London. At first it seems to bear no resemblance to the dignified nineteenth-century terraces adjacent to it—or in fact to any of the accepted architectural forms. Many people still cannot relate it in any way to their architecture schema, and therefore avert their gaze. But on a deeper analysis it is evident that the architect took great care to establish points of contact with the neighbouring buildings. The scale of the college is similar to the adjacent five-storey houses. To minimise the shock, the roof-line is kept well below that of the terrace. Furthermore, it maintains the strong horizontal emphasis of the terrace and blends with it by virtue of its facing

materials. It is sited at a strategic position in relation to the Park and the terrace, and forms a dramatic focal point.

What makes this building so acceptable is that it is uncompromisingly modern, and yet is inflected towards the traditional space which surrounds it. In subtle ways it makes contact with established concepts and at the same time enlarges them. It offers a new experience of space without disorientating the mind. Because it is able to show some affinity with established space, it satisfies the psychological demand for tension. The tension is creative because it enhances the individual's concept of architectural space; it increases the possibilities for mental stimulation. This process is never stable but follows the cycle of birth, maturity, and decay, for the moment habituation sets in, the mind searches for new symbols of breakthrough, new tensions with which to defeat homeostasis.

Finally there is the element of *conflict* which has, from time to time, been introduced into architecture. In relation to the opposite principle to that under consideration, certain architectural motifs have been devised specifically to effect a reconciliation between the various elements and axes of a building in the interests of harmony, supremely exemplified by the Parthenon. Periodically, architects have deliberately counteracted the harmonic tendency by introducing conflict. As suggested earlier, the Romanesque ideal of harmony and balance reached its climax in the cathedral of Chartres—possibly the medieval equivalent of the Parthenon. Long before Chartres was completed, Reims Cathedral began to take shape (Chartres was begun in 1194, Reims in 1211), revealing that the ideal of balance had been abandoned in favour of attenuated verticality. Concentration on the vertical at the expense of the horizontal developed through Amiens, the abortive and pathetic Beauvais, to the insensitive design of Cologne, begun in 1248 and finished in 1880. In all these cases architects were introducing tension in order to arouse emotions. Their motives were at first theological but latterly egotistical.

Master in the art of creating tension in architecture was Michelangelo. The aim of architects during the High Renaissance was complete balance and a classical perfection in the integration

of elements in the design. The building which a consensus places at the pinnacle of this phase is Bramante's Tempietto of San Pietro in Montorio, a circular temple of classical perfection but of entirely Renaissance conception. Fifteen years after it was completed, Michelangelo produced his design for the entrance to the Biblioteca Laurenziana in Florence. As it was an anteroom, the architect was possibly attempting to create a space which compelled movement and offered no restful sojourning place. Whatever the motive, Michelangelo used this room to create a style which broke all the rules of the High Renaissance. Where columns normally project from walls, here they are counter-sunk, and most of all in corners where the greatest strength was to be expected. Columns are traditionally placed upon a weighty podium, suggestive of strength and durability. Not only is Michelangelo's wall recessed beneath the columns; he shows humorous contempt for accepted canons of design by placing frivolous scrolls beneath the column bases. In the modulation of wall surfaces he introduces design motifs which certainly had no precedent, and the like is not seen again until the next tangential architect of real calibre, Sir John Soane. This tendency to create disturbing, tensile architecture has been defined as Mannerist, and it can be experienced on the urban as well as the individual scale. Usually when buildings, individually or in groups, disturb the harmony of the urban scene, the result is regrettable. But such a consequence is not inevitable. As in much twentieth-century music, discord has a constructive part to play. An environment can be lifted out of the commonplace by elements which, in a calculated way, fracture the harmony and predictability of the scene. In his *Pulcinella* Stravinsky has given new vitality to a classically conceived piece of music by expressing it in twentieth-century harmonies. The same is true of Prokofiev's *Classical* Symphony. Urban designers have traditionally been conscious of the potential of this kind of thing. They have introduced tension by making city routes and gateways narrow and tortuous in order to increase the impact of a spacious piazza. Man's fascination for towers may spring from the same demand. Certainly vertical features introduced into the horizontality of a town give new life to the whole scene. The Italians could not

resist them; a Renaissance engraving of Venice shows it bristling with towers, as does Canaletto's view of London. Siena would seem destitute without the tower of the Palazzo Pubblico. Such towers exceed the requirements of harmony, passing on into the realm of drama.

Modern architecture has considerable potential for inducing a psychological state of tension. Adhering to the logic of modern materials, Miës van der Rohe makes his Seagram Building and Lakeshore Flats terminate on the ground in a comparatively few slender columns. The visual effect is of immense buildings floating twenty feet or so above the ground. For the majority this is still disturbing, and will remain so until the strength-to-mass ratio of modern steel and concrete has become a natural part of the architectural schema of the community. Men must have experienced similar sensations when they first crossed Telford's suspension bridges or entered Paxton's Crystal Palace.

Because of their very nature, it is perhaps not unreasonable to call such features conflict symbols. Tension and conflict are as necessary to the mind as homeostasis. There is a rebellious side to the psyche which holds a radical view of the cosmos. It delights in the destruction of the obvious and the frustration of the inevitable. Even the most conservatively orientated psyche derives a fragment of satisfaction from seeing rules broken. The mind needs to be shocked from time to time, and the visual environment has an unlimited capacity to satisfy this need. Perhaps it is all derived from a kind of mental claustrophobia—a universal disease which has compelled man to build towers and discover continents.

Finally, there is the abstract realm of symbolism related to this particular pole. Within the Judeo-Christian tradition of the West, the model of history is linear. Mankind is progressing towards a goal preordained by God. This fundamental assumption has conditioned the attitude of the individual and society towards life, and consequently towards the nature of environment. It has been an elementary assumption behind the psychological theories of Jung, Adler, Goldstein, and many others. Even the philosophy of Marx might be considered a secularised version of this tele-

ological principle, with the proletariat as the modern equivalent of the chosen race.

As a result of the operation of the teleological aspect of his psyche, Western man has projected his ultimate aspirations onto various cultural objects, including architectural environment. In the urban arrangement of buildings he has delighted in creating spaces which imply that deeper satisfaction lies around the corner; just over the horizon lies the "land flowing with milk and honey." Space which directs the attention upwards and outwards, which is centrifugal in its emphasis and open-ended, may be described as teleological in its symbolism. Such symbolism is also abstract because its vocabulary is simply space and light. It occurs when the junction between architecture and sky is brought to life, suggesting exciting but intangible possibilities for human experience. It occurs when the curve of a road is accompanied by a crescendo of light, finally bursting out into a wide piazza; or when suddenly, from within a completely urban and circumscribed enviornment, a distant view breaks open the enclosure. This accounts for much of the appeal of towns like Todi, Villeneuve d'Aveyron, and St. Peter Port, Guernsey. To use Gordon Cullen's terms, these symbols emphasize "Thereness" as opposed to "Hereness";[44] they compel movement towards a goal. That goal might be a distant view or it may be an architectural revelation. After most of the city surrounding St. Paul's, London, had been destroyed in the blitz, there was a suggestion among planners that the opportunity should be taken to free the cathedral of architectural encumbrance in the replanning and create a direct axial approach to it. The executed plan, basically by Lord Holford, maintains the old approach from Ludgate Hill, but reveals only a portion of the facade. The effect is infinitely preferable to that imposed on St. Peter's, Rome, by the architects of Mussolini. The shape of St. Paul's is inferred. A varied panorama of architectural roof-scape passes before it as the approach is made from Fleet Street to Ludgate Hill, culminating in the magnificent foil of St. Martin's spire. This is perhaps a spectacular example; the same effect is achieved in many towns and villages which offer seductive glimpses of their principal buildings, usually a church. A combination of curiosity and idealism

is perhaps what makes such features in a town so irresistable to the psyche. Inference is one of the most effective tools of the civic designer.

This is really another side to ambiguity, but in this case the partially revealed object acts as an incentive to movement in order to experience the whole. In one case the mind completes the picture, in the other the mind induces movement towards the goal in order that the picture might be perceived.

Such symbols stimulate a reaction from that aspect of the psyche which seeks to affirm life and looks for the unfolding of a pattern both in phenomena and history. Theological expression of this need has focussed on the final "day of the Lord" when all things shall be revealed; when men shall come "from east and west, and from north and south," to the great messianic banquet. The New Testament offers perhaps the most eloquent expression of man's yearning for ultimate truth and for harmony in that social order within which all needs are met: a city built over the tomb of the last enemy, death.

The symbols of the secular environment will not point explicitly to this goal. However, their potential to offer drive satisfaction in this direction is perhaps even greater than with specifically religious symbols because there is no partisan element, and modern man is far more receptive to inference than explication.[45]

The capacity of environment to provide mental stimulation depends a great deal upon the amplitude, diversity, and frequency of its symbolism. The secret of success lies in dialogue; the mind searches environment for an enactment of the drama of life, with symbols as players. Upon this stage are projected all internal fears and aspirations, and above all the hope that life is ordered to a plan, that the unfolding of history is to a purpose which will transform the human race. What makes the human psyche unique is that it maintains two basic goals in constant tension. At one end of this psychological tightrope is the ideal of perfect security and ultimately Nirvana; at the other is the life principle pointing to the ideal of absolute self-fulfilment within the perfect environment.

Symbols in both fields are organised on a hierarchical basis, and are, in a sense, like vectors in a force diagram. Each field of vectors resolves itself into a resultant. The tension between them produces the ultimate resultant which is the actual consequence of the transaction between the individual and his objective environment. Perfect balance never really occurs, which is fortunate; otherwise our fate might resemble that of the donkey who starved to death between two equal piles of hay.

Gordon Cullen puts this concept of environmental dialogue into his particular language: "Having established the fact of Hereness, the feeling of identity with a place, it is clear that this cannot exist of itself but must automatically create a sense of Thereness, and it is in the manipulation of these two qualities that the spatial drama of relationship is set up."[46] E. N. Bacon reinforces the theme by suggesting that nodal points in a town, "places of repose . . . can be understood only in relation to the movement to arrive there and anticipation of movement away. Together these two elements, the architecture of movement and architecture of repose make up the city as a work of art."[47]

It is hoped that this essay has thrown some light upon the deeper implications of these two types of architecture, one symbolising repose and security, the other movement and tension. Any town consists of an intricate array of symbols from each field reacting upon each other in an infinite variety of ways. The symbolic and aesthetic personality of a town is as unique as the human character.

This theory should now really be reinforced by references to various towns of diverse nature to demonstrate the subtlety of the symbolic force system that is constructed in the mind as a result of such stimulation. Space only permits reference to a small village in Bavaria which has the advantage of being largely unknown because it is neither on a major route nor possesses buildings of any special merit.[48] Yet with comparatively few buildings and within a limited space, this village of Wolfegg achieves a remarkable level of symbolic potency: the simple yet profound kind of spatial drama which seems to be the particular talent of anonymous vernacular builders throughout Europe—"the people's art," as E. N. Bacon calls it.

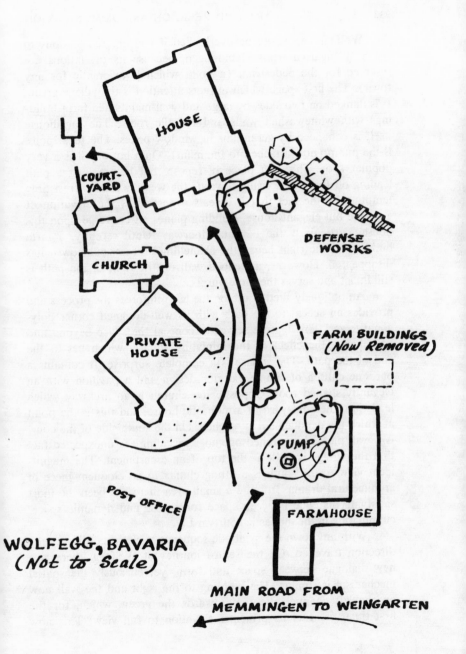

HOUSE

COURT-
YARD

CHURCH

PRIVATE
HOUSE

DEFENSE
WORKS

FARM BUILDINGS
(Now Removed)

PUMP

POST OFFICE

FARMHOUSE

WOLFEGG, BAVARIA
(Not to Scale)

MAIN ROAD FROM
MEMMINGEN TO WEINGARTEN

Wolfegg can easily be overlooked if you are too anxious to reach Wiengarten from Memmingen, because its revelations are reserved for the pedestrian (a point which is axiomatic for any town). The first space which attracts attention is the village green. It is flanked on two sides by large and well-maintained farm buildings with whitewashed walls and red tile roofs. The farmhouse itself is enhanced by geraniums in window boxes. The focal point is the pump (now attached to the main). On a hot day it is a very popular spot. This is a place of repose, but before long a path leading off the green, rising towards the west, becomes irresistibly tempting by the fact that it reveals a portion of the elevation of a simple but elegant house. Building planes all converge upon this house, particularly the baroque doorway. Until recently, a farm building on the right began the chanelling process, but now it has disappeared. However, a stepped wall on the right of the path is still intact and serves the same purpose.

An obliquely sited house on the left reinforces the process and provides an accent to the path with its well-designed corner polygonal tower. This feature serves to conceal the space beyond and so enhance the effect of the miniature square, which lies at the end of the path. The square is a complete surprise. It contains a baroque church of simple exterior design and a pavilion with an elegantly shaped roof. Opposite the church is an archway which leads into the courtyard of a monastic house, and this is the point at which the denouement is reached. On the south side of the court is a wall pierced by arched openings revealing the unexpected fact that the village is built at the top of an escarpment. The magnificent view to the south is a fitting climax to an eloquent piece of architectural drama. In quite a small area there has been the most satisfying dialogue between space for repose and dynamic space, culminating in the monastic courtyard.

With any town the symbolic sequence varies according to the direction travelled. On the return journey at Wolfegg, there is a new dialogue between space and form, yet curiously the spatial mechanism is similar. The building to the right and the wall now on the left channel attention towards the green, which, for the first time, presents its principal elevation to full view. This now

becomes the ultimate objective—the place of repose—and achieves new significance since it has been placed in its wider context.

The lesson of Wolfegg is that the simplest architecture, disposed with insight and sensitivity, can produce an overall environment of great aesthetic and symbolic significance. Here there is no great architectural virtuosity displayed, but the very smiplicity of the architecture allows the dialogue between space and object, introvert and extrovert symbolism, to make its full impact, unhindered by architectural competition. The last word in this dialogue is the superb teleological symbol of the simple arches which frame infinity, the place of repose from which it is possible to look out towards the rim of paradise.

In conclusion, there is at present in Britain a tendency for many specialists to demand a place in the process of urban design. As yet no specialists of the human mind have made very much of a contribution to the field. This is perhaps because a subject like symbolism relies heavily upon psychological theories which at present do not seem to be of much interest to psychologists. Nevertheless, the history of art, architecture, and religion testifies to the fact that man has always sought to project his internal needs upon the external environment he creates. Despite a veneer of sophistication, these internal needs remain constant, and the mind continues to seek for answers from external objects and their symbolism. The fact that these needs are largely registered unconsciously means that the transaction between the individual and his environment is not inhibited by so-called rational interference. This also means that the possibility of a common reaction to the symbolism of space increases the deeper it penetrates into the psyche. This implies that it should be possible to design town environment which will elicit a reasonably predictable reaction, especially towards the level of abstract symbolism. Despite changes on the surface, the ground swell of the human unconscious maintains a constant and coporate rhythm.

In a world of growing insecurity, with the spectre of thermonuclear war brooding over it, the psyche needs more than ever to satisfy its needs through the environment within which the fabric of everyday life is spun out. Form and space have therapeutic possibilities when they conduct the mind through places of security,

repose, and ultimately Nirvana to situations which suggest a prognosis for the personality of life regenerated and every latent possibility realised within the redeemed community.

Possibly contemporary architecture has more potential than that of any previous age to satisfy this psychological appetite. There is a spontaneous movement in art, drama, and architecture to fabricate symbols which are secular yet have this ultimate component. Their form is imprecise and open-ended; they leave room for the mind to manoeuvre because they make inferences rather than categorical statements. Of all art forms architecture has the greatest responsibility to the community, because it is unavoidable. Consequently it is imperative that it should use its contemporary vocabulary to satisfy the various needs of the psyche—and at the levels upon which these needs present themselves. Perhaps architecture is most effective in this respect when it reinforces in secular terms the ageless axiom that some form of death is a necessary prelude to life.

Marshall McLuhan suggests that man is being so conditioned by his "electric environment" that the point has been reached when this conditioning process should be deliberately programmed so that its effects benefit both the individual and society. Equally potent amongst "hidden persuaders" is built environment, and this too needs to be programmed to meet the variety of psychological needs which can be satisfied through the medium of visual stimulation. As with television, there are very few signs at present that contemporary architecture is even aware of the problem.

NOTES

We regret that it was not possible to locate names for some publishers of materials listed below.

THE INCARNATION, ART, AND THE COMMUNICATION OF THE GOSPEL

By E. J. Tinsley

1. Augustine, *De Trinitate* 6, 10; *De Musica* 6, 29.
2. Vincent van Gogh, Letter XI to Bernard, quoted in W. J. de Gruyter, *The World of Van Gogh* (The Hague, 1953), p. 126.
3. C. F. Burney, *The Poetry of Our Lord* (Oxford: The Clarendon Press, 1925).
4. Austin Farrer, *The Glass of Vision* (Naperville, Ill.: Alec R. Allenson, 1948).
5. *Panegyrico por la poesie,* anonymous, 1627, quoted in Ernst R. Curtius, *European Literature and the Latin Middle Ages* (Princeton: Princeton University Press, 1953), p. 558.
6. Quoted by Albert Camus, *L'homme Révolté* (New York: French & European Publications, 1951), p. 320.
7. John Hick, *Evil and the God of Love* (New York: Harper & Row, 1966), p. 313.
8. Mircea Eliade, "Myths, Dreams and Mysteries," in F. W. Dillistone, ed., *Myth and Symbol* (London: S.P.C.K., 1966), p. 47.
9. Nicholas Berdyaev, *The Destiny of Man,* trans. by Natalie Duddington (London: Geoffrey Bles, 1937), p. 35.
10. *Ibid.*
11. *Ibid.,* p. 43.
12. *Ibid.,* p. 36.
13. *Ibid.,* p. 37.
14. *Ibid.,* pp. 167–168.
15. T. S. Eliot, *Four Quartets* (London: Faber and Faber, 1944), pp. 22 and 12.
16. Günther Bornkamm, *Jesus of Nazareth* (London, 1960), p. 53.
17. *Ibid.,* p. 24.
18. John McIntyre, *The Shape of Christology* (Philadelphia: The Westminster Press ,1966), p. 117.
19. Rudolf Bultmann, *Theology of the New Testament* (London, 1952), p. 26.
20. C. K. Barrett, "The Bible in the New Testament Period," in D. E. Nineham, ed., *The Church's Use of the Bible* (Naperville, Ill.: Alec R. Allenson, 1963), p. 20.
21. Ernst Käsemann, *Essays on New Testament Themes* (London: SCM, 1964), p. 45.
22. McIntyre, *The Shape of Christology,* p. 123.
23. *Ibid.,* p. 124.

24. *Ibid.*
25. John Knox, *The Death of Christ* (London: Collins, 1959), pp. 115–116.
26. *Ibid.*, p. 120.
27. T. W. Manson, *The Teaching of Jesus* (New York: Cambridge University Press, 1935).
28. Quoted in Robert W. Funk, *Language, Hermeneutic, and Word of God* (New York: Harper & Row, 1966), p. 129.
29. See C. H. Dodd, *The Parables of the Kingdom* (London, 1936), p. 126.
30. See F. Noel Davey and Sir Edwin C. Hoskyns, *The Riddle of the New Testament* (Naperville, Ill.: Alec R. Allenson, 1957).
31. William Blake, Letter to Dr. Trusler, August 23, 1799, in Geoffrey Keynes, ed., *The Letters of William Blake* (London, 1956), p. 34.
32. C. S. Lewis, *An Experiment in Criticism* (New York: Cambridge University Press, 1961), p. 140.
33. Helen Gardner, *The Business of Criticism* (New York: Oxford University Press, 1959), pp. 86–87.
34. Dietrich Bonhoeffer, *Letters and Papers from Prison* (New York: The Macmillan Company, 1962), pp. 199–200 (June 8th 1944).
35. T. S. Eliot, *Collected Essays* (London: Faber and Faber, 1932), pp. 237–277.
36. T. S. Eliot, "Tradition and the Individual Talent," in *The Sacred Wood* (London: Faber and Faber, 1920), p. 49.
37. William F. Lynch, *Christ and Apollo* (New York: Sheed & Ward, 1960), pp. 19–41.
38. Bethge is careful to add that in fact Bonhoeffer's position transcends the idealistic devaluation of the real and avoids the positivistic overvaluation of it. See Ronald G. Smith, ed., *World Come of Age* (Philadelphia: Fortress Press, 1967), p. 74.
39. William Butler Yeats, *Letters of W. B. Yeats,* Allan Wade, ed. (London, 1954), p. 922.

THE INDIRECT COMMUNICATION: KIERKEGAARD AND BECKETT

By James D. Whitehill

1. See the following works: Gregor Malantschuk, *Kierkegaard's Way to the Truth,* trans. by Marie Michelsen (Minneapolis: Augsburg Publishing House, 1963); Walther Rehm, *Kierkegaard und der Verführer* (München: Verlag Hermann Rinn, 1949), pp. 393–433; and Lars Bejerholm, *Meddelelsens Dialektik* (Copenhagen: Munksgaard, 1964).
2. Kierkegaard sketched a different fourfold consideration of communicating: the object, the communicator, the receiver, and the communication. See Søren Kierkegaard's *Journals and Papers,* ed. and trans. by Howard V. Hong and Edna H. Hong (Bloomington: Indiana University Press, 1967), Vol. 1, p. 281.
3. Søren Kierkegaard, *The Point of View for My Work As an Author,* trans. by Walter Lowrie (New York: Oxford University Press, 1939), pp. 22–26, 40, 144–147.

4. *Ibid.,* pp. 27–28.
5. Kierkegaard, *Journals and Papers,* Vol. 1, p. 316.
6. Søren Kierkegaard, *Concluding Unscientific Postscripts,* trans. by David F. Swenson and Walter Lowrie (Princeton: Princeton University Press, 1941), p. 73. Reprinted by permission of Princeton University Press and the American Scandinavian Foundation.
7. *Ibid.,* pp. 552–553.
8. *Ibid.,* p. 320.
9. *Ibid.,* pp. 319–320.
10. This is also the secret to approaching a variety of communication situations—between psychotherapist and patient, Zen master and disciple, to mention two. Indeed, since the indirect communication is defined by its *effect,* it becomes arguable that Rorschach blots, abstract paintings, and even sunsets, as well as communications in verbal and existential (witnessing) media, are indirect. A critical problem in discussing and differentiating indirect communications is to discover what, if anything, prevents their being interchangeable with one another in evoking the subjective response. The rub is that the communication sets the recipient free in his own subjectivity.

COMMUNICATION IN
THE CUCKOO'S NEST

By James Waddell

1. Sallie McFague TeSelle, *Literature and the Christian Life* (New Haven: Yale University Press, 1966), p. 27. Used by permission.
2. Hans W. Frei, "Reflections on the Gospel Accounts of Jesus' Death and Resurrection" (unpublished paper, mimeographed), pp. 53–54. Cited by TeSelle, *Literature and the Christian Life,* pp. 27–28.
3. E. J. Tinsley, "The Incarnation, Art, and the Communication of the Gospel," p. 51 in this volume.
4. Ken Kesey, *One Flew Over the Cuckoo's Nest* (New York: The Viking Press, 1962), p. 8. Page numbers of subsequent quotes from the Viking Press edition will follow in the text.
5. See James D. Whitehill's essay "The Indirect Communication: Kierkegaard and Beckett" in this volume. While indebted to his explorations of the categories, I have not rigidly followed them, but have developed the categories to correspond to the nature of the indirect communication in the novel as they suggest aspects of Jesus' communication.
6. Tinsley, "The Incarnation, Art, and the Communication of the Gospel," p. 51.

THE ACHIEVEMENT OF MARSHALL McLUHAN:
FORMALIST OF TECHNOLOGICAL CULTURE

By W. Richard Comstock

1. The McLuhan controversy can now be examined in three anthologies: *The McLuhan Explosion,* edited by Harry Crosby and George Bond

(New York: Van Nostrand Reinhold Company, 1968), contains fugitive materials appearing in the more popular media; *McLuhan: Hot and Cool,* edited by Gerald E. Stearn (New York: The Dial Press, 1967), provides useful essays and important comments and responses by McLuhan (the general impression left by this volume is favorable to McLuhan's exploration); *McLuhan: Pro and Con,* edited by Raymond Rosenthal (New York: Funk & Wagnalls Company, 1967), leaves a generally "con" impression and articulates the reasons for the strong negative reaction evoked by McLuhan in the intellectual community.

2. Stearn, *McLuhan: Hot and Cool,* p. 269.

3. See Norman Jacobs, ed., *Culture for the Millions: Mass Media in Modern Society* (Boston: Beacon Press, 1964).

4. Marshall McLuhan, "Media Alchemy in Art and Society," *Journal of Communication,* Vol. 8, No. 2 (1958), p. 64.

5. Stearn, *McLuhan: Hot and Cool,* p. 279.

6. T. S. Eliot, "Tradition and the Individual Talent," in *Selected Essays, 1917–1932,* rev. ed. (New York: Harcourt Brace Jovanovich, 1950).

7. Stearn, *McLuhan: Hot and Cool,* p. 129. Cf. Marshall McLuhan, *Understanding Media* (New York: The New American Library, 1966), pp. 70–71.

8. Stearn, *McLuhan: Hot and Cool,* p. 285.

9. "Playboy Interview: Marshall McLuhan," *Playboy,* Vol. 16, No. 3 (March 1969), p. 61.

10. Solomon Fishman, *The Interpretation of Art* (Berkeley: University of California Press, 1963), p. 70.

11. McLuhan, *Understanding Media,* pp. 23–24.

12. *Ibid.,* Introduction to the Second Edition, p. ix. Cf. Marshall McLuhan and Harley Parker, *Through the Vanishing Point: Space in Poetry and Painting* (New York: Harper & Row, Publishers, 1968), pp. 237–261; Marshall McLuhan, "The Relation of Environment to Anti-Environment," in F. W. Matson and Ashley Montagu, eds., *The Human Dialogue* (New York: The Free Press, 1967), pp. 39–47; Marshall McLuhan, "Environment as Programmed Happening," in Walter J. Ong, ed., *Knowledge and the Future of Man* (New York: Simon & Schuster, 1968), pp. 113–124; Marshall McLuhan, "New Media and the Arts," *Arts in Society,* Vol. 3, No. 2 (1965), pp. 239–242.

13. McLuhan and Parker, *Through the Vanishing Point,* p. 238.

14. McLuhan, *Understanding Media,* p. 71.

15. *Ibid.,* pp. 67, 105.

16. James Carey, "Harold Adams Innis and Marshall McLuhan," in Rosenthal, *McLuhan: Pro and Con,* pp. 270–308.

17. Marshall McLuhan, *The Gutenberg Galaxy: The Making of Typographic Man* (Toronto: University of Toronto Press, 1965), pp. 1, 72; McLuhan, *Understanding Media,* p. 19.

18. Theodore Thass-Thienemann, *Symbolic Behavior* (New York: Washington Square Press, 1968).

19. Irving Weiss, "Sensual Reality in the Mass Media," in Rosenthal, *McLuhan: Pro and Con,* p. 42.

20. McLuhan, *Gutenberg Galaxy*, p. 3.
21. Stearn, *McLuhan: Hot and Cool*, p. 156.
22. McLuhan, *Gutenberg Galaxy*, p. 252.
23. Walter J. Ong, *Ramus Method, and the Decay of Dialogue* (New York: Octagon Books, 1972).
24. Kenneth Boulding, "The Medium and the Message," in Stearn, *McLuhan: Hot and Cool*, p. 61.
25. See Margaret Masterman, "The Existence of God as a Scientific Hypothesis," *Theoria to Theory*, Vol. 1, Fourth Quarter (1967), pp. 338–353, for discussion of the model as icon.
26. Marshall McLuhan, "Inside the Five Sense Sensorium," *Canadian Architect*, Vol. 6, No. 6 (1961), p. 49. Cf. McLuhan, *Understanding Media*, pp. 268–294.
27. McLuhan, *Understanding Media*, pp. 182–184; *Gutenberg Galaxy*, p. 268.
28. McLuhan, "Inside the Five Sense Sensorium," p. 54.
29. McLuhan, *Understanding Media*, pp. 75–76.
30. McLuhan, "Inside the Five Sense Sensorium," p. 54; *Gutenberg Galaxy*, p. 278.
31. Susan Sontag, "One Culture and the New Sensibility," in Stearn, *McLuhan: Hot and Cool*, pp. 252–263.
32. Marshall McLuhan, *Verbi-Voco-Visual Explorations* (Millerton, N.Y.: Something Else Press, 1967), item 15.
33. McLuhan, *Gutenberg Galaxy*, p. 1; *Understanding Media*, p. 59.
34. McLuhan, *Gutenberg Galaxy*, p. 157.
35. McLuhan and Parker, *Through the Vanishing Point*, p. 247.
36. *Ibid.*, p. 248.
37. McLuhan, *Understanding Media*, p. 162.
38. Stearn, *McLuhan: Hot and Cool*, p. 283.
39. McLuhan, *Gutenberg Galaxy*, p. 82.
40. See James J. Gibson, "Pictures, Perspective, and Perception," in Gyorgy Kepes, ed., *The Visual Arts Today* (Middletown, Conn.: Wesleyan University Press, 1960), pp. 220–231; cf. *Gutenberg Galaxy*, p. 37 with *Through the Vanishing Point*, p. 240.
41. McLuhan, *Gutenberg Galaxy*, p. 5.
42. Wyndham Lewis, *Blasting and Bombardiering* (Berkeley: University of California Press, 1967), pp. 34–35.
43. McLuhan, *Gutenberg Galaxy*, p. 32; *Understanding Media*, p. 144.
44. Stearn, *McLuhan: Hot and Cool*, p. 279.
45. McLuhan, *Understanding Media*, p. 56.
46. McLuhan and Parker, *Through the Vanishing Point*, p. 243.
47. *Ibid.*, p. 241.
48. *Ibid.*, p. 244.
49. McLuhan, *Understanding Media*, pp. 141–142.
50. McLuhan, *Gutenberg Galaxy*, p. 5.
51. McLuhan, *Understanding Media*, p. 38.

PERSONS AND PLACES:
PARADIGMS IN COMMUNICATION

By W. H. Poteat

1. This has been argued, I believe definitively, by P. F. Strawson, *Individuals: An Essay in Descriptive Metaphysics* (London: Methuen & Co., 1959), *passim*.

2. In all honesty it is improper to tax Plato with this misguidance. The richness and equivocacy of his "true" meanings need not detour us, since they are for the Platonic scholars. It surely is a fact, however, that the Plato of the Renaissance—the Plato uprooted from Pythagorean mysticism and from the Neoplatonism of Augustine and Plotinus—is the thinker who has most deeply impregnated the imagination of the West. It is this which matters here.

3. See especially Erwin W. Strauss, "Forms of Spatiality," in *Phenomenological Psychology* (New York: Basic Books, 1966).

4. I shall not undertake to document this sweeping suggestion here, but will only bid the skeptical reader to examine the major epistemologists of our tradition with this question in the forefront.

5. T. A. Langford and W. H. Poteat, eds., *Intellect and Hope: Essays in the Thought of Michael Polanyi* (Durham, N.C.: Duke University Press, 1968), pp. 449–455.

6. It surely is true as Sigfried Giedion says: "Perspective was not the discovery of any one person; it was the expression of the whole era. . . . The significant thing is the mixture of art with science . . . the two worked together . . . in the development of perspective. Indeed, one rarely sees so complete a unity of thinking and feeling—art and science—as is to be found in the early fifteenth century." *Space, Time and Architecture*, 4th rev. ed. (Cambridge, Mass.: Harvard University Press, 1962), p. 31.

7. Cf. Alexandre Koyré: "It is . . . sufficient to describe [the spiritual revolution of the sixteenth century], to describe the mental or intellectual attitude of modern science by two [connected] characteristics. They are: (1) the destruction of the cosmos . . .; (2) the geometrization of space—that is, the substitution of the homogeneous and abstract space of Euclidian geometry for the qualitatively differentiated and concrete world-space conception of the pre-galilean physics." *Metaphysics and Measurement* (Cambridge, Mass.: 1968), pp. 19–20. A reader who supposes there is an anomaly in my concern with a return to the heterogeneity of qualitative differentiation in concrete world-space at the same time that I appear to trace the triumph of the abstract, in part, to the glories of illusionistic naturalism in Renaissance perspectival painting, should be aware that it is solely the invitation of the eye to lead the imagination as a whole toward its self-abstraction into infinity, reinforced by the other elements I mention, which concerns me.

8. It should go without saying that the logical force of the word "body" as it appears in the statement of the commonsense view is *derivative*

and importantly different even as this formula as a whole is derivative; and similarly that "body" as the ground of the primordial sense of space has, as well, a primordial sense not to be assimilated to any derived sense.

9. René Descartes, *The Principles of Philosophy,* Pt. I, LIII.

10. *Ibid.,* Pt. I, VIII. Italics added.

11. *Ibid.,* Pt. II, IV. Italics added.

12. Koyré, *Metaphysics and Measurement,* p. 20.

13. Hiram Haydn, *The Counter-Renaissance* (Gloucester, Mass.: Peter Smith, 1950), *passim.*

14. Blaise Pascal, *Pensées,* trans. by W. F. Trotter (London, 1932), pp. 16–21.

15. Henceforth I shall distinguish the derived from the radical by placing double quotes around the derived. This will mean, though specific articulations of their relations may be opaque, that "extension" will stand to *extension* as space (in our developed sense) stands to *place,* "place" stands to *place* and "body" stands to body.

16. Pascal, *Pensées,* p. 16.

17. *Ibid.,* p. 61.

18. I wish to make clear, in short, that the precision which I have undertaken to achieve up to this point by using conventions like *place,* "place," space, body, and "body," imprecise though even *they* are, will be abandoned in favor of a reliance upon the reader to read the shifting analogies off the contexts of their use.

19. Events will almost certainly outrun the publication of these words, but now that the distinction between the actor and his role has virtually disappeared and that between audience and cast along with it, there seems no reason why we should not carry immediacy, audience and cast participation to the ultimate. Why not mount a drama (in the round) in which a different actor is put to death on stage each night of the run; even one in which the holder of the lucky ticket is allowed to choose the victim. Dissertations can be arranged on "The Head-on Collision at 80 M.P.H. As a Work of Art."

20. Robert Coles, "Symposium: Violence in Literature," *American Scholar,* Vol. 27, No. 3 (1968), pp. 491–492.

21. J. D. Salinger, *The Catcher in the Rye* (New York: Grosset & Dunlap, 1951), pp. 256–257.

22. Cf. Alexandre Koyré: "The dissolution of the cosmos means the destruction of the idea of a hierarchically ordered finite world-structure, of the idea of a qualitatively and antologically differentiated world, and its replacement by that of an open, indefinite and even infinite universe." *Metaphysics and Measurement,* p. 20.

23. From John Donne, "An Anatomie of the World."

24. Søren Kierkegaard, *Either/Or,* trans. by David F. and Lillian M. Swenson, Vol. I (Princeton: Princeton University Press, 1944), p. 105.

25. Ernst Cassirer *et al.,* eds., *The Renaissance Philosophy of Man* (Chicago: University of Chicago Press, 1948), pp. 224–225.

26. Pascal, *Pensées,* Fragments 205–427.

27. Jean Paul Sartre, *The Flies,* in *Two Plays,* trans. by Stuart Gilbert (London, 1946), pp. 96–97.

ARCHITECTURAL ENVIRONMENT
AND PSYCHOLOGICAL NEEDS

By Peter F. Smith

1. "Outrage" was originally featured in the *Architectural Review* (June 1955).

2. For example, S. J. L. Taylor and Sidney Chave, *Mental Health and Environment* (London: Longmans, Green, 1964).

3. Summarised in "Social Problems Arising from Housing Solutions," a paper delivered at Newcastle University in 1967. Demers is now Social Development Officer, Washington (England) Development Corporation.

4. Amos Rapoport and R. E. Kantor, "Complexity and Ambiguity in Environmental Design," *Journal of the American Institute of Planners* (July 1967).

5. See John L. Fuller, *Motivation: A Biological Perspective* (New York: Random House, 1962) and Edward J. Murray, *Motivation and Emotion* (Englewood Cliffs, N.J.: Prentice-Hall, 1964).

6. Cf. George A. Miller, *Psychology: The Science of Mental Life* (London: Hutchinson, 1964), p. 114: "One does not literally *see* space the way one sees surfaces, colours, contours, shadows, one infers it, either perceptually, conceptually, or both. Space is one of the abstract schemata we impose on our world in order to make experience more coherent and meaningful."

7. Fuller, *Motivation: A Biological Perspective*, p. 4ff.

8. Cf. Donald O. Hebb, *A Textbook of Psychology*, 2nd ed. (Philadelphia: W. B. Saunders Co., 1966) and Steven Rose, *The Chemistry of Life* (Baltimore: Penguin Books, 1966).

9. Frederic C. Bartlett, *Remembering: A Study in Experimental and Social Psychology* (Cambridge: Cambridge University Press, 1932), p. 201.

10. Extra emphasis may be given to this symbolism by the words inscribed in the charred cross made from timbers from the destroyed church: "Father, Forgive."

11. As in Mircea Eliade, *Images and Symbols: Studies in Religious Symbolism*, trans. by Philip Mairet (London: Harvill Press, 1961).

12. Miller, *Psychology*, p. 114.

13. *Ibid.*, p. 269.

14. Murray, *Motivation and Emotion*, p. 75.

15. Miller, *Psychology*, p. 34.

16. Norman O. Brown's summary of the central idea in "Beyond the Pleasure Principle," in *Life Against Death* (London: Routledge & Kegan Paul, 1959), p. 100.

17. Carl G. Jung, *Modern Man in Search of a Soul* (New York, 1936).

18. A. W. N. Pugin, *Contrasts* (New York: Humanities Press, 1968).

19. Cf. Arthur Koestler, *The Act of Creation* (New York: The Macmillan Co., 1965), Jacques Barzun, *Classic, Romantic and Modern* (London: Secker & Warburg, 1961), and Vincent Scully, Jr., *Modern Architecture* (New York: George Braziller, 1961).

20. Cf. Leon Festinger, *A Theory of Cognitive Dissonance* (Stanford, Calif.: Stanford University Press, 1957).

21. In Barzun, *Classic, Romantic and Modern.*

22. The theory of Sacred Geometry is well described by Otto Georg von Simson in *The Gothic Cathedral* (London: Routledge & Kegan Paul, 1956).

23. Cf. Rudolf Wittkower, *Architectural Principles in the Age of Humanism* (London: A. Tiranti, 1952).

24. Eliade, *Images and Symbols*, p. 42.

25. *Ibid.* When Jerusalem became Muslim, the binary symbolism of the Hebrew temple was automatically transferred to the mosque, evidence that such symbolism must be extremely deep-rooted to overcome bitter religious and political differences.

26. *Ibid.*, p. 44.

27. William R. Lethaby, *Mediaeval Art from the Peace of the Church to the Eve of the Renaissance*, pp. 312–1350, D. Talbot Rice, ed. (Westport, Conn.: Greenwood Press, 1950).

28. Excellently described by Joseph Rykwert, *The Idea of a Town* (London: St. George's Gallery, n.d.).

29. F. W. Dillistone, *Christianity and Symbolism* (London: Collins, 1955), p. 221.

30. Cf. von Simson, *The Gothic Cathedral.*

31. The term is used by Koestler, *The Act of Creation.*

32. Carl G. Jung, *The Development of Personality* (London, 1954), p. 171.

33. Alfred Adler, *The Science of Living* (London, 1930), p. 32.

34. Pioneer experiments in this field were conducted at McGill University College. Volunteers, who were offered $20 a day, had all receptors muffled for as long as they could tolerate it. After a period of hours the subjects experienced extreme discomfort, and later vivid hallucinations. Described by Murray, *Motivation and Emotion*, p. 75. Also, R. L. Fanz conducted experiments which clearly indicated that young children prefer complex to simple patterns: "Pattern Vision in Young Infants," *Psychological Record*, Vol. 8 (1958), pp. 43ff.

35. In particular, the Pavilions of the Academia and Piazze d'Oro, in Hadrian's Villa, Tivoli.

36. An idea offered by Niklaus Pevsner, *Outline of European Architecture* (New York: Pelican, 1960).

37. The longest cathedrals in Europe are in St. Albans and Winchester.

38. Allan Temko, *Notre-Dame of Paris* (New York: Viking Press, 1959), p. 159.

39. Miller, *Psychology*, p. 34. Miller cites A. N. Sokolov: "Psychological indicators show increasing habituation whenever a person can formulate some kind of expectation, some internal model for what is going on around him; arousal occurs when his internal model disagrees with external reality." (From "Neurological Models and Orienting Reflex," in M. A. B. Brazier, ed., *The Central Nervous System.*)

40. W. N. Dember and R. W. Earl, on the basis of numerous experiments with rats, have concluded that a need for variability of stimuli, complexity, and ambiguity is inherent to human behavior as well as to

that of rats. They introduce the term "ideal" to describe the maximum complexity, etc., an individual can cope with in a given time. ("Analysis of Exploratory, Manipulative, and Curiosity Behavior," *Psychological Review*, Vol. 64 (Jan.–Nov. 1957), pp. 91–96.)

41. Streufert and Schroder, "Conceptual Structure, Environmental Complexity and Task Performance," *Journal of Experimental Research in Personality*, Vol. 1 (1965), pp. 132–137.

42. In his book *Social Psychology* (New York: Free Press, 1965) Roger Brown devotes a chapter to Balance Theories in which he proposes that an individual's ability to accept and process variability, ambiguity, etc. assumes a parabolic shape when plotted on a graph. This has led to the term "U-curve hypothesis."

43. D. Krech, M. R. Rosenzweig and F. L. Bennett have conducted experiments on three groups of rats, carefully matched. One group was placed in a visually enriched environment, another in a standard one, and the third in a visually impoverished situation. Those from the enriched environment outstripped the other two in problem-solving and learning ability, and also, most significantly, in brain weight. The same results were obtained from mature as well as young rats, implying that brain development does not fall off with age. ("Relation Between Chemistry and Problem-Solving in Enriched and Impoverished Environments," *Journal of Comparative and Physiological Psychology*, Vol. 55 (1962), pp. 594–596.)

 Dr. B. G. Craig of University College, London, continues to achieve the above results through exposing rats to positive and negative visual environment.

44. Gordon Cullen, *Townscape* (New York: Van Nostrand Reinhold, 1962).

45. Cf. R. W. White, "Motivation Reconsidered: The Concept of Competence," *Psychological Review*, Vol. 66 (Jan.–Nov. 1959), pp. 297–333 and Frank Barron, *Creativity and Psychological Health* (Princeton: D. Van Nostrand Co., 1963).

46. Cullen uses the terms "Hereness" and "Thereness" throughout *Townscape*.

47. Edmund N. Bacon, *Design of Cities* (London, 1967), p. 280.

48. For an illustration of Wolfegg's design, see p. 217.

SELECTED BIBLIOGRAPHY

Each author compiled his section of the selective list to provide guidelines for further study in the area of his essay. Books and essays which chart the way ahead in more than one area are appropriately relisted in the form recorded by the individual contributors.

THE WAY INTO MATTER

Bachelard, Gaston. *The Poetics of Space.* Translated by Maria Jolas. New York: The Orion Press, 1964.

Barfield, Owen. *Saving the Appearances.* New York: Harcourt, Brace & World, n.d.

Barr, James. *The Semantics of Biblical Language.* London: Oxford University Press, 1961.

Blunt, Anthony. *Artistic Theory in Italy.* London: Oxford University Press, 1964.

Brandt, William J. *The Shape of Medieval History.* New Haven: Yale University Press, 1966.

Brock, Hermann. "The Style of the Mythical Age," introduction to *On the Illiad* by Rachel Bespaloff. New York: Harper Torchbooks, 1962.

Brown, Norman O. *Life Against Death.* New York: Vintage Books, 1959.

Cassirer, Ernst. *Essay on Man.* New Haven: Yale University Press, 1944.

Dix, Dom Gregory. *The Shape of the Liturgy.* London: Adam and Charles Black, 1960.

Ehrenzweig, Anton. *The Hidden Order of Art.* Berkeley: University of California Press, 1967.

Eliade, Mircea. *The Sacred and the Profane.* New York: Harper Torchbooks, 1961.

Farrer, Austin. *A Rebirth of Images.* Boston: Beacon Press, 1963.

Frankfort, Henri, *et al. Before Philosophy.* Baltimore: Penguin Books, 1949.

Geertz, Clifford. "The Growth of Culture and the Evolution of Mind," in Jordan Scher, ed., *Theories of the Mind.* New York: The Free Press, 1962.

————. "Religion as a Cultural System," in Donald R. Cutler, ed., *The Religious Situation: 1968.* Boston: Beacon Press, 1968.

Giedion, Sigfried. *The Eternal Present: The Beginnings of Art.* New York: Pantheon Books, 1962.

————. *The Eternal Present: The Beginnings of Architecture.* New York: Pantheon Books, 1964.

Hall, Edward T. *The Hidden Dimension.* Garden City, N.Y.: Doubleday, 1966.

Hayek, Friedrich A. *The Sensory Order.* Chicago: University of Chicago Press, 1952.

Ivins, William M., Jr. *Prints and Visual Communication.* Cambridge, Mass.: Harvard University Press, 1953.

Kubler, George A. *The Shape of Time*. New Haven: Yale University Press, 1962.

Kuhn, Thomas S. *The Structure of Scientific Revolutions*. Chicago: University of Chicago Press, 1962.

Langer, Susanne K. *Philosophy in a New Key*. 3rd ed. Cambridge, Mass.: Harvard University Press, 1957.

Leeuw, Gerardus van der. *Sacred and Profane Beauty*. Translated by David Green. New York: Holt, Rinehart and Winston, 1963.

Levy, G. Rachel. *Religious Conceptions of the Stone Age and Their Influence upon European Thought*. New York: Harper Torchbooks, 1963.

McLuhan, Marshall. *The Gutenberg Galaxy*. Toronto: University of Toronto Press, 1962.

May, Rollo, *et al*, eds. *Existence: A New Dimension in Psychiatry and Psychology*. New York: Simon and Schuster, 1967.

Ortega y Gasset, Jose. *Meditations on Quixote*. New York: W. W. Norton, 1961.

Otto, Rudolph. *The Idea of the Holy*. New York: Oxford University Press, 1958.

Otto, Walter F. *The Homeric Gods*. Boston: Beacon Press, 1964.

Polanyi, Michael. *Personal Knowledge*. New York: Harper Torchbooks, 1964.

Portmann, Adolf. *New Paths in Biology*. New York: Harper & Row, 1963.

Read, Herbert. *Icon and Idea*. New York: Shocken Books, 1965.

Scher, Jordan, ed. *Theories of the Mind*. New York: The Free Press, 1962.

Schwarz, Rudolf. *The Church Incarnate*. Translated by Cynthia Harris. Chicago: Henry Regnery, 1958.

Sewell, Elizabeth. *The Human Metaphor*. Notre Dame, Ind.: University of Notre Dame Press, 1964.

Strauss, Erwin. *The Primary World of the Senses*. Translated by Joseph Needleman. New York: The Free Press, 1963.

Whorf, Benjamin Lee. *Language, Thought and Reality*. Edited by John B. Carroll. Cambridge, Mass.: M.I.T. Press, 1956.

Whyte, L. L. *Internal Factors in Evolution*. New York: George Braziller, 1965.

————. "A Scientific View of the 'Creative Energy' of Man," in Morris Philipson, ed., *Aesthetics Today*. New York: Meridian, 1961.

Wittkower, Rudolf. *Architectural Principles in the Age of Humanism*. London: Alec Tiranti, 1952.

THE INCARNATION, ART, AND
THE COMMUNICATION OF THE GOSPEL

Auerbach, Erich. *Mimesis: The Representation of Reality in Western Literature*. Translated by W. R. Trask. Princeton, N.J.: Princeton University Press, 1953.

Berdyaev, Nicholas. *The Destiny of Man.* Translated by Natalie Dudding-ton. London: Geoffrey Bles, 1937.

————. *The Meaning of the Creative Act.* London: Gollancz, 1955.

Bridge, A. C. *Images of God.* London: Hodder and Stoughton, 1960.

Burney, C. F. *The Poetry of Our Lord.* Oxford: The Clarendon Press, 1925.

Cassirer, Ernst. *Essay on Man.* New Haven: Yale University Press, 1944.

————. *Language and Myth.* Translated by Susanne K. Langer. New York: Dover Publications, 1946.

————. *The Philosophy of Symbolic Forms.* Translated by Ralph Manheim. 3 Vols. New Haven: Yale University Press, 1953.

Chase, Richard V. *The Quest for Myth.* Baton Rouge: Louisiana State University Press, 1949.

Cope, Gilbert Frederick, ed. *Christianity and the Visual Arts.* London: Faith Press, 1964.

Dillistone, Frederick W., ed. *Myth and Symbol.* Naperville, Ill.: Alec R. Allenson, 1966.

Dixon, John W., Jr. *Nature and Grace in Art.* Chapel Hill: University of North Carolina Press, 1964.

Fletcher, Angus J. S. *Allegory: The Theory of a Symbolic Mode.* Ithaca, N.Y.: Cornell University Press, 1964.

Focillon, Henri. *Vie des Formes.* Paris: Presses Universitaires de France, 1964.

Foss, Martin. *Symbol and Metaphor in Human Experience.* Lincoln, Nebr.: University of Nebraska Press, 1964.

Frye, Northrop. *Anatomy of Criticism.* Princeton, N.J.: Princeton University Press, 1971.

————, et al. *Myth and Symbol.* Lincoln, Nebr.: University of Nebraska Press, 1963.

Hazelton, Roger. *New Accents in Contemporary Theology.* New York: Harper & Row, 1960.

Hough, Graham. *An Essay on Criticism.* New York: W. W. Norton & Co., 1967.

Jaspers, Karl. *Truth and Symbol.* Translated by Jean T. Wilde, William Kluback, and William Kimmel. London: Vision Press, 1959.

Johnson, F. Ernest, ed. *Religious Symbolism.* Port Washington, N.Y.: Kennikat Press, 1969.

Knox, John. *Myth and Truth.* London: Carey Kingsgate Press, 1966.

Leeuw, Gerardus van der. *Sacred and Profane Beauty.* Translated by David Green. New York: Holt, Rinehart and Winston, 1963.

McIntyre, John. *The Shape of Christology.* Philadelphia: The Westminister Press, 1966.

Maritain, Jacques. *Art and Scholasticism and the Frontiers of Poetry.* New York: Sheed and Ward, 1943.

Niebuhr, H. Richard. *Christ and Culture.* London: Faber & Faber, 1952.

Ogden, S. M. "Five Theses on Religious Symbolism." A contribution to the special colloquium on Symbolism in the Superior Studies Programme, Southern Methodist University, December 16, 1964.

Raine, Kathleen. *Defending Ancient Springs.* London: Oxford University Press, 1967.

Régamey, P. R. *Art Sacré au XXV Siècle?* Paris: Editions du Cerf, 1952.

Schwarz, Rudolf. *The Church Incarnate.* Translated by Cynthia Harris. Chicago: Henry Regnery, 1958.

Scott, Nathan A., Jr. *Rehearsals of Discomposure.* New York: Columbia University Press, 1952.

Throckmorton, B. H. *The New Testament and Mythology.* Philadelphia: The Westminster Press, 1959.

Tillich, Paul. *Theology of Culture.* New York: Oxford University Press, 1964.

Westcott, Brooke F. "The Relationship of Christianity to Art." Appendix to *The Epistles of St. John.* London, 1902.

Wilder, Amos N. *Early Christian Rhetoric.* Cambridge, Mass.: Harvard University Press, 1971.

Wimsatt, William K. *The Verbal Icon.* Lexington, Ky.: University Press of Kentucky, 1967.

THE INDIRECT COMMUNICATION: KIERKEGAARD AND BECKETT

Beckett, Samuel. *Endgame.* New York: Grove Press, 1958.

————. *Krapp's Last Tape.* New York: Grove Press, 1960.

————. *Play.* London: Faber & Faber, 1964.

————. *Proust.* London: Chatte & Windus, 1931.

————. *Waiting for Godot.* New York: Grove Press, 1966.

Bejerhelm, Lars. *Meddelelsens Dialectik.* Copenhagen: Munksgaard, 1964.

Esslin, Martin, ed. *Samuel Beckett: A Collection of Critical Essays.* Englewood Cliffs, N.J.: Prentice-Hall, 1965.

Hoffman, Frederick J. *Samuel Beckett: The Language of Self.* Carbondale, Ill.: Southern Illinois University Press, 1962.

Kierkegaard, Søren. *Concluding Unscientific Postscript.* Translated by David F. Swenson and Walter Lowrie. Princeton: Princeton University Press, 1941.

————. *The Point of View for My Work As an Author.* Translated by Walter Lowrie. New York: Oxford University Press, 1939.

————. *Søren Kierkegaard's Journal and Papers,* Vol. 1. Edited and translated by Howard V. Hong and Edna H. Hong. Bloomington: Indiana University Press, 1967.

Malantschuk, Gregor. *Kierkegaard's Way to the Truth.* Translated by Marie Michelsen. Minneapolis: Augsburg Publishing House, 1963.

Mueller, William R., and Jacobsen, Josephine. *The Testament of Samuel Beckett.* New York: Hill & Wang, 1964.

Rehm, Walther. *Kierkegaard und der Verführer.* München: Verlag Hermann Rinn, 1949.

Scott, Nathan A. *Samuel Beckett.* New York: Hillary House Publishers, 1965.

COMMUNICATION IN
THE CUCKOO'S NEST

Bonhoeffer, Dietrich. *The Cost of Discipleship.* Translated by R. H. Fuller. New York: The Macmillan Co., 1963.

Bornkamm, Günther. *Jesus of Nazareth.* New York: Harper & Row, 1961.

Dillistone, Frederick W. *Christianity and Symbolism.* London: Collins, 1955.

_____. *The Novelist and the Passion Story.* New York: Sheed and Ward, 1961.

Frye, Northrop. *Anatomy of Criticism.* Princeton: Princeton University Press, 1971.

Lewis, Richard W. B. *The Picaresque Saint: Representative Figures in Contemporary Fiction.* Philadelphia: J. B. Lippincott Co., 1961.

Lynch, William F. *Christ and Appollo: The Dimensions of the Literary Imagination.* New York: Sheed and Ward, 1960.

Scott, Nathan A., Jr., ed. *Adversity and Grace.* Chicago: University of Chicago Press, 1968.

_____. *The Broken Center: Studies in the Theological Horizon of Modern Literature.* New Haven: Yale University Press, 1966.

THE RELATIONSHIP BETWEEN
FORM AND CONTENT/MEDIUM AND MESSAGE IN
CHRISTIAN COMMUNICATION

Bultmann, Rudolf. *Jesus Christ and Mythology.* New York: Charles Scribner's Sons, 1958.

_____. *Kerygma and Myth: A Theological Debate.* Edited by Hans W. Bartsch. New York: Harper & Row, 1961.

Duncan, Hugh D. *Symbols in Society.* New York: Oxford University Press, 1968.

Langer, Susanne K. *Feeling and Form.* New York: Charles Scribner's Sons, 1953.

McLuhan, Marshall. *The Gutenberg Galaxy.* Toronto: University of Toronto Press, 1962.

_____. *Understanding Media: The Extensions of Man.* New York: McGraw-Hill, 1966.

Newton, Eric and Neil, William. *Two Thousand Years of Christian Art.* New York: Harper & Row, 1966.

THE ACHIEVEMENT OF MARSHALL McLUHAN:
FORMALIST OF TECHNOLOGICAL CULTURE

Crosby, Harry H., and Bond, George R. *The McLuhan Explosion.* New York: Van Nostrand Reinhold Co., 1968.

Finkelstein, Sidney. *Sense and Nonsense of McLuhan.* New York: International Publishers, 1968.

McLuhan, Marshall. *The Gutenberg Galaxy*. Toronto: University of Toronto Press, 1962.

_____. *The Mechanical Bride*. Boston: Beacon Press, 1967.

_____, and Fiore, Quentin. *The Medium Is the Massage*. New York: Bantam Books, 1967.

_____, and Parker, Harley. *Through the Vanishing Point*. New York: Harper & Row, 1968.

_____. *Understanding Media*. New York: Signet Books, 1966.

_____. *Verbi- Voco- Visual Explorations*. New York: Something Else Press, 1967.

_____. *War and Peace in the Global Village*. New York: Bantam Books, 1971.

Rosenthal, Raymond. *McLuhan: Pro and Con*. Baltimore: Penguin Books, 1969.

Stearn, Gerald Emanuel, ed. *McLuhan: Hot and Cool*. New York: The Dial Press, 1967.

PERSONS AND PLACES:
PARADIGMS IN COMMUNICATION

Auden, W. H. *The Dyer's Hand*. New York: Random House, 1962.

_____. *Homage to Clio*. New York: Random House, 1960.

Boman, Thorleif. *Hebrew Thought Compared with Greek*. Translated by Jules L. Moreau. New York: W. W. Norton & Co., 1970.

Buber, Martin. *I and Thou*. Translated by R. G. Smith. Edinburgh: T. and T. Clark, 1944.

Burtt, Edwin A. *The Metaphysical Foundations of Modern Physical Science*. New York: Humanities Press, 1964.

Butterfield, Herbert. *The Origins of Modern Science*, rev. ed. New York: Free Press, 1965.

Cassirer, Ernst. *The Philosophy of Symbolic Forms*. Translated by Ralph Manheim. 3 Vols. New Haven: Yale University Press, 1953.

_____, et al, eds. *The Renaissance Philosophy of Man*. Chicago: University of Chicago Press, 1948.

Collingwood, Robin G. *The Idea of Nature*. Oxford: The Clarendon Press, 1945.

Foster, M. B. "The Christian Doctrine of Creation and The Rise of Modern Natural Science." *Mind*, Vol. 43 (October 1934), pp. 446–468.

_____. "Christian Theology and Modern Science of Nature." *Mind*, Vol. 44 (October 1935), pp. 439–466.

Frank, Erich. *Philosophical Understanding and Religious Truth*. New York: Oxford University Press, 1945.

Giedion, Sigfried. *Space, Time and Architecture*. 4th ed., rev. Cambridge, Mass: Harvard University Press, 1962.

Haydn, Hiram. *The Counter-Renaissance*. Gloucester, Mass: Peter Smith, 1950.

Jammer, Max. *Concepts of Space*. 2nd ed. Cambridge, Mass: Harvard University Press, 1969.

Jaspers, Karl. *Leonardo, Descartes, Max Weber*. Translated by Ralph Manheim. London: Routledge & Kegan Paul, 1965.

_____. *The Origin and Goal of History*. Translated by Michael Bullock. New Haven: Yale University Press, 1968.

Kierkegaard, Søren. *Either/Or*. Translated by David and Lillian Swenson. 2 Vols. Princeton, N.J.: Princeton University Press, 1944.

Köhler, Ludwig. *Hebrew Man*. Translated by P. R. Ackroyd. London: SCM Press, 1956.

Marcel, Gabriel. *Metaphysical Journal*. Translated by Bernard Wall. Chicago: Henry Regnery, 1967.

Merleau-Ponty, Maurice. *The Phenomenology of Perception*. Translated by Colin Smith. New York: Humanities Press, 1962.

_____. *Signs*. Translated by Richard C. McCleary. Evanston, Ill.: Northwestern University Press, 1964.

Onians, R. B. *The Origins of European Thought*. Cambridge, Eng.: Cambridge University Press, 1951.

Ortega y Gasset, Jose. *Man and People*. Translated by Willard R. Trask. New York: W. W. Norton, 1963.

Pedersen, Johannes. *Israel: Its Life and Culture*. Translated by Mrs. Aslang Moller. 2 Vols. London: Oxford University Press, 1926–1947.

Polanyi, Michael. *Personal Knowledge: Towards a Post-Critical Philosophy*. Chicago: University of Chicago Press, 1958.

Poteat, William H. "God and the 'Private-I'." *Philosophy and Phenomenological Research*, Vol. 20 (March 1960), pp. 409–416.

_____. "Birth, Suicide and the Doctrine of Creation." *Mind*, Vol. 68 (July 1959), pp. 309–321.

Sewell, Elizabeth. *The Orphic Voice*. New York: Harper & Row, 1971.

Straus, Erwin W. *Phenomenological Psychology*. New York: Basic Books, 1965.

_____. *The Primary World of Senses*. Translated by J. Needleman. New York: The Free Press, 1963.

Strong, E. W. *Procedures and Metaphysics*. Berkeley: University of California Press, 1936.

Weizsäcker, Carl F. von. *The History of Nature*. Chicago: University of Chicago Press, 1949.

Whitehead, Alfred North. *The Concept of Nature*. Cambridge, Eng.: Cambridge University Press, 1920.

_____. *Science and the Modern World*. New York: The Macmillan Co., 1926.

Whiteman, Michael. *Philosophy of Space and Time*. New York: Humanities Press, 1968.

Willey, Basil, *The Seventeenth Century Background*. New York: Doubleday & Co., 1953.

Wittgenstein, Ludwig. *Philosophical Investigations*. Translated by G. E. M. Anscombe. New York: The Macmillan Co., 1953.

ARCHITECTURAL ENVIRONMENT
AND PSYCHOLOGICAL NEEDS

Bacon, Edmund N. *Design of Cities*. London: Thames & Hudson, 1967.

Bartlett, Frederic C. *Remembering*. Cambridge: Cambridge University Press, 1964.

Barzun, Jacques. *Classic, Romantic and Modern*. London: Secker & Warburg, 1961.

Brown, Norman O. *Life Against Death*. London: Routledge & Kegan Paul, 1959.

Cullen, Gordon. *Townscape*. New York: Van Nostrand Reinhold, 1962.

Dillistone, Frederick W. *Christianity and Symbolism*. London: Collins, 1955.

Eliade, Mircea. *Images and Symbols*. Translated by Philip Mairet. London: Harvill Press, 1961.

Festinger, Leon. *A Theory of Cognitive Dissonance*. Stanford, Calif.: Stanford University Press, 1957.

Fuller, John L. *Motivation: A Biological Perspective*. New York: Random House, 1962.

Goldstein, Kurt. *The Organism*. Boston: Beacon Press, 1963.

Gregory, R. L. *Eye and Brain*. New York: McGraw-Hill, 1966.

Koestler, Arthur. *The Act of Creation*. New York: The Macmillan Co., 1965.

Lynch, Kevin. *The Image of the City*. Cambridge, Mass.: M.I.T. Press, 1960.

Miller, George A. *Psychology: The Science of Mental Life*. London: Hutchinson, 1964.

Moholy-Nagy, Sibyl. *The Matrix of Man*. New York: Praeger Publishers, 1968.

Norberg-Schulz, Christian. *Intentions in Architecture*. Cambridge, Mass.: M.I.T. Press, 1968.

Rose, Steven. *The Chemistry of Life*. Baltimore: Penguin Books, 1966.

Rykwert, Joseph. *The Idea of a Town*. London: St. George's Gallery, n.d.

Simson, Otto Georg von. *The Gothic Cathedral*. London: Routledge & Kegan Paul, 1956.

Spreiregen, Paul D. *Urban Design: The Architecture of Towns and Cities*. New York: McGraw-Hill, 1965.

Stripe, R. E. ed. *Perception and Environment*. Chapel Hill, N.C.: Foundations of Urban Design, 1966.

Taylor, S. J. L. T. and Chave, Sidney. *Mental Health and Environment*. London: Longmans, Green, 1964.

Temko, Allan. *Notre-Dame of Paris*. New York: Viking Press, 1959.

Whiffen, Marcus, ed. *The Architect and the City*. Cambridge, Mass.: M.I.T. Press, 1966.

Wittkower, Rudolf. *Architectural Principles in the Age of Humanism*. London: A Tiranti, 1952.

CONTRIBUTORS

W. RICHARD COMSTOCK, Associate Professor in the Religious Studies Department of the University of California at Santa Barbara, is the author of articles on Santayana, Tillich, James, and McLuhan. He also has written *Religion and Man: An Introduction.*

F. W. DILLISTONE is former Fellow and Chaplain of Oriel College, Oxford University. He also has taught at Wycliffe College, Toronto, and the Episcopal Theological School, Cambridge, Massachusetts. Among his many books published are *Christianity and Symbolism, Christianity and Communication,* and *The Novelist and the Passion Story.*

JOHN W. DIXON, JR., Professor of Art and Religion at the University of North Carolina at Chapel Hill, is the author of *Nature and Grace in Art.*

W. H. POTEAT, after teaching at the University of North Carolina and The Episcopal Theological Seminary of the Southwest, is now Chairman of the Department of Religion at Duke University. He is the co-editor of *Intellect & Hope: Essays in the Thought of Michael Polanyi.*

PETER F. SMITH, educated at Queens' College, Cambridge, and Manchester University, is Lecturer in Architecture at the University of Sheffield and Principal of the firm of P. Ferguson Smith and Associates. He is the author of *Third Millennium Churches, Dynamics of Urbanism,* and numerous articles on psychology and urban design.

E. J. TINSLEY has been Professor of Theology at the University of Leeds since 1962. He previously served as head of the Department of Theology at the University of Hull. Among his publications are *The Imitation of God in Christ* and *The Gospel According to Luke.*

JAMES WADDELL, former Melancthon W. Jacobus Instructor in Religion, Princeton University, received his doctoral education at Oxford University. He is Associate Dean of the Faculty at Stephens College and teaches courses in philosophy, religion, and art.

JAMES D. WHITEHILL, who obtained his doctoral degree in religion and literature from Drew University, also studied at Trinity College, Hartford, Connecticut, and at Columbia University. Before going to Stephens College in 1968, he lectured at Fairleigh Dickinson University.